European Art
in the
High Museum

The research and publication of this catalogue were
supported by grants from the National Endowment
for the Arts, the Georgia Council for the Arts and
Humanities, and the Mellon Foundation.

Published by the High Museum of Art
Atlanta, Georgia

Edited by Kelly Morris
Designed by Jim Zambounis, Atlanta
Type set by Preston Rose Company, Atlanta
Printed by Balding + Mansell, Wisbech, England

Library of Congress Catalogue No. 84-81666
ISBN 0-939802-22-8

Cover:
Giovanni Battista Tiepolo, *Vestals Making
Offerings to Juno* (detail)

European Art
in the
High Museum

Eric M. Zafran

High Museum of Art
Atlanta, Georgia

Foreword

The collection of European art in the High Museum grew slowly with gifts from various individuals and organizations. In 1938 the Junior League donated the painting by Maufra (p. 137), and in 1940 the Piedmont Driving Club gave the Merson work (p. 94), which had first come to Atlanta for exhibition in 1895.

In 1942 the first works purchased for the collection by the Friends of Art were added—the notable early Venetian painting by Jacobello del Fiore (p. 9) and the Pseudo Pier Francesco Fiorentino (p. 35). Later acquisitions through the Friends of Art included the Austrian panel *Christ Carrying the Cross* (p. 81) in 1944, the French limestone *Madonna and Child* (p. 122) in 1950, and the School of Bosch *Temptation of St. Anthony* (p. 81) in 1952.

In 1949, through the generosity of his family, the Museum received the collection of J. J. Haverty. The collection consisted primarily of American paintings but also contained the excellent Impressionist landscape by Boudin (p. 144) and the characteristic *fête* by Monticelli (p. 152). The first Great Painting Fund purchase, the still life of *Cherries, Iris, and Lupin* by Blas de Ledesma (p. 24), was made in 1957. It was followed the next year by the acquisition of the painting (after Caravaggio) of a youth with a vase of flowers (p. 18), and in 1959 the important *Houses of Parliament* by Monet (p. 95) was added to the collection through the same source.

Samuel Kress, the owner of perhaps the largest collection of Italian paintings in the world, had given the Museum a major work by Tiepolo (p. 23) in 1932. In 1958, in the single most important step for our European collection, the Samuel H. Kress Foundation donated works by such important 15th and 16th century Italian painters as Niccolò di Segna (p. 25), Giovanni Bellini (p. 16), and Vittore Carpaccio (p. 17), and, from the 17th and 18th centuries, works by Baciccio (pp. 20, 21) and Ricci (p. 22). There were also three Northern sculptures, including the extraordinary wood *St. Andrew* by Tilmann Riemenschneider (p. 83). In 1961 the Kress Foundation added the small but exquisite *Adoration* by Francesco di Giorgio (p. 11).

Individual private donations also continued, with the Ceraiolo (p. 13) from Victor van der Linde (1949), the 1950 anonymous gift of the large Zugno *Debarkation of Antony and Cleopatra* (p. 68), the Harpignies landscape (p. 140) from Judge and Mrs. Underwood (1955), the Martinelli *Violinist* (p. 18) given by Mrs. Charles T. Hopkins (1955), the Monnoyer flower picture (p. 88) from Mrs. Newdigate Owensby and Mr. and Mrs. Ogden Geilfuss (1957), the Constable watercolor (p. 118) given by Mr. and Mrs. Alfred Jones (1961), and the Averkamp (p. 84) from R. Roland (1961). In 1963 Mrs. Irma Straus gave several works in memory of her collector husband, Jesse Straus, including paintings by Cozzarelli (p. 34) and Cranach (p. 82). Henry Flackman donated in 1966 an anonymous French painting which has since been identified as an important van Loo (p. 89). Mrs. Emory Cocke donated to the Museum two wonderful English portraits in 1967—a Kneller (p. 116) and a Lely (p. 86). In 1968, in memory of the victims of the Orly air crash, the French government donated a large Rodin bronze, *The Shade* (p. 162).

In the 1970s, the Forward Arts Foundation, a group of civic-minded women, began a program of acquisitions for the Museum with funds raised from their

gift shop and restaurant at the Swan Coach House. The first purchase, in 1970, was a Vuillard interior (p. 95), followed by a Corot landscape (p. 91) in 1972, the Pissarro *Still Life of Flowers* (p. 93) in 1974, and in 1980 the Bazille *View of the Beach at Sainte-Adresse* (p. 92), currently touring America and France in the exhibition *A Day in the Country*.

Though the Museum purchased the drawing attributed to Peruzzi (p. 44) in 1971 and the *Still Life* by van Streek (p. 85) in 1973, the collection continued to grow chiefly through private donations. In 1976 Mrs. Floyd McRae left the Museum an outstanding example of Salon art, Fromentin's *Arabs on the Way to the Pastures of the Tell* (p. 91). In 1977 the B. J. Cantor Foundation gave the Museum a fine Rodin bronze, *Eternal Spring* (p. 161), and in 1979 an anonymous donor gave the Degas drawing of ballet dancers (p. 93).

In this decade, donations made by Mr. and Mrs. Arthur Montgomery have included the Guercino (p. 57), the de Horn (p. 84), and the Berchem (p. 103). The creation of a purchase fund by Fay and Barrett Howell brought to the collection the paintings by de Matteis (p. 22), Cazin (p. 141), and, most recently, Conca (p. 19). Also of long-range significance was the receipt by the Museum in 1983 of a bequest from Austell Thornton which has been used to purchase the extraordinary large painting by Max Ernst (p. 96). Other donations have included the Boudin view of Antwerp harbor (p. 144) from Dr. Nancy Walls, a view of the harbor at Ostend by Stevens (p. 148) from Noel Wadsworth, and the Delacroix drawing (p. 134) from Dr. and Mrs. Michael Schlossberg. With the funds obtained from the deaccession of various works, the Museum has been able to acquire two important French paintings—one rococo, Natoire's *Departure of Jacob* (p. 89), and the other neoclassical, Fabre's *Portrait of Alfieri* (p. 90). Finally, we note with pleasure the inclusion in the catalogue of promised gifts from two dedicated long-time members of the Museum's Board of Trustees: the two drawings by Bernard (p. 153, 154) from Mildred Snodgrass and the exceptional *Bowl of Strawberries* by du Mélezet (p. 87) from Mrs. Francis Storza.

For the celebration of the High Museum's first anniversary in its new building and the reinstallation of the European galleries, it seems appropriate to at last publish an up-to-date catalogue of this collection. Aside from the Kress Collection catalogue published in 1958 under the Museum's auspices, no catalogue of European art in the High Museum has been prepared until now, though European pieces were included in the Museum's 1965 and 1981 publications of outstanding works in our collections. It was not until the appointment in 1979 of Eric M. Zafran as Curator of European Art that we could give serious thought to a scholarly description of this kind. Dr. Zafran spent much of his time here on research for the catalogue. The completion of his manuscript in the summer of 1984 coincided with his departure for the Walters Art Gallery in Baltimore, where he has assumed the curatorial post in the Renaissance and Baroque departments.

I would like to second Dr. Zafran's thanks to the people who helped in the preparation of this catalogue and to express on the Museum's behalf our gratitude to the National Endowment for the Arts, the Georgia Council for the Arts and Humanities, and the Mellon Foundation for their assistance in making this catalogue a reality.

Gudmund Vigtel
Director

Acknowledgements

A catalogue of a collection such as the High Museum's collection of European art, which spans five centuries and includes paintings, sculpture, and drawings, requires the assistance and expertise of a great many people. The scholars who furnished opinions on particular works are acknowledged in the text; of those who either visited the Museum or reviewed photographs of the collection, Creighton Gilbert, Everett Fahy, Pierre Rosenberg, Rodolfo Pallucchini, Keith Christiansen, and Robert Simon contributed especially valuable assistance. Several libraries and archives provided resources necessary to carry out the research on the collection, and I would like to thank the staffs of the following: The Frick Art Reference Library, New York; The Institute of Fine Arts, New York; the Public Library, New York; Knoedler's Reference Library, New York; the National Gallery, Washington; The Witt Library, London; the Centre de Documentation, Musée du Louvre, Paris; The Rijksbureau, The Hague; the Institut Royal du Patrimonie Artistique, Brussels; I Tatti, Florence; and the Fondazione Giorgio Cini, Venice.

Several members of the High Museum's staff helped with the research for the catalogue. Foremost among them was Paula Hancock, who did much of the preliminary gathering of information and provided insight into several recondite iconographical questions. Theodore Kingsley, Lucia Case, Kristin Olive, and Diana Spitzer also aided in the preparation of the bibliographical and biographical information. Throughout the research and writing of the catalogue Liz Lane provided skilled assistance in maintaining order and preparing the manuscript. The registrar's office, under the direction of Marjorie Harvey, contributed much valuable support to the project.

In the preparation of this publication, the Museum's editor, Kelly Morris, was assisted by Amanda Woods. Jim Zambounis solved the complicated problems of catalogue design, and Katherine Gunn expertly set the type. Guy Dawson and Michael Wojtowycz oversaw the production of the book at Balding + Mansell.

Eric M. Zafran
Curator of European Art
June 1984

Italian and Spanish

Color Plates, page 9
Commentaries, page 25

Works are in loose chronological order within national groupings. Dimensions are given height before width before depth.

Italian

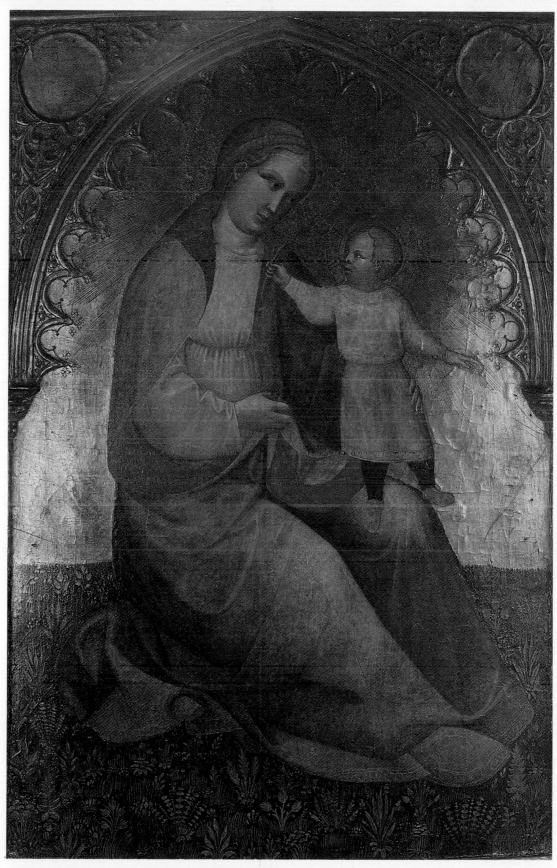

Jacobello del Fiore, *Madonna of Humility*

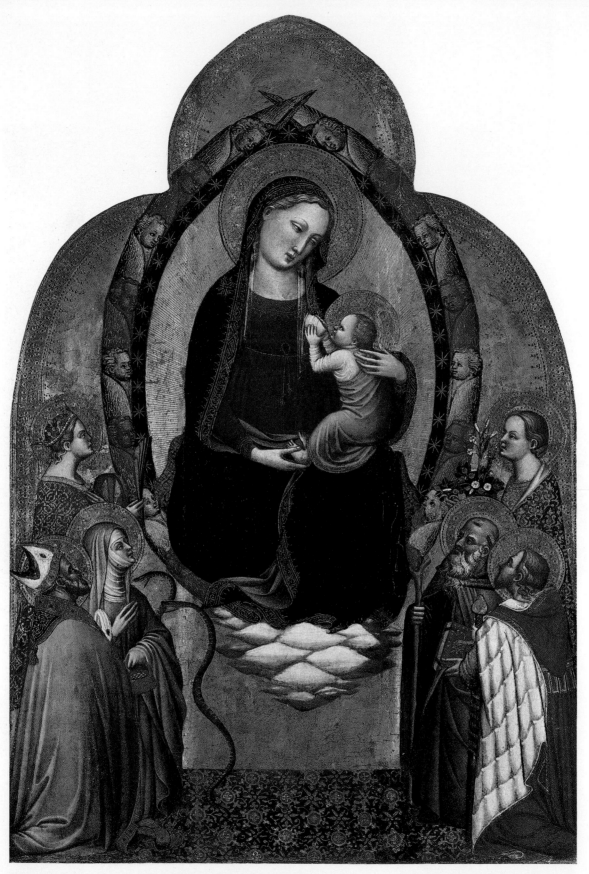

The Master of the St. Verdiana Panel, *Madonna and Child with Six Saints*

Francesco di Giorgio, *The Nativity*

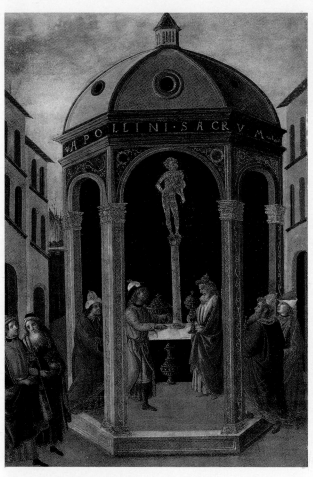

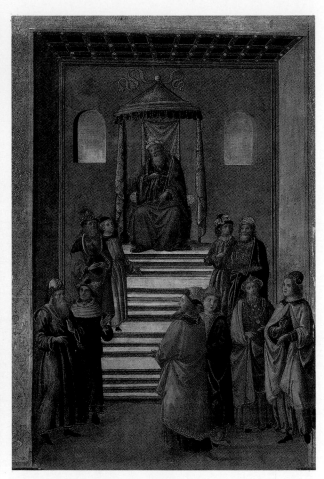

The Master of the Apollini Sacrum,
A Tribute to Apollo

The Master of the Apollini Sacrum,
A King with His Counselors

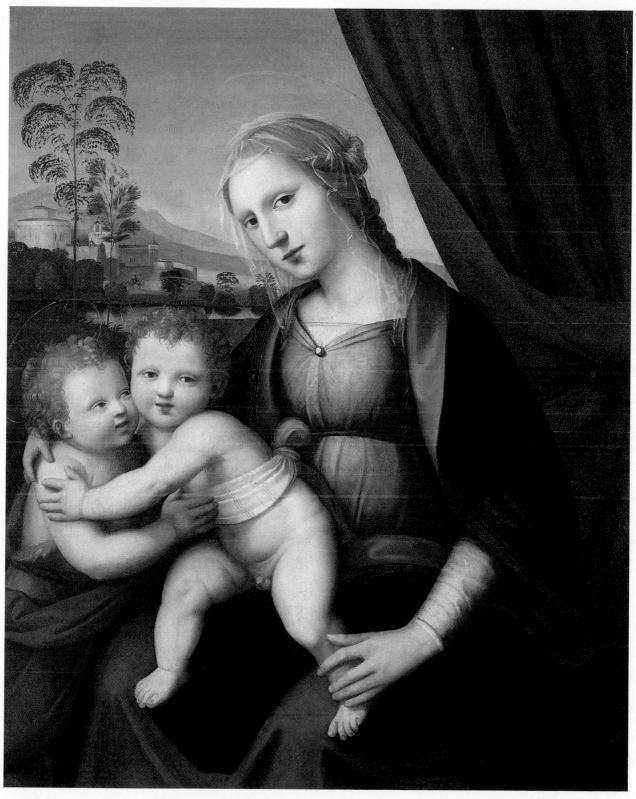

Antonio del Ceraiolo, *Madonna and Child with the Infant St. John the Baptist*

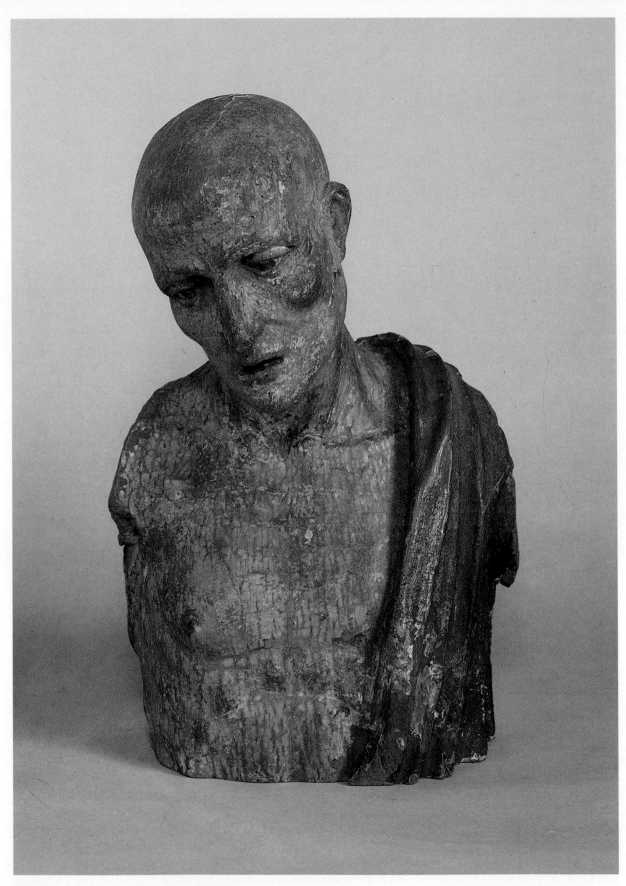

Unknown Italian, *Bust of a Man*

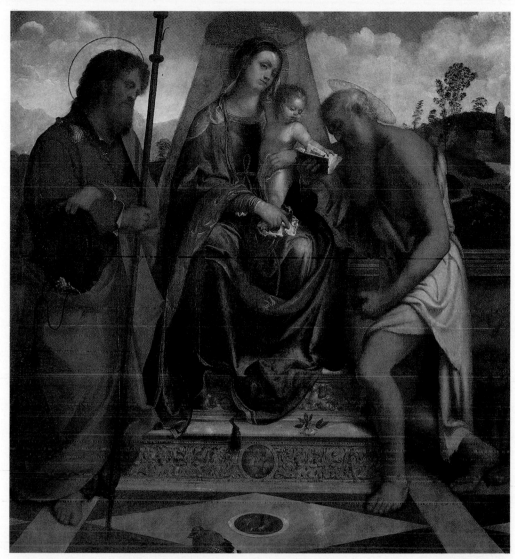

Girolamo di Romano, called Il Romanino,
Madonna and Child with St. James Major and St. Jerome

Benvenuto Tisi, called Il Garofalo, *Adoration of the Magi*

15

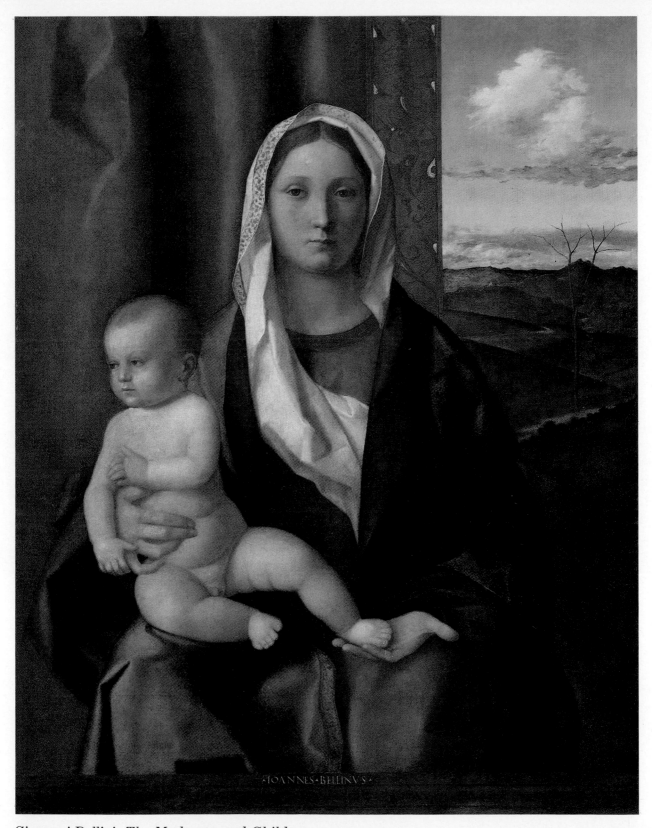

Giovanni Bellini, *The Madonna and Child*

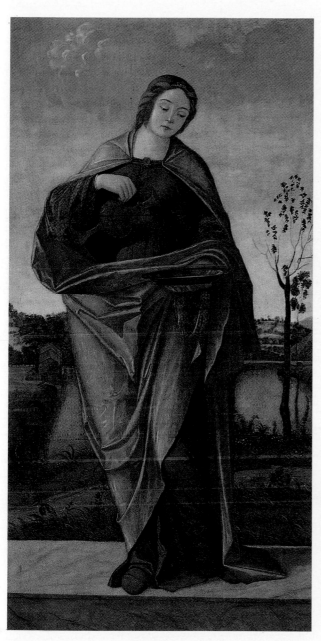 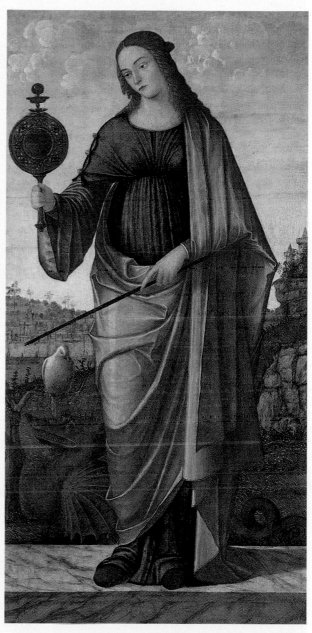

Vittore Carpaccio, *Temperance* Vittore Carpaccio, *Prudence*

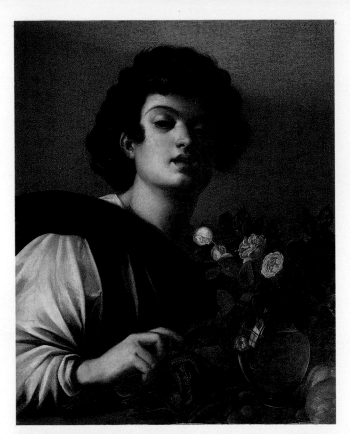

Follower of Caravaggio,
Boy with a Carafe of Roses

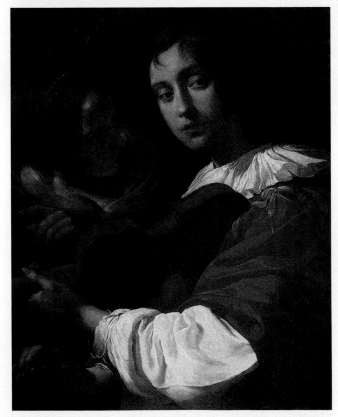

Giovanni Martinelli, *Youth with Violin*

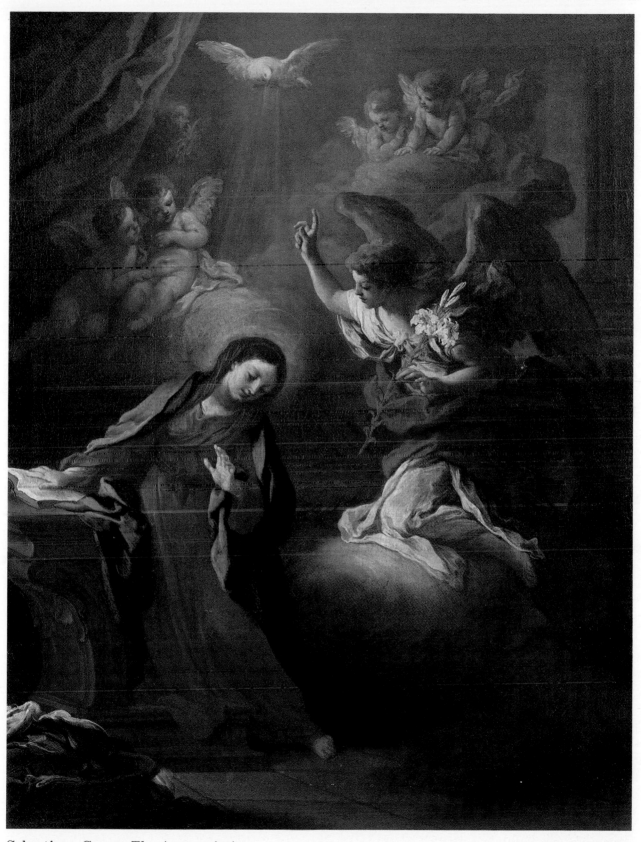

Sebastiano Conca, *The Annunciation*

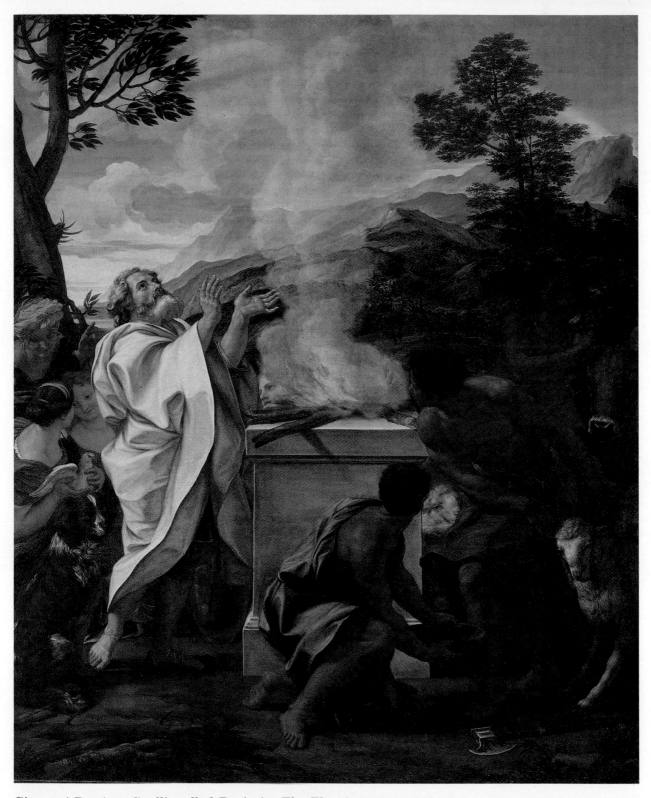

Giovanni Battista Gaulli, called Baciccio, *The Thanksgiving of Noah*

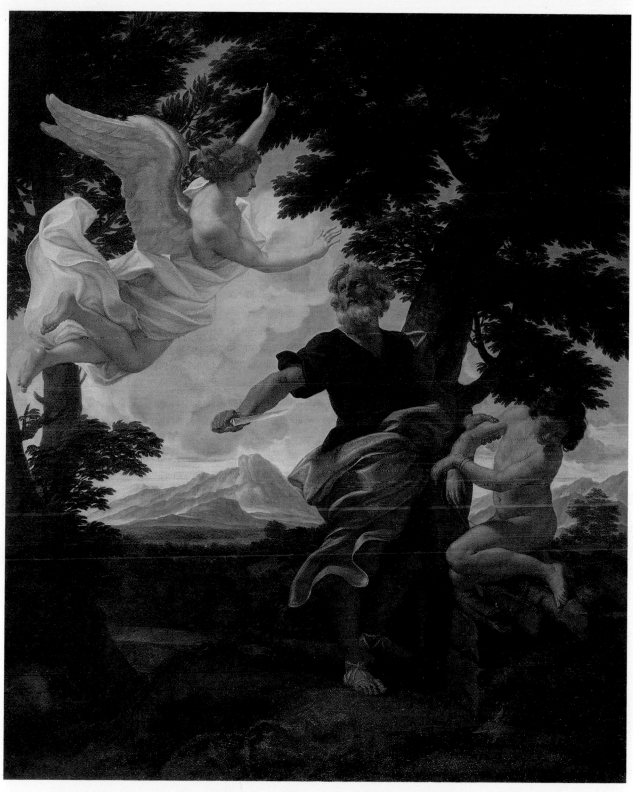

Giovanni Battista Gaulli, called Baciccio, *Abraham's Sacrifice of Isaac*

Sebastiano Ricci, *The Battle of the Lapiths and Centaurs*

Paolo de Matteis, *St. Nicholas of Bari Felling a Tree Inhabited by Demons*

22

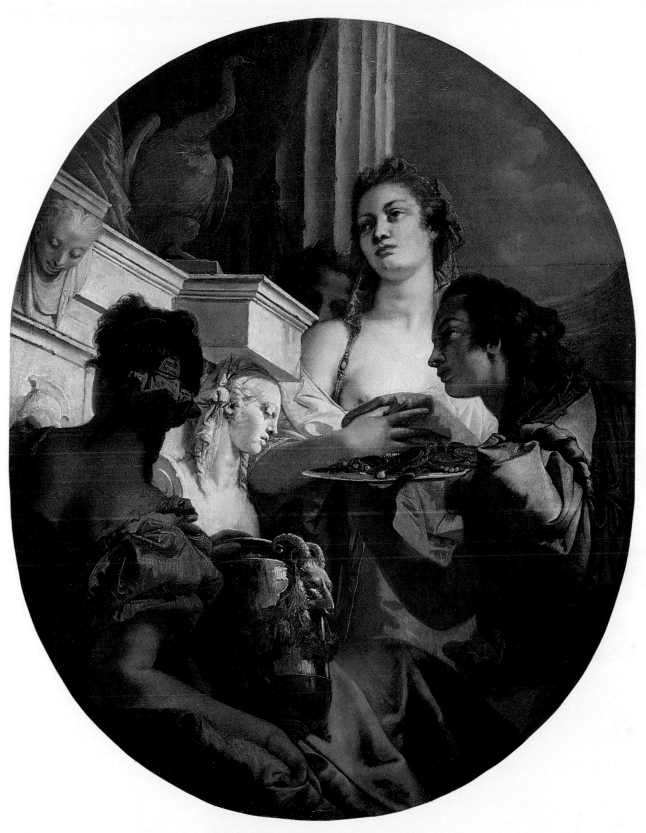

Giovanni Battista Tiepolo, *Vestals Making Offerings to Juno*

Spanish

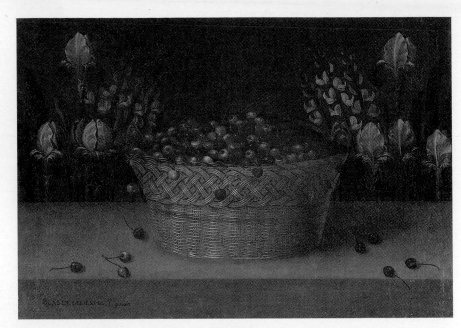

Blas de Ledesma, *Still Life with Cherries, Lupin and Iris*

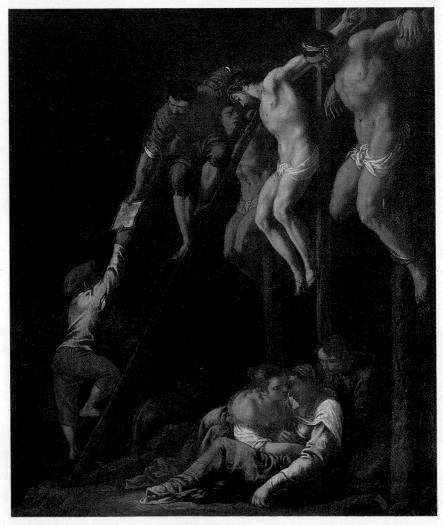

Pedro Orrente, *The Crucifixion*

Italian

Niccolò di Segna, *St. Vitalis*

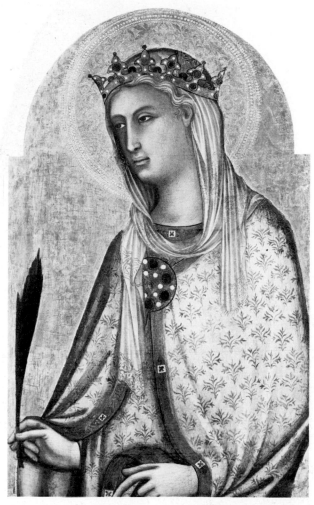

Niccolò di Segna, *St. Catherine of Alexandria*

Niccolò di Segna
Siena, active 1331-1345

St. Vitalis, ca. 1340
Tempera on panel, 27⅛ x 19 inches (69 x 48.3 cm.)

St. Catherine of Alexandria, ca. 1340
Tempera on panel, 26⅞ x 16⅝ inches (68.3 x 42.5 cm.)

Gifts of the Samuel H. Kress Foundation, 1958.51 and 1958.52.

Provenance: Lord Holland, London; Contini Bonacossi, Rome; Samuel H. Kress Foundation, 1929.

Exhibition: National Gallery of Art, Washington, D.C., 1941-51.

Bibliography: *Preliminary Catalogue of Painting and Sculpture*, National Gallery of Art, Washington, D.C., 1941, p. 184, no. 139; George Kaftal, *Iconography of the Saints in Tuscan Painting*, Florence, 1952, c. 1026; Gertrude Coor, "A Painting of St. Lucy in the Walters Art Gallery and Some Closely Related Representations," *Journal of the Walters Art Gallery*, XVIII, 1955, pp. 80-84, 90, figs. 2, 4; *Kress Collection*, Atlanta, 1958, pp. 8-11; *Masterpieces*, Atlanta, 1965, p. 4; Shapley, I, 1966, pp. 17-18, figs. 36-37; III, 1973, p. 382; H. K. Gerson and H. W. van Os, *Sienese Painting in Holland*, Groningen, 1969, under nos. 30-31; Fredericksen and Zeri, 1972, pp. 150, 557; Hendrick W. van Os, "Possible Additions to the Work of Niccolò di Segna," *The Bulletin of the Cleveland Museum of Art*, LVIV, March 1972, pp. 79, 81; Hayden B. J. Maginnis, "Una Madonna col Bambino di Niccolò di Segna a Cortona," *Arte illustrata*, 7, July 1974, p. 214; Federico Zeri, *Italian Paintings in the Walters Art Gallery*, Baltimore, 1976, I, p. 37; James H. Stubblebine, *Duccio di Buoninsegna and His School*, Princeton, 1979, I, pp. 138, 153-154; II, figs. 481, 485.

Niccolò di Segna was one of two painter sons of the Sienese artist Segna di Bonaventura. Little is known about his life or training. A document referring to a workshop he rented from the monks of the Casa di Misericordia suggests that he was already an independent painter by 1331. A *Madonna and Child* of 1336 is now in the Cappella di San Galgano on Monte

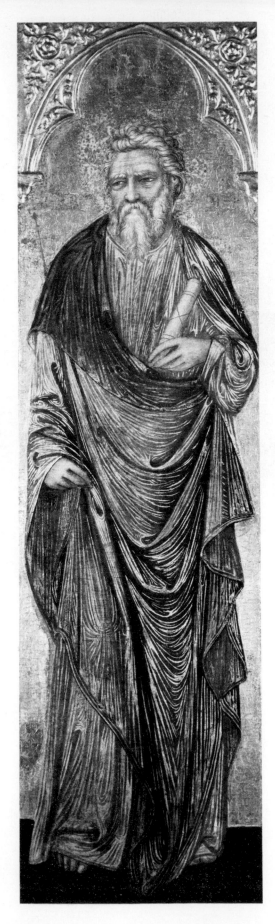

Siepi, and a signed *Crucifixion* of 1345 is in the Pinacoteca, Siena. His style is close to the Duccio-like manner of his father, but the elegance of line is similar to the style of Simone Martini, and the hard surfaces and faces with serious expressions recall works by Pietro Lorenzetti.

Niccolò's devotion to the tradition of Duccio, which was already beginning to wane among Sienese artists, is evident in the High Museum's paintings. These works were tentatively attributed to Lippo Vanni by Berenson, van Marle, and Venturi (in manuscript opinions), but through the connection of these two panels with others of a dismembered polyptych, Coor, van Os, Zeri, and Stubblebine have made the convincing attribution to Niccolò. The other panels are *St. Lucy* (Walters Art Gallery, Baltimore) and *St. Bartholomew* (Pinacoteca, Siena), which are identical in size and shape to these two works. These four panels all show the saints in half-length and are remarkable for the elaborate gold tooling of the halos. The polyptych originally also had an upper tier of six small panels of half-length saints. The central panel has tentatively been identified as the *Madonna and Child* once in the Church of San Francesco, Prato, and now in the Cini Collection, Venice. There may in addition have been three triangular pinnacles at the top of the complex. The High Museum's paintings, in which the figures are both turned to face to the side (unlike the *St. Lucy* and *St. Bartholomew*, who look straight out), probably were located on the two ends of the altarpiece.

St. Catherine of Alexandria is shown with a crown signifying her royal birth and a palm branch symbolizing her victory over paganism through martyrdom. St. Vitalis, an early Christian saint who had been a Roman officer, holds a mace, the instrument of his martyrdom. He was not often represented, but a very similar image appears in a polyptych by the Sienese painter Paolo di Giovanni Fei.[1]

[1]See Kaftal, 1952, c. 1026, fig. 1151.

Attributed to Lorenzo Veneziano
Venetian, active 1356-1372

St. Andrew, ca. 1360
Tempera on panel, 40¼ x 11 inches (102.3 x 28 cm.)
Inscribed at sides of the head: *ANDRE/AS*

Gift of the Samuel H. Kress Foundation, 1958.56.

Provenance: Villa Dahm, Godesberg; Sale, Lempertz's, Cologne, March 18-19, 1901, no. 5; Private collection, Capri; Contini Bonacossi, Florence; Samuel H. Kress Foundation, 1939.

Exhibition: National Gallery of Art, Washington, D.C., 1948-52.

Bibliography: Roberto Longhi, *Viatico per cinque secoli di pittura veneziana*, Florence, 1946, p. 46, no. 9 (re-

Attributed to Lorenzo Veneziano, *St. Andrew*

printed in *Ricerche Sulla Pittura Veneta, 1946-69*, Florence, 1978, p. 42, fig. 8a); Bernard Berenson, *Italian Pictures of the Renaissance, Venetian School*, London, 1957, I, p. 99; *Kress Collection*, Atlanta, 1958, pp. 40-41; Shapley, I, 1966, p. 9, fig. 24; III, 1973, p. 381; Fredericksen and Zeri, 1972, pp. 112, 553.

Lorenzo Veneziano belongs to the generation of Venetian painters who made the transition from a Byzantine to a Gothic style. He probably was a pupil of Paolo da Veneziano (active 1324-1358) in Venice and most likely worked in Bologna and Verona before returning to Venice. His major work is an *Annunciation* polyptych painted in 1357 for the Venetian senator Domenico Lion and now in the Accademia, Venice.

The High Museum's *St. Andrew*, which at one time had a pendant *St. Margaret*, shows the dual nature of Lorenzo's art. The expressive face is similar to that of a *St. Anthony Abbot* in the Pinacoteca, Bologna,[1] as well as to the faces of the elongated male saints, particularly St. Peter, in the Lion polyptych.[2] The old-fashioned decorative pattern of gold folds is found in paintings from the workshop of Paolo da Veneziano.[3] St. Andrew is typically represented as an aged apostle with flowing white hair and beard. Frequently, as in this case, he carries a thin cross, but his common attributes, a net and fish, have been replaced by what appears to be a scroll.

[1]According to Shapley, I, 1966, p. 9.
[2]See John Steer, *A Concise History of Venetian Painting*, New York, 1970, fig. 11, and photographs at I Tatti (Florence).
[3]See Michelangelo Murano, *Paolo da Veneziano*, Pennsylvania State University Press, 1970, fig. 106.

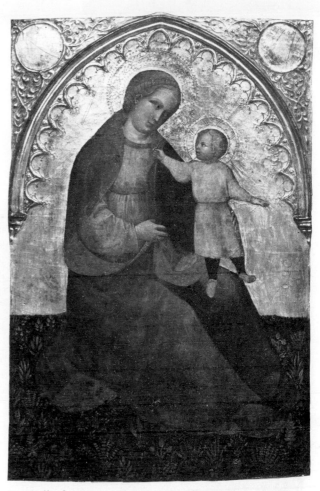

Jacobello del Fiore, *Madonna of Humility* (color plate, page 9)

Jacobello del Fiore
Venice, active 1394-1439

Madonna of Humility, ca. 1395-1405
Tempera and gold leaf on panel, 34 x 24 inches (86.4 x 61 cm.)

Friends of Art purchase, 1942.15.

Provenance: Dan Fellows Platt, Englewood, New Jersey; E. & A. Silberman Galleries, New York.

Exhibitions: *Religious Art From Giotto to Gauguin*, Montclair Art Museum, Montclair, New Jersey, and The Grand Rapids Art Gallery, Michigan, April-May 1941, no. 34.

Bibliography: Bernard Berenson, *Italian Pictures of the Renaissance, Venetian School*, London, 1957, I, p. 93.

Jacobello, the son of the painter Francesco, had his artistic roots in the Byzantine tradition, which had remained strong in Venice. In his case, this stiff style was tempered by influences from Bologna. His reputation as an accomplished painter was certainly established by 1412, when as official artist for the Venetian Republic he was paid the generous sum of 100 gold ducats for a painting of the *Lion of St.*

Mark. Documents record that he lived in the St. Moyse quarter of the city between 1415 (when he became the chief of the corporation of Venetian painters) and 1434.

Jacobello evolved from a medieval to a Renaissance style through the influence of Gentile da Fabriano. Gentile had come to Venice in the early years of the fifteenth century and made a marked impression with his new naturalism, rich coloration, and elaborately tooled gold backgrounds. This influence is most obvious in a work such as Jacobello's *Justice Between the Archangels Michael and Gabriel* (now in the Accademia, Venice), painted in 1421.

The High Museum's painting was correctly identified by Berenson as a work of Jacobello del Fiore when it was in the collection of Dan Fellows Platt. At that time the Christ Child was shown holding a palm frond in his left hand.[1] Later this detail, perhaps an old restoration, was removed and the painting acquired an attribution to Lippo di Dalmazio di Scannabecchi. More recently, both Everett Fahy and Rodolfo Pallucchini have accepted (in conversation) the work as by Jacobello. Miklòs Boskovits (in a letter of July 31, 1981) states that although the back-

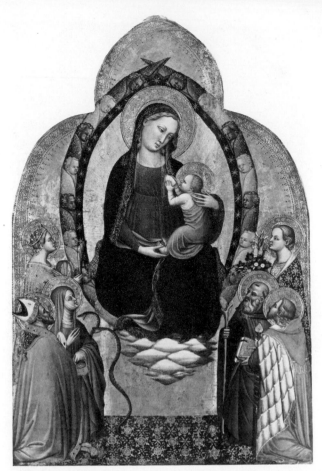

The Master of the St. Verdiana Panel, *Madonna and Child with Six Saints* (color plate, page 10)

The Master of the St. Verdiana Panel
Florentine, active 1390-1415

Madonna and Child with Six Saints, ca. 1390
Tempera on panel, 31¾ x 21⅜ inches (80.7 x 54.3 cm.)

Gift of the Samuel H. Kress Foundation, 1958.49.

Provenance: Contini Bonacossi, Florence; Samuel H. Kress Foundation, 1936.

Exhibition: National Gallery of Art, Washington, D.C., 1945-54.

Bibliography: G. Kaftal, *Iconography of the Saints in Tuscan Painting*, Florence, 1952, c. 1008, no. 308c, fig. 1135; William E. Suida, *The Samuel H. Kress Collection*, Birmingham Museum of Art, 1952, p. 23; *Kress Collection*, Atlanta, 1958, pp. 14-15; Federico Zeri, "Il Maestro di Santa Verdiana," *Studies in the History of Art Dedicated to William E. Suida*, London, 1959, p. 40, fig. 4; *Masterpieces*, Atlanta, 1965, p. 6; Shapley, I, 1966, p. 42, fig. 105; Miklòs Boskovits, "Der Meister der Santa Verdiana," *Mitteilungen des Kunsthistorischen Institutes in Florenz*, XIII, 1967, pp. 32, 53, fig. 19; idem, *Pittura Fiorentina alla vigilia del rinascimento, 1370-1400*, Florence, 1975, pp. 107, 382; Richard Fremantle, *Florentine Gothic Painters*, London, 1975, pp. 293-295, fig. 599; *Selected Works*, Atlanta, 1981, p. 10.

The Master of the St. Verdiana Panel, an anonymous Florentine artist who worked in the manner of Agnolo Gaddi, was given his pseudonym based upon the painting in the High Museum, which includes the rarely represented St. Verdiana. The early thirteenth century saint, Verdiana Attavanti, who lived as a recluse in a cell, tormented by serpents, is shown as a nun with a basket. The rearing snakes are her distinctive attribute. This work was probably painted for a church near Florence dedicated to St. Verdiana.

Other works by the same hand include similar paintings of the Virgin and Child appearing as a celestial vision to a group of saints—for example, a painting in the Birmingham Museum of Art.[1] Many of this master's works show delicate figures with expressive hands set in sharp relief against gold backgrounds. In this case, St. Verdiana is very much like the kneeling St. Mary in a *Christ as Man of Sorrows* now in a private collection (New York). That work also shows the crowned St. Catherine, who appears in a number of the artist's paintings. The saints in the High Museum's panel are, at left, St. Nicholas, St. Catherine of Alexandria, and St. Verdiana; and at right, St. Anthony Abbot, St. Julian, and St. Dorothy.

[1]Shapley, I, 1966, p. 41, fig. 104.

ground and the child are restored, the Virgin's face and figure still retain the characteristics of Jacobello's early style; he dates the painting ca. 1395-1405. A similar type of Virgin by Jacobello appears in a panel formerly in the Lederer Collection, Vienna.[2]

As Millard Meiss observed, the term Madonna of Humility "is commonly applied to representations of the Virgin in which she is seated on the ground" in Trecento and Quattrocento painting.[3] In this case, Jacobello has characteristically made the ground into a garden-carpet filled with a variety of decorative plants.

[1]A photograph of the painting in this state is in the archives of I Tatti, Florence.
[2]Reproduced in Leo Planiscig, "Jacobello del Fiore," *Jahrbuch der Kunsthistorischen Sammlungen*, Vienna, 1926, pl. XVII, op.p. 86.
[3]Millard Meiss, "The Madonna of Humility," *The Art Bulletin*, Dec. 1936, p. 435.

Giuliano di Simone da Lucca
Florence and Tuscany, active 1380s-1420s

St. Stephen and *An Unidentified Female Saint*
Tempera on panels, each 30 x 11 inches (76.2 x 28 cm.)

Gift of Mrs. Irma N. Straus in memory of her husband, Jesse Isidor Straus, 1964.19 and 1964.20.

Provenance: Mr. and Mrs. Jesse I. Straus, New York, ca. 1926.

Bibliography: Bernard Berenson, *Italian Pictures of the Renaissance*, Oxford, 1932, p. 494; Fredericksen and Zeri, 1972, pp. 93, 554.

An altar painting at Castiglione di Garfagnana near Bagni di Lucca, signed and dated 1389, has provided a basis for attributing a group of works to Giuliano di Simone da Lucca. At one time the High Museum's two panels, along with a similar pair of saints in Boston,[1] were considered to be the work of the Maestro del Bambino Vispo, but the more recent attribution to Giuliano di Simone by Fredericksen and Zeri seems convincing. This opinion is shared by Mina Gregori (in a letter of September 22, 1975) and Everett Fahy (letter of May 15, 1981). Giuliano's works include very similar depictions of standing saints, notably an *Enthroned Madonna* at the Pinacoteca, Parma, and another in the Louvre.[2]

[1]See Raimond van Marle, *The Italian Schools of Painting*, The Hague, 1927, IX, fig. 132.
[2]See Bernard Berenson, *Italian Pictures of the Renaissance: Central Italian and North Italian Schools*, London, 1968, pls. 379, 381.

Paolo di Giovanni Fei
Siena, ca. 1345-1411

Madonna and Child with Two Angels, St. Francis and St. Louis of Toulouse, ca. 1375
Tempera on panel, 70⅛ x 50⅝ inches (178.1 x 128.6 cm.)
Inscribed on the Child's scroll: *EGO SUM LUX MU(NDI)*; and on the base of the throne: *MCCCXXXIII*

Gift of the Samuel H. Kress Foundation, 1958.42.

Provenance: Paolo Paolini, Rome, 1931; Alessandro Contini Bonacossi, Florence; Samuel H. Kress Foundation, 1931.

Exhibition: National Gallery of Art, Washington, D.C., 1941-52.

Bibliography: E. Cecchi, "Un Pannello di Paolo di Giovanni Fei," *Vita Artistica*, II, April 1927, pp. 70-71; Raimond van Marle, *Le Scuole della pittura italiana*, 1934, II, pp. 462, 587, no. 1; *Preliminary Catalogue of Painting and Sculpture*, National Gallery of Art, Washington, D.C., 1941, p. 63, no. 193; *Kress Collection*, Atlanta, 1958, p. 12; Shapley, I, 1966, p. 62, fig. 161; Michael Mallory, *The Sienese Painter Paolo di Giovanni Fei (c. 1345-1411)*, New York, 1976, pp. 91-94, 228-29, no. 3, pl. 32; Mojmir S. Frinta, "The Quest for a Restorer's Shop of Beguiling Invention: Restorations and Forgeries in Italian Panel Painting," *The Art Bulletin*, LVIII, March 1978, pp. 10, 19, fig. 6.

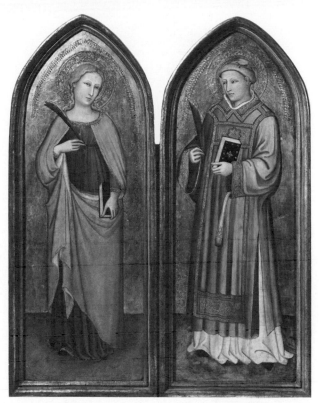

Giuliano di Simone da Lucca, *St. Stephen* and *An Unidentified Female Saint*

Paolo di Giovanni Fei is mentioned in many late fourteenth and early fifteenth century Sienese documents as an outstanding citizen as well as a leading artist. He was the son of a blacksmith, but the date of his birth is not known. The earliest reference to Fei records that he was a member of the general council of Siena on July 1, 1369. During the 1380s Fei held several public offices in Siena, including service on a panel of 1388-89 to select a painter for the Choir of the Duomo. Documents dating from the 1380s through the last years of his life refer to payments Fei received; he apparently worked in the Duomo on several occasions after 1395.

There is much confusion regarding the development of Fei's style, but Michael Mallory has suggested a rough chronology of his works which shows a progression from elegant forms and formal poses to a more exaggerated and expressive style after 1385. His *Birth of the Virgin* (Pinacoteca, Siena), which Mallory dates to 1380-85, is derived from Pietro Lorenzetti's 1342 painting and also shows some similarity to the style of Bartolo di Fredi, especially in the rigid frontality of the figures.

Fei's later work is livelier and more expressive, paralleling the development of such contemporaries as Taddeo di Bartolo. An *Assumption of the Virgin* (National Gallery, Washington, D.C.) from ca. 1400 reflects this evolution, showing figures with elongated faces, exaggerated features, and emphatic gestures. Fei's colors also became brighter. This late

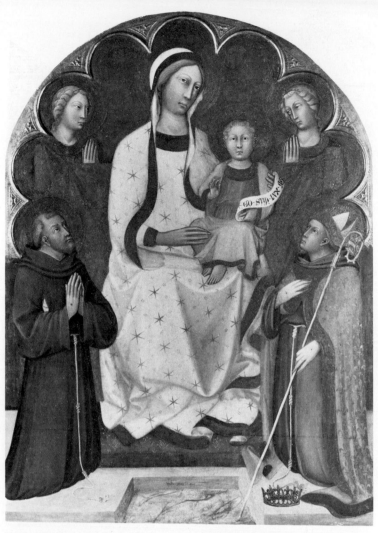

Paolo di Giovanni Fei, *Madonna and Child with Two Angels, St. Francis, and St. Louis of Toulouse*

style had a marked influence on the next generation of Sienese artists, notably Sassetta and Giovanni di Paolo.

This large altarpiece represents the Virgin and Child enthroned before a cloth of honor. Christ's scroll is inscribed with the words from John 8:12, "I am the light of the world." The holy pair are attended by two prayerful angels and two kneeling saints. At the left is St. Francis in the traditional Franciscan habit tied with a knotted cord. On his side and hands he reveals the stigmata, the wounds of Christ. At the right is the thirteenth century St. Louis of Anjou, the son of Charles II, King of Sicily and Anjou, who joined the Franciscan Order, became bishop of Toulouse, and abdicated the throne in 1295-96 in favor of his brother Robert of Anjou. He is shown as a Franciscan bishop carrying a crozier and wearing a mitre, gloves with stylized stigmata, and a cape adorned with the lilies of Anjou over his Franciscan habit. The crown which he renounced is at his feet. The choice of these particular saints makes it seem likely that this altar was intended for a Fran-

ciscan church or chapel.

Although, as Frinta has noted, much of the painting (including the punch work) is the result of modern restoration and repainting, the date 1333 inscribed on the Virgin's throne is authentic, according to the Kress Foundation's restorer, M. Modestini. This, however, is clearly not the date of the painting, which Shapley gives as "about 1400." Mallory, who places the work earlier in Fei's career, suggests that the inscribed date might be the remains of an older work which Fei repainted or it may have some commemorative significance. In support of his early dating he notes the work's stylistic similarity to a *Nativity* altarpiece in the Pinacoteca, Siena, and a compositional similarity to Bartolo di Fredi's *Madonna della Misericordia* of 1364 at Pienza and Fei's own *Madonna and Child with Saints* at Santa Maria della Scala in Siena, as well as his polyptych at San Bernardino, Siena, in which the enthroned Virgin and Child are shown in front of a cloth of honor flanked by kneeling saints.

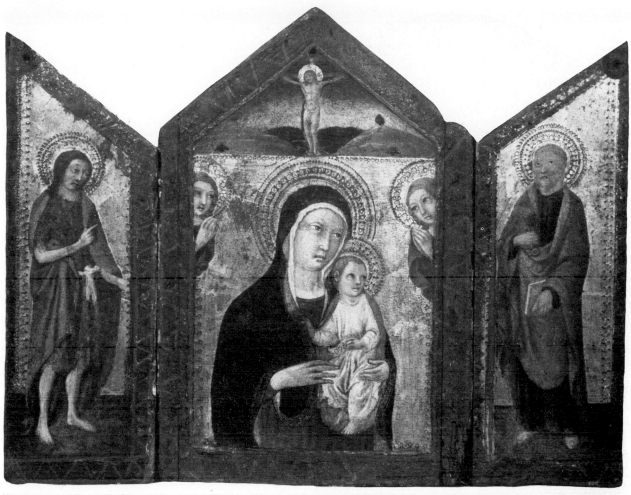

Workshop of Sano di Pietro, Triptych: *Madonna and Child with Two Angels and Christ on the Cross, St. John the Baptist*, and *St. Peter*

Workshop of Sano di Pietro
Siena, 1406-1481

Triptych: *Madonna and Child with Two Angels and Christ on the Cross, St. John the Baptist*, and *St. Peter*
Tempera on panels: central, 13 x 8½ inches (33 x 21.6 cm.); sides, each 12¾ x 3¾ inches (32.4 x 9.6 cm.)

Gift of E. & A. Silberman Galleries, 1942.11.

Provenance: Dan Fellows Platt, Englewood, New Jersey; E. & A. Silberman Galleries, New York.

Exhibitions: The Hackley Art Gallery, Muskegon, Michigan, and The John Herron Museum of Art, Indianapolis, Oct.-Dec. 1941; Columbus Museum of Arts and Crafts, Columbus, Georgia, Dec. 1966.

Bibliography: Emile Gaillard, *Sano di Pietro*, Chambery, 1923, pp. 176-177, 203; Bernard Berenson, *Pitture italiane del rinascimento*, Milan, 1936, p. 429; Bernard Berenson, *Italian Pictures of the Renaissance: Central Italian and North Italian Schools*, London, 1968, I, p. 375.

A skillful miniaturist and a prolific painter, Ansano di Pietro di Mencio (known as Sano di Pietro) first appears on a 1428 list of painters in Siena. Although he may have been influenced by artists such as Sassetta, Vecchietta, Giovanni di Paolo, and Domenico di Bartolo, Sano developed a distinctive style of his own.

His earliest major work is a polyptych painted in 1444 for the Convent of St. Jerome in Siena. From that time on, Sano and his workshop, the largest in the city, produced an immense number of devotional Madonnas characterized by sad expressions and large, downcast eyes. "The vast majority of Sano di Pietro's altarpieces," according to Sir John Pope-Hennessy, "were designed to satisfy the unexacting demands of local churches in the villages around Siena, and his smaller panels show a simplicity of form and narrative technique which sometimes reminds us of the Douanier Rousseau."[1] This is evident in the High Museum's small portable altar. Although Berenson included it in his list of works by Sano,[2] its rather crude painting, particularly in the two flanking saints, makes it likely that it is a workshop product.

[1]Pope-Hennessy, *Sienese Quattrocento Painting*, Oxford, 1947, p. 14.
[2]Berenson, 1968, p. 375.

31

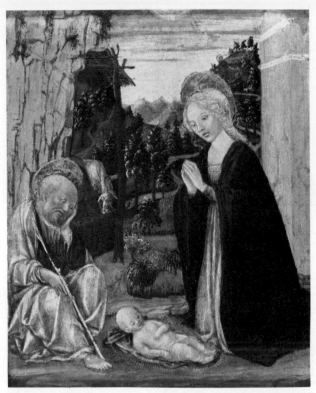

Francesco di Giorgio, *The Nativity* (color plate, page 11)

Francesco di Giorgio
Siena, 1439-1502

The Nativity, ca. 1460-65
Tempera on panel, 9⅜ x 8¾ inches (23.9 x 22.3 cm.)

Gift of the Samuel H. Kress Foundation, 1961.42.

Provenance: Cook Collection, Richmond, Surrey; Contini Bonacossi, Florence; Samuel H. Kress Foundation, 1948.

Exhibitions: *Winter Exhibition*, Burlington Fine Arts Club, London, 1902, no. 12; *Pictures of the School of Siena*, Burlington Fine Arts Club, London, 1904, no. 35; *Kress Collection*, William Rockhill Nelson Gallery of Art, Kansas City, 1952-60, no. 6.

Bibliography: Bernard Berenson, *The Central Italian Painters of the Renaissance*, London, 1909, p. 170; Tancred Borenius, *A Catalogue of the Paintings in the Collection of Sir Frederick Cook, Bart.*, London, 1913, no. 7; J. A. Crowe and G. B. Cavalcaselle, *A History of Painting in Italy* (ed. T. Borenius), London, 1914, V, p. 157 n.; Arthur McComb, "The Life and Works of Francesco di Giorgio," *Art Studies*, II, 1924, p. 18, fig. 12; F. Mason Perkins, "Una Miniatura Sconosciuta di Francesco di Giorgio," *La Diana*, IV, 1929, p. 219, fig. 2; Bernard Berenson, *Italian Pictures of the Renaissance*, Oxford, 1932, p. 203; Bernard Berenson, *Pitture italiane del rinascimento*, Milan, 1936, p. 174; Raimond van Marle, *Italian Schools of Painting*, The Hague, 1937, XVI, p. 273; John Pope-Hennessy, *Sienese Quattrocento Painting*, Oxford, 1947, pp. 20, 32; *Kress Collection*, Atlanta, 1958, p. 18; Shapley, I, 1966, p. 153, fig. 419; Bernard Berenson, *Italian Pictures of the Renaissance: Central Italian and North Italian Schools*, London, 1968, I, p. 140; Federico Zeri and Elizabeth Gardner, *Italian Paintings in the Metropolitan Museum of Art, Sienese and Central Italian Schools*, New York, 1980, p. 12.

As a youth Francesco Maurizio di Giorgio Martini served as an apprentice in the workshop of a Sienese master, probably the painter-sculptor Vecchietta. The first record of Francesco's artistic activity is a 1464 document concerning payment for a statue of St. John which he carved in wood for the Campagnia di San Giovanni della Morte. He is not referred to as a painter until 1467, in a document related to his first marriage. Two years later he married again, to Agnese, daughter of Antonio di Benedetto de Neroccio. About this time, Francesco entered a partnership with the painter Neroccio di Bartolommeo Landi, who may have been related to his father-in-law. The partnership lasted until 1475, when Francesco apparently abandoned painting to devote himself to engineering and architecture. From 1469 to 1472, Francesco was overseer of aqueducts for the Sienese government, but his greatest achievements as a military engineer and architect came after he moved to Urbino in 1477 to work for Duke Federigo da Montefeltro.

Among Francesco's earliest surviving paintings are two miniatures, dated 1463 and 1466, in the Osservanza Monastery near Siena. They show the sweetness and delicacy of his early style, reminiscent of the manner of Vecchietta. Although he must have been aware of new trends in the work of contemporary Florentine painters such as Pollaiuolo, Botticelli, and Verrocchio, his *Coronation of the Virgin* (1471) reveals the lingering influence of earlier Sienese traditions. His *Nativity*, an altarpiece commissioned four years later by the Olivetan Monks for the Church of San Benedetto, shows greater Florentine influence.

In 1484, Signorelli suggested that Francesco design the Church of Our Lady of Grace near Cortona; it was constructed in 1485. In 1486 he made some drawings for the Palazzo della Signoria in Iesi, and in 1490 he was called to Milan to advise on the construction of the cupola of the cathedral. There he became friendly with Leonardo da Vinci, and they travelled together to Pavia in 1490 to inspect building projects.

In the final years of his life, Francesco returned to sculpture, creating bronze reliefs with a Donatellesque spirit such as a *Deposition* for the Church of the Carmelites in Venice and a *Flagellation* in Perugia. Among his last creations were two magnificent bronze candelabra in the form of angels, produced in 1497 for the high altar of the Siena Cathedral.

The High Museum's charming small panel is related to the miniatures Francesco painted in the early part of his career, particularly a *Nativity* painted in an antiphonal now in the Cathedral Museum at Chiusi. A similar composition in a more severe manner is in the Metropolitan Museum of Art, and Zeri has speculated that all these works are derived from a composition by Girolamo da Cremona now in the Yale University Art Gallery (1871.7).

Girolamo did not arrive in Siena until about 1470, however, and the High Museum's painting and the Chiusi miniature probably predate this—thus, the composition may have originated with Francesco himself. Sir John Pope-Hennessy, noting the influence of Florentine artists such as Fra Filippo Lippi, has tellingly described the delicate beauty of the work:

> Built up of pigment which seems blown rather than brushed on to the surface of the panel, the figures of the Virgin, bending with parted lips over the still and unresponsive Child, and of St. Joseph, his weary head supported on his hand, are conceived with the intimacy of a casual sketch.[1]

[1]Pope-Hennessy, 1947, p. 20.

Giovanni Francesco da Rimini
Rimini, ca. 1420-1470

Madonna Adoring the Christ Child
Tempera on panel, 32½ x 21½ inches (82.6 x 54.6 cm.)

Gift of the Samuel H. Kress Foundation, 1958.43.

Provenance: Ing. Corsi, Florence; Baron Raoul de Kuffner, Castle Dioszegh, Hungary; Paul Drey, New York; Samuel H. Kress Foundation, 1948.

Exhibition: J. B. Speed Art Museum, Louisville, Kentucky, 1946-47.

Bibliography: F. Mason Perkins, "Un altro dipinto di Giovanni da Rimini," *Rassegna d'Arte*, I, 7, 1910, p. 114; J. A. Crowe and G. B. Cavalcaselle, *A History of Painting in Italy*, London, 1914, V, p. 225; Raimond van Marle, *The Italian Schools of Painting*, The Hague, 1934, XV, p. 42; *Kress Collection*, Atlanta, 1958, p. 25; Shapley, II, 1968, p. 7, fig. 11; Serena Padovani, "Un Contributo alla Cultura Padovana del Primo Rinascimento: Giovan Francesco da Rimini," *Paragone*, Sept. 1971, pp. 7, 22, fig. 7.

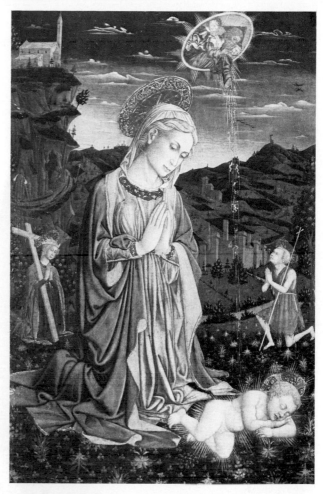

Giovanni Francesco da Rimini, *Madonna Adoring the Christ Child*

Giovanni Francesco da Rimini was active throughout northern Italy. His career seems to have begun in Padua, where he lived from 1441 to 1444, working in collaboration with Francesco Squarcione. He is next recorded in Bologna, receiving a 1464 commission to paint an *Annunciation* and a figure of *God the Father*, both now lost, in the Church of San Petronio. Two signed and dated works by Giovanni Francesco survive. The earlier is a *Madonna and Child* painted in 1459 for a chapel of the Church of San Domenico in Bologna. The figures are rendered in a hard, incisive manner characteristic of the Paduan school. The other signed work is a 1461 *Madonna*, now in the National Gallery, London, which recalls Fra Filippo Lippi's *Virgin Adoring the Christ Child* of 1445.

The union of Florentine Renaissance elements and Umbrian Gothic features characterizes the other works attributed to Giovanni Francesco, such as the High Museum's painting and two similar paintings, one at the Museum of Le Mans and the other in the Pinacoteca, Bologna.[1] All these works depict a Florentine Madonna (similar to the National Gallery painting) set in a stylized landscape reminiscent of Gozzoli and his followers. The variation in the scale of the figures, an archaic device, is used expressively. In the High Museum's painting, an enormous Virgin with large praying hands is flanked by the small figures of St. John the Baptist and St. Helena. The unusual detail of God the Father in the sky, sending a stream of sacred light onto the Child, is also found in a painting by the artist formerly in the Cook Collection.[2] Giovanni Francesco's inventiveness is also apparent in such details as the monks on the road to the mountaintop church and the somewhat ominous flight of birds across the sky.

[1]See Andrea Emiliani, *La Pinacoteca Nazionale di Bologna*, Bologna, 1967, fig. 26.
[2]See Padovani, 1971, fig. 11.

Guidoccio Cozzarelli, *Madonna and Child with Two Angels*

Guidoccio Cozzarelli
Siena, ca. 1450-ca. 1516

Madonna and Child with Two Angels, ca. 1485
Tempera on panel, 27¾ x 18½ inches (70.5 x 47 cm.)

Gift of Mrs. Irma N. Straus in memory of her husband, Jesse Isidor Straus, 1963.1.

Provenance: Richard von Kaufmann Collection; Sale, Paul Cassirer, Berlin, Dec. 4, 1917, no. 26; Duveen Brothers, London, 1925; Mr. and Mrs. Jesse Isidor Straus, New York.

Bibliography: Bernard Berenson, *Central Italian Paintings*, London, 1900, p. 155; Bernard Berenson, *Italian Pictures of the Renaissance*, Oxford, 1932, p. 158; Raimond van Marle, *The Italian Schools of Painting*, The Hague, 1937, XVI, p. 382; *Masterpieces*, Atlanta, 1965, p. 7; Bernard Berenson, *Italian Pictures of the Renaissance: Central and North Italian Schools*, London, 1968, I, p. 98; Fredericksen and Zeri, 1972, pp. 58, 554; Mojmir S. Frinta, "The Quest for a Restorer's Shop of Beguiling Invention: Restorations and Forgeries in Italian Panel Painting," *The Art Bulletin*, LVIII, March 1978, pp. 8, 10, 19, fig. 5; Mojmir Frinta, "Drawing the Net Closer . . . ," *Pantheon*, July-Sept. 1982, p. 222.

Guidoccio di Giovanni di Marco, known as Guidoccio Cozzarelli, was the son of a master woodcutter. A painter of miniatures and panels, he was active in Siena in the last half of the fifteenth century. His style is so close to that of another Sienese painter, Matteo di Giovanni (d. 1495), that he must have been a pupil of the older master. Cozzarelli's dated works fall into the period from 1480 through 1499, and in-

clude miniatures painted in choir books for the Os-
pedale della Scala in Siena (1480-81), many panel
paintings of half-length Madonnas (in the manner of
Matteo di Giovanni), painted book covers (dated
1484-99) which are in the archives of Siena, and sev-
eral *cassone* panels.

This *Madonna and Child with Angels* (sometimes
known as the *Kaufmann Madonna*), like a similar
painting in the Walters Art Gallery (37.586)[1] and one
now in the Kress Collection at Amherst College,[2]
was at one time exhibited as a Matteo di Giovanni.
The composition and figure types are borrowed from
Matteo, but the less brilliant color, stiffer forms, and
lack of elegance or intensity are typical of Cozzarel-
li's work. Attribution to Cozzarelli was made by both
Berenson and van Marle, and was confirmed (in con-
versation, January 17, 1980) by Creighton Gilbert.

When the painting was restored in 1972, it was
discovered that the figures had originally been set
before a landscape, a small section of which can now
be seen to the left of the Virgin's neck. According
to Frinta, the gold ground overpainting and the
punched border are the work of a forger active in
Siena and Florence in the early part of this century.[3]
In fact, the overpainting must have been done after
1917, for the Kaufmann sale catalogue shows the
work in its original state.

[1]F. Zeri, *Italian Paintings in the Walters Art Gallery*,
Baltimore, 1976, I, p. 129, no. 86, pl. 67.
[2]Shapley, I, 1966, p. 160, fig. 439.
[3]Frinta, 1978, p. 19.

Pseudo Pier Francesco Fiorentino
Florence, active 1450-1500

*Madonna and Child with Angels and the Infant St.
John the Baptist*
Tempera on panel, 23 x 12¾ inches (58.5 x 32.5 cm.)

Friends of Art purchase in memory of Florence Hand
Hinman, 1942.14.

Pier Francesco Fiorentino was a master active in
Florence from 1474 to 1497. A large oeuvre showing
the influence of Gozzoli, Castagno, and Baldovinetti
was formerly attributed to him. In 1932, Berenson,
recognizing that many of these works were clearly
not by the master but displayed marked similarities
to works by Filippo Lippi and Pesellino, designated
the paintings as products of the "Pseudo Pier Fran-
cesco Fiorentino." These works are so repetitious in
subject matter and so variable in quality that they
probably represent the creation of several different
artists working in the same shop, sometimes re-
ferred to as the Lippi-Pesellino imitators.[1] The most
common subjects of these works are the half-length
Virgin holding the Child, with both figures set before
a floral ground, and the kneeling Virgin adoring the
Child, accompanied by angels and/or the infant St.
John the Baptist, with a background of gold tooling

Pseudo Pier Francesco Fiorentino, *Madonna and Child
with Angels and the Infant St. John the Baptist*

or a landscape. Stylistically, these works are charac-
terized by sharp, definite outlines and flat, bright
areas of color.

The High Museum's painting shows three angels
presenting the Christ Child to the kneeling Virgin.
This composition probably derives from a lost work
of Filippo Lippi and is repeated in many versions,
such as one in the Museo Horne, Florence, and an-
other in the Cleveland Museum of Art (16.802).[2] The
Virgin's pose and the little St. John are similar to
those found in a painting in the Kress Foundation,
New York (K57).[3]

[1]See Federico Zeri and Elizabeth Gardner, *Italian
Paintings, Florentine School, Metropolitan Museum of
Art*, New York, 1971, p. 106.
[2]*The Cleveland Museum of Art: European Paintings
Before 1500*, Cleveland, 1974, pp. 84-85, fig. 31.
[3]Shapley, I, 1966, p. 115, fig. 314.

Attributed to Lorenzo Costa, *St. Julian and St. Nicholas of Tolentino*

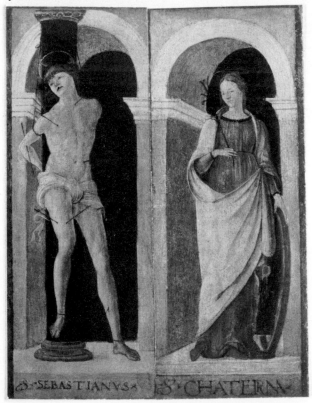

Attributed to Lorenzo Costa, *St. Sebastian and St. Catherine of Alexandria*

Attributed to Lorenzo Costa
Ferrara and Bologna, ca. 1460-1535

St. Julian and St. Nicholas of Tolentino, St. Sebastian and St. Catherine of Alexandria, St. Roch and St. Lucy, St. Vincent Ferrer and St. Christopher, ca. 1480s
Tempera on panels, each 14⅞ x 5½ inches (37.8 x 14 cm.)
Inscribed under the respective saints: *S ZVLIANO S NICHOLAVS DE TOLENTINO / S SEBASTIANVS S CHATELINA / S ROCHVS S LVCIA / S VICENCIVS S CHRISTFARO*

Gifts of the Samuel H. Kress Foundation, 1958.38, 1958.39, 1958.40, and 1958.41.

Provenance: Private collection, Italy (1928); Contini Bonacossi, Florence; Samuel H. Kress Foundation, 1935.

Exhibitions: National Gallery of Art, Washington, D.C., 1941-56.

Bibliography: William E. Suida, *Der Cicerone*, II, 1928, p. 552; Roberto Longhi, *Officina ferrarese*, Florence, 1934, p. 87, fig. 119; Roberto Longhi, "Ampliamenti nell'officina ferrarese," *Critica d'Arte*, Florence, 1940, pp. 15-16, figs. XIX-XXI; *Preliminary Catalogue of Paintings and Sculpture*, National Gallery of Art, Washington, D.C., 1941, pp. 46f.; F. Zeri, "Il terzo pannello degli Argonauti," *Proporzioni*, II, 1948, p. 171; Roberto Longhi, *Officina ferrarese*, Florence, 1956, pp. 53-54, figs. 175-76; *Kress Collection*, Atlanta, 1958, pp. 28-31; E. Arslan, "La Assunta del Costa a Monteveglio e la sua predella," *Rivisita d'Arte*, XXXIV, 1959, p. 51; G. Ferguson, *Signs and Symbols in Christian Art*, New York, 1961, pl. 89; Ranieri Varese, *Lorenzo Costa*, Milan, 1967, p. 76, no. 84., figs. 6a, 6b, 6c; Shapley, II, 1968, p. 66, figs. 157-160; Fredericksen and Zeri, 1972, pp. 57, 553.

Probably trained in the Ferrarese school of Cossa and Ercole di Roberti, Lorenzo Costa was influenced early in his development by artists such as Giovanni Bellini and Antonello da Messina. Costa went from Ferrara to Bologna when he was about twenty years old; documents show that he was working in 1483 at the Bentivoglio Palace there. He remained in Bologna until 1506, with the exception of a brief trip to Rome in 1503 as a member of a delegation from the Bolognese Senate. Costa was influenced by the gentle style of Francesco Francia and Amico Aspertini, followers of Perugino, and he collaborated with them on altarpieces for various churches in Bologna.

About 1506, Costa left Bologna for Mantua, where he succeeded Andrea Mantegna as court painter to the Gonzaga family. For the next several years he

was occupied with commissions for the Gonzagas, including the painted decorations for the Palazzo di San Sebastiano, now destroyed, and a series of family portraits. In Mantua, Costa's style once again absorbed new elements, this time from the works of Leonardo da Vinci and Correggio.

These panels of eight saints, all of whom are connected with healing and intercession for illness, probably formed the pilasters of a large altarpiece. Longhi attempted to relate these panels and a predella of the *Miracle of the Catafalque* (Kress Collection, North Carolina Museum of Art) to the Rondini altarpiece in the Berlin Museum.[1] However, this unconvincing reconstruction has been superseded by Arslan's, in which the predella—but not these panels —is related to the altarpiece of the *Assumption* in the Abbey of Monteveglio.[2]

[1]Longhi, 1940, pp. 15-16.
[2]Arslan, 1959, pp. 49ff.

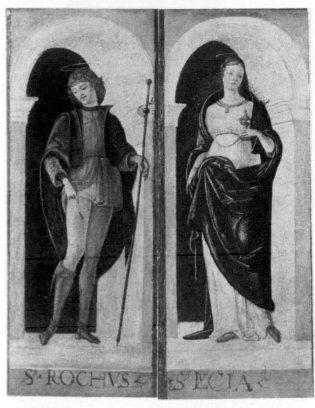

Attributed to Lorenzo Costa, *St. Roch and St. Lucy*

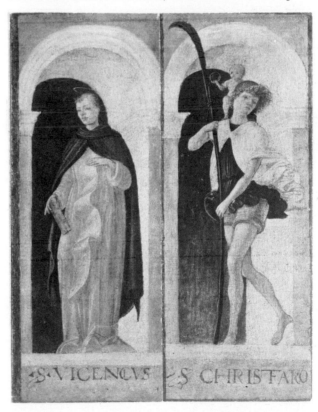

Attributed to Lorenzo Costa, *St. Vincent Ferrer and St. Christopher*

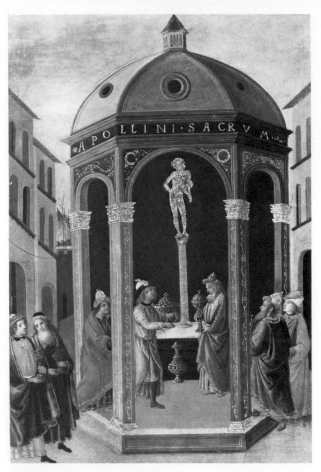

The Master of the Apollini Sacrum, *A Tribute to Apollo* (color plate, page 12)

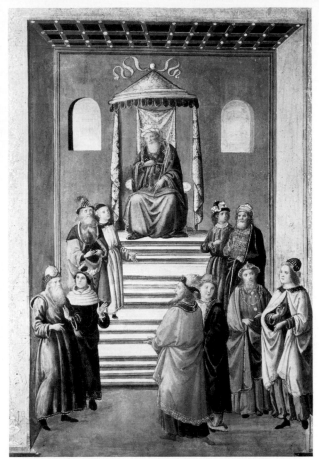

The Master of the Apollini Sacrum, *A King with His Counselors* (color plate, page 12)

The Master of the Apollini Sacrum
Florence, late 15th century

A Tribute to Apollo, ca. 1490
Tempera on panel, 24⅞ x 16⅞ inches (63.2 x 42.9 cm.)

A King with His Counselors, ca. 1490
Tempera on panel, 24¾ x 16½ inches (62.9 x 41.9 cm.)

Gifts of the Samuel H. Kress Foundation, 1958.47 and 1958.48.

Provenance: Max Bondi, Rome; Sale, Galleria Lurati, Milan, Dec. 9, 1929, no. 42; Contini Bonacossi, Florence; Samuel H. Kress Foundation, 1930.

Exhibitions: *Italian Paintings from the Collection of Samuel H. Kress*, Atlanta, Memphis, Charlotte, and National Gallery of Art, Washington, D.C., 1941-1957, nos. 150, 151; *Developments in the Early Renaissance*, The Center for Medieval and Early Renaissance Studies, University Art Gallery, State University of New York at Binghamton, May 4-14, 1968, nos. 12, 13.

Bibliography: Raimond van Marle, *The Italian Schools of Painting*, The Hague, 1931, XII, p. 414; Bernard Berenson, *Pitture italiane del rinascimento*, Milan, 1936, p. 6; *Preliminary Catalogue of Paintings and Sculpture*, National Gallery of Art, Washington, D.C., 1941, p. 15, nos. 150, 151; *Kress Collection*, Atlanta, 1958, pp. 16-19; "The Samuel H. Kress Foundation Study Collection," *The Register of the Museum of Art*, The University of Kansas, Lawrence, II, 4, March 1960, p. 18; Federico Zeri, "Eccentrici fiorentini," *Bollettino d'arte*, XLVIII, 1962, pp. 249-250; *Masterpieces*, Atlanta, 1965, p. 8; Shapley, I, 1966, p. 128, figs. 345-346; Everett Fahy, "Some Early Italian Pictures. . .," *Burlington Magazine*, March 1967, p. 134; Fredericksen and Zeri, 1972, pp. 131, 553; Everett Fahy, *Some Followers of Domenico Ghirlandaio*, New York, 1976, p. 181.

The Master of the Apollini Sacrum was a Florentine painter active during the late fifteenth century. William Suida derived this name from the inscription on the temple in the High Museum's painting. Longhi called the artist "Master Tondo" because most of his figures have round faces, and Zeri refers to him as the Master of Marradi, since his major works are located near that mountain town between Florence and Faenza. Stylistically, the painter was a close follower of Domenico Ghirlandaio and Bartolommeo di Giovanni. He specialized in historical scenes in contemporary dress, often for *cassone* fronts. Typically, his works show quaint, almost toy-like, architectural settings inhabited by small figures.

The specific subjects of *A Tribute to Apollo* and *A King with His Counselors* have not been identified,

Workshop of Luca Signorelli, *Birth of St. Nicholas of Bari*

Workshop of Luca Signorelli, *St. Nicholas Rescues Adeodatus*

but probably illustrate a story of classical history comparable to the scenes of *Caesar on His Way to the Senate*,[1] attributed to this master by Fahy,[2] in which there also appears a pagan shrine. The High Museum's two panels have been related by Fahy (in a letter of April 24, 1981) to another panel formerly in the Boehler Collection (Munich) and most recently in a private collection, New York. All have the same floral scrollwork at the edges and probably formed a *cassone* front or a scheme of decorative room panels.

[1]See the exhibition catalogue *Beyond Nobility*, Allentown Art Museum, 1980, pp. 12-13, no. 9.
[2]Fahy, 1976, p. 185.

Workshop of Luca Signorelli
Umbria, early 16th century

Birth of St. Nicholas of Bari, ca. 1500-1520
Oil on panel, 9⅞ x 8 inches (25.1 x 20.3 cm.)

St. Nicholas Rescues Adeodatus, ca. 1500-1520
Oil on panel, 9⅞ x 8 inches (25.1 x 20.3 cm.)

Gifts of the Samuel H. Kress Foundation, 1958.54 and 1958.53.

Provenance: Contini Bonacossi, Florence; Samuel H. Kress Foundation, 1937.

Exhibition: National Gallery of Art, Washington, D.C., 1941-54.

Bibliography: *Preliminary Catalogue of Paintings and Sculpture*, National Gallery of Art, Washington, D.C., 1941, p. 185f.; *Kress Collection*, Atlanta, 1958, pp. 21, 23;

Shapley, II, 1968, p. 98, figs. 235-236; Fredericksen and Zeri, 1972, pp. 187, 553.

Luca d'Egidio di Luca di Ventura, known as Signorelli, was active by 1470 and died in 1523. His early work shows the influence of Piero della Francesca. He worked in Cortona, Loreto, and in the Sistine Chapel at the Vatican in 1482. His greatest works, the fresco cycle in the Cathedral of Orvieto, painted between 1499 and 1503, show his mastery of perspective space and anatomy.

The surprisingly crude quality of the High Museum paintings is consistent with works produced in the workshop of Signorelli during his later years.[1] Perhaps the only sign of the master's influence is the lively conception of these narrative scenes. The two panels, which depict miracles attributed to the popular St. Nicholas of Bari, are probably from an altar predella devoted to the saint. The first miracle gave early evidence of Nicholas's sanctity; shortly after his birth, he stood straight up in his bath for two hours. The other painting presents one of the saint's posthumous miracles. Adeodatus, a young Christian, was taken captive by a pagan king and made his cupbearer. The boy's parents prayed to St. Nicholas, who then appeared in the sky, seized the boy by his hair, and returned him safely to his family.

[1]See especially the predella panels reproduced in Mario Salmi, *Luca Signorelli*, Novara, 1953, pls. 75, 76, 78.

Attributed to Francesco Bonsignori, *Martyrdom of St. John the Evangelist*

Attributed to Francesco Bonsignori
Verona, ca. 1455-1519, Caldiero

Martyrdom of St. John the Evangelist
Tempera on panel, 13⅜ x 20 inches (34 x 50.8 cm.)

Gift of Abris Silberman in memory of his brother, Elkan Silberman, 1952.9.

Provenance: Vieweg Collection, Braunschweig; Sale, Lepke, Berlin, March 1930, no. 23; E. & A. Silberman Galleries, New York.

Bibliography: Fritz Heinemann, *Giovanni Bellini e I Belliniani*, Venice, 1963, I, p. 242, no. V.163, II, fig. 700.

This small predella panel has been attributed to various artists working in northern Italy, particularly in Padua. Heinemann published it as a work by Lauro Padovano, a painter influenced by Giovanni Bellini who worked in Padua, Venice, and Rome. But stylistic differences between this work and the others he attributed to that artist make the identification doubtful.

A predella panel in the Accademia Carrara (Bergamo)—the same size as the High Museum's painting and with similar figures apparently by the same hand—has been attributed to the Veronese painter Francesco Bonsignori.[1] Although not identified as such in that museum's catalogue, the subject of the Bergamo painting is most likely St. John the Evan-

gelist raising Drusiana at Ephesus.[2]

The High Museum's painting follows the traditional iconography of the martyrdom of St. John the Evangelist. The saint is in a cauldron of boiling oil, and the scene is set in Rome in front of the Latin Gate and in the shadow of a pagan statue.[3] Since both this work and the Bergamo panel deal with events from the life of St. John, they were probably part of the predella of a now dispersed altarpiece devoted to the saint.

[1]Francesco Rossi, *Accademia Carrara, Bergamo, Catalogo dei dipinti*, Bergamo, 1979, pp. 44, 50.
[2]See Louis Réau, *Iconographie de l'Art chrétien*, Paris, 1958, III, pp. 716-717.
[3]Ibid., pp. 714-715. See, e. g., Filippino Lippi's 1503 fresco in the Cappella Strozzi in Santa Maria Novella, Florence.

Antonio da Viterbo, called Il Pastura, *Pietà*

Antonio da Viterbo, called Il Pastura
Umbria, active 1478-1509

Pietà, ca. 1505
Tempera on panel, 11⅝ x 17 inches (29.5 x 43.2 cm.)

Gift of the Samuel H. Kress Foundation, 1958.50.

Provenance: Robert Holford (d. 1892), Westonbirt, Gloucestershire; Sir George Lindsay Holford, Westonbirt, Gloucestershire; Sale, Christie's, London, July 15, 1927, no. 81; Colnaghi's, London; Private collection; Sale, Sotheby's, London, June 19, 1935, no. 154; Dubois; Contini Bonacossi, Florence; Samuel H. Kress Foundation, 1935.

Exhibitions: Burlington Fine Arts Club, London, 1910, no. 53; *Pictures and Other Objects from the Collection of Mr. Robert Holford*, Burlington Fine Arts Club, London, 1921-22, no. 5; National Gallery of Art, Washington, D.C., 1941-51; *Religion in Painting*, Arkansas Arts Center, Little Rock, Dec. 7, 1963-Jan. 30, 1964, no. 11; *Italian Renaissance Paintings from Southern Museums*, The Mint Museum, Charlotte, Oct. 18, 1981-Jan. 3, 1982, no. 9.

Bibliography: Roger Fry, "The Umbrian Exhibition at the Burlington Fine Arts Club," *Burlington Magazine*, XVI, 1910, p. 268; A. Venturi, *Storia dell'arte italiana*, VII, pt. 2, 1913, pp. 511f.; U. Gnoli, *Pittori e miniatori nell'Umbria*, 1923, pp. 191, 274; C. Phillips and A. Venturi, *Catalogue of the Holford Collection*, 1924, no. 18; *Preliminary Catalogue of Paintings and Sculpture*, National Gallery of Art, Washington, D.C., 1941, p. 9; *Kress Collection*, Atlanta, 1958, p. 37; E. Camesasca, *Tutta la pittura del Perugino*, Milan, 1959, p. 150, pl. 220; Shapley, II, 1968, pp. 102-103, fig. 248; Fredericksen and Zeri, 1972, pp. 12, 553.

Little is known of the development of the Umbrian fresco painter Antonio da Viterbo, called *Il Pastura*. He first appears in 1478, as a member of the Corporation of St. Luke in Rome. In the early 1490s, he was recorded as working in Orvieto, and in 1492 was back in Rome, assisting Pintoricchio with fresco decorations for the Borgia Apartments in the Vatican. In the late 1490s Antonio returned to Orvieto to work on frescoes in the choir of the Duomo, remaining there until 1504, when he was mentioned as working in Viterbo. His last known work was a fresco cycle of the *Life of the Virgin* for the choir of the Cathedral of Tarquinia. Completed by 1509, these frescoes show the marked influence of Perugino, recalling the graceful proportions of the master's *Baptism of Christ* in the Sistine Chapel. Perugino's influence is also apparent in this *Pietà*, which led Berenson and Zeri to attribute the panel to Antonio. The dead Christ, the Virgin, St. John, Mary Magdalen, Mary the mother of James, and Salome (according to Mark 15:40) are placed before a plain, dark background, giving the work a timeless quality that makes it seem a Renaissance icon.

41

Antonio del Ceraiolo, *Madonna and Child with the Infant St. John the Baptist* (color plate, page 13)

Antonio del Ceraiolo
Florence, active 1500-1550

Madonna and Child with the Infant St. John the Baptist, ca. 1510-15
Oil and tempera on panel, 43 x 34½ inches (109.2 x 87.7 cm.)

Gift of a Friend, 1949.46.

Provenance: E. & A. Silberman Galleries, New York, 1944; Private collection, New York.

Bibliography: Federico Zeri, "Antonio del Ceraiolo," *GBA*, 70, 1967, pp. 150, 152, fig. 10; Fredericksen and Zeri, 1972, pp. 11, 554.

Antonio di Arcangelo, better known as Antonio del Ceraiolo, was a Florentine artist who was mentioned twice by Vasari in his *Lives*. One of his works—a depiction of the *Archangel St. Michael* now in the Accademia in Florence—was the basis upon which Zeri grouped a considerable number of works by the same hand. Vasari noted that Ceraiolo studied with Lorenzo di Credi and Ridolfo Ghirlandaio, but his work was most strongly influenced by Fra Bartolommeo and Mariotto Albertinelli, adopting from them sweet facial types such as the ones seen in the High Museum's painting. A 1944 certificate by Lionello Venturi attributed this work to Andrea del Brescianino, but it has been plausibly identified as a Ceraiolo by Zeri. A similar delicacy in the treatment of the landscape and the tenderness of feeling between the figures is evident in Ceraiolo's *Adoration of the Shepherds* in Santa Elisabetta delle Convertite, Florence.[1]

[1]See Christian von Holst, "Florentiner Gemälde und Zeichnungen . . . von 1480 bis 1580," *Mitteilungen des Kunsthistorischen Institutes in Florenz*, XV, 1971, I, pp. 30-40, fig. 48.

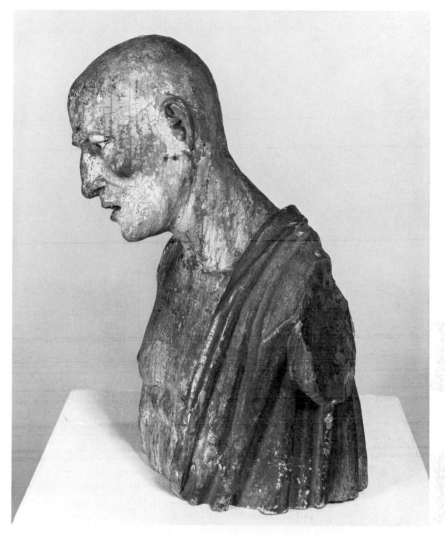

Unknown Italian, *Bust of a Man* (color plate, page 14)

Unknown North Italian
ca. 1475-1525

Bust of a Man (St. Jerome?)
Polychromed wood, 17 x 10 x 8 inches (43.2 x 25.4 x 20.3 cm.)

Gift of Mrs. Irma N. Straus in memory of her husband, Jesse Isidor Straus, 1964.21.

Provenance: Mr. and Mrs. Jesse Isidor Straus, New York.

This powerful sculptural fragment was, when first acquired, called Florentine School, on the basis of its superficial resemblance to the well-known marble *Zuccone* by Donatello of 1423-25. H. W. Janson (in a letter of February 22, 1980) suggests that the subject may be a penitent St. Jerome, who was often depicted, as in the famous unfinished example by Leonardo da Vinci, as a bald man with a woeful expression, striking his bare chest with a stone. The marks and remains of red paint on the chest of this figure make such an identification likely. The best-known wooden sculpture of St. Jerome is by Torrigiano. Janson, stressing the rarity of wood sculpture of this type in Tuscany, suggests that the work might be by a Spanish artist living in Italy in the first half of the sixteenth century.

The connection of the work to Leonardo suggests the possibility of a North Italian origin. This was the opinion of Alan Darr (in a letter of January 21, 1980), who suggested that it might be Genoese or Bolognese, resembling the sculpture of Niccolo dell'Arca or Guido Mazzoni,[1] although probably not by either. The same sense of tragic emotion is evident in other sculpture of the Paduan School.[2]

[1]See examples in Franco Russoli, *Scultura Italiana, Il Rinascimento*, Milan, 1967, pls. 89, 90.
[2]See examples in the exhibition catalogue *Dopo Mantegna*, Palazzo della Ragione, Padua, 1976, nos. 84-86, 88, 89.

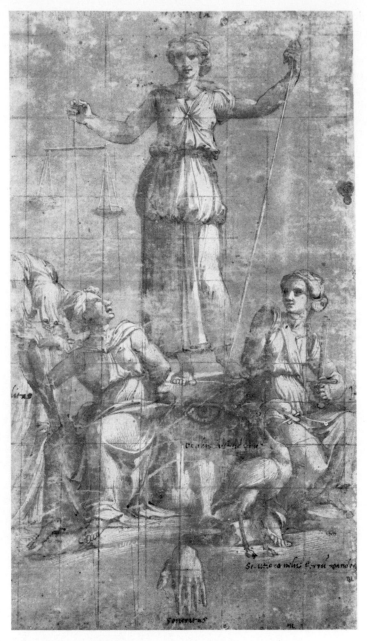

Attributed to Baldassare Peruzzi, *Allegory of Justice*

Attributed to Baldassare Peruzzi
Siena, 1481-1536

Allegory of Justice
Pen, brown ink, and brown wash, heightened with white, squared on pink tinted paper, 12½ x 7¼ inches (31.8 x 18.5 cm.)
Inscribed in brown ink near top center: *Justitia*; at middle center: *oculus*; at bottom center: *severitas*; and at lower right: *Sicuti oca nihi ferrum mandet* (?)

Purchase in honor of Mrs. Tench C. Coxe, President 1970-71 of the Members Guild, 1971.9.

Provenance: Sir Peter Lely; Prosper Henry Lankrick; Earl of Pembroke and Montgomery; Sale, Sotheby's, London, July 9, 1917, no. 397/5; Mr. and Mrs. Jesse Isidor Straus, New York; Sale, Parke-Bernet, New York, Oct. 21, 1970, no. 6; H. Shickman Gallery, New York.

Exhibition: *Drawings and Prints of the First Maniera, 1515-1535*, Brown University and Rhode Island School of Design, Providence, Feb. 22-March 25, 1973, no. 43.

Bibliography: S. A. Strong, *Reproductions in Facsimile of Drawings by the Old Masters in the Collection of the Earl of Pembroke and Montgomery*, London, 1900, no. 59; Christophe Frommel, "Peruzzi als Maler und Zeichner," *Beiheft zur Romischen Jahrbuch für Kunstgeschichte*, II, 1967/68, pp. 107-08, pl. XLIIc; Ebria Feinblatt, *Old Masters Drawings from American Collections*, Los Angeles County Museum of Art, 1976, p. 88; *Selected Works*, Atlanta, 1981, p. 42; Nicole Dacos, "Ni Polidoro ni Peruzzi: Maturino," *La Revue de l'art*, 57, 1982, p. 28.

Peruzzi's early training was probably as a draughtsman and a painter, and it has been suggested that his first master was Giacomo Pacchiarotti, a pupil of Bernardino Fungai, who painted in the style of the earlier Quattrocento Sienese school. At first Peruzzi concentrated on drawing, but after the death of his father, who had opposed his artistic career, he turned to painting. In 1501 he was commissioned to design the interior of the Chapel of St. John in the Siena Cathedral and to paint frescoes on the vaulting of the ceiling in collaboration with the well-known mural painter Pintoricchio. Peruzzi also spent a short time in Volterra, where he met Pietro d'Andrea da Volterra, with whom he travelled to Rome in 1503 to embark on a fruitful career as a painter, architect, and stage designer.

In 1509 Peruzzi, probably employed by Pope Julius II, worked on the ceiling decorations in the Raphael Stanze in the Vatican. This resulted in a close friendship with Raphael, which, along with his interest in classical and Roman art, led Peruzzi away from the Sienese tradition. Between 1509 and 1511 Peruzzi, who was also influenced by the architect Bramante, designed and built a villa in Trastevere (known as the Farnesina) for the Sienese banker Agostino Chigi. Peruzzi decorated its exterior and some of the interiors with frescoes, including scenes from Ovid's *Metamorphoses*, illustrations of Agostino's horoscope, and illusionistic architectural scenes with imaginary landscapes.

On August 1, 1520, Peruzzi became an associate architect for the construction of St. Peter's in Rome. This appointment lasted until 1527 and was renewed in 1531 for the rest of his life. Peruzzi also made trips to Capri, Todi, and Bologna during the 1520s, designing many churches, gardens, palaces and tombs, as well as façade decorations, stage designs, and theatrical scenery.

Throughout the 1520s and 1530s, Peruzzi's work reflected the current mannerist tendencies: elegant, elongated forms in elaborate, imaginary settings. He returned to Siena for three years in 1527, and was there again between 1531 and 1532 to decorate the chapel, garden, and salon of a castle at Belcaro. Peruzzi died in Siena, but was buried with great ceremony in the Pantheon in Rome.

This is one of four drawings by Peruzzi or his workshop which portray the Cardinal Virtues with attributes symbolizing their public or civic aspects. This sheet is devoted to the triumph of Justice, readily identified by her balance and lance; the other drawings represent *Prudence* (Los Angeles County Museum), *Fortitude* (formerly Vidol and Co.), and *Temperance* (formerly Jules Brasner Galleries). All of these, plus a drawing of *Liberality* (sold from the Straus Collection in 1970), were together in the Pembroke Collection, where they were at one time thought to be by Raphael. Frommel has identified the inscriptions as by Peruzzi's hand and has noted a stylistic similarity to the frescoes Peruzzi painted in

1519 for Cardinal Raffaelle Riario on the *Volta Dorata* of the Palazzo Canaelleria.[1]

These drawings were probably intended as designs for a public building in Siena, where there was a tradition of such subjects, beginning with Ambrogio Lorenzetti's frescoes of *Good and Bad Government* (ca. 1388) for the Palazzo Pubblico and continuing with Domenico Beccafumi's vault paintings (1529-1535) in the same building. Local traditions may account for the obscurity of much of the iconography in the High Museum's drawings. Justice is shown standing on an axis with an open eye and downturned hand, elements which symbolize the all-seeing and punitive aspects of justice. Frommel has identified the figures over whom Justice triumphs as Discord on the left and Injustice on the right.[2] Anne Wagner has proposed instead that the figures represent the retributive aspects of justice.[3] Or perhaps, in the tradition of Lorenzetti, the figures refer to the two kinds of justice defined by Aristotle in his *Ethics* and amplified by Thomas Aquinas in his *Summa theologica*. Nicolai Rubinstein has identified these in Lorenzetti's fresco as "distributive justice," referring to the legal function of reward and punishment, and "commutative justice," referring to the regulation of civil affairs.[4] The same ideas are present in Beccafumi's fresco of Justice, where one of the subsidiary female figures representing distributive justice holds a sword.[5] Although Frommel described the emblematic bird accompanying this figure as a goose with a nail in its beak, it is much more likely that, as Colin Eisler suggested (in conversation, July 1984), it is actually the artist's conception of an ostrich, a bird traditionally shown with a nail in its mouth. In the Middle Ages this often symbolized gluttony, but in the Renaissance the image came to be associated with valor and endurance.[6] A much more accurate representation of an ostrich, also in relation to an allegorical figure of Justice, appears in the fresco of the Sala di Constantino by the School of Raphael.[7]

[1]Frommel, 1967/68, pp. 107-108. Dacos, 1982, p. 24, suggests the drawings may be by the young Maturino.
[2]Frommel, 1967/68, pp. 107-108.
[3]See the exhibition catalogue *Drawings and Prints of the First Maniera*, 1973, p. 42.
[4]See Nicolai Rubinstein, "Political Ideas in Sienese Art: The Frescoes by Ambrogio Lorenzetti and Taddeo di Bartolo in the Palazzo Pubblico," *Journal of the Warburg and Courtauld Institutes*, XXI, 1958, p. 182.
[5]See Marianna Jenkins, "The Iconography of the Hall of the Consistory in the Palazzo Pubblico, Siena," *The Art Bulletin*, Dec. 1972, p. 436, fig. 5.
[6]See Beryl Rowland, *Birds with Human Souls*, Knoxville, 1978, pp. 111-115.
[7]See Frederick Hart, *Giulio Romano*, New Haven, 1968, II, pl. 78. The ostrich can be seen more clearly in the drawing after the fresco which has been attributed to Rubens. See Michael Jaffé, "Rubens and Italy: Two More Drawings," *Master Drawings*, Winter 1983, pl. 21.

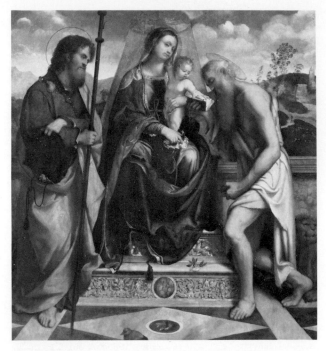

Girolamo di Romano, called Il Romanino, *Madonna and Child with St. James Major and St. Jerome* (color plate, page 15)

Girolamo di Romano, called Il Romanino
Brescia and Venice, ca. 1484-ca. 1562

Madonna and Child with St. James Major and St. Jerome, ca. 1512
Oil on panel, 58⅝ x 54½ inches (148.9 x 138.4 cm.)

Gift of the Samuel H. Kress Foundation, 1958.45.

Provenance: Sir Frederick Cook, Doughty House, Richmond, Surrey; Contini Bonacossi, Florence; Samuel H. Kress Foundation, 1949.

Exhibition: *The Kress Collection*, Philadelphia Museum of Art, 1950-52.

Bibliography: Bernard Berenson, *The North Italian Painters of the Renaissance*, London, 1907, p. 285; Tancred Borenius, *A Catalogue of the Paintings in the Collection of Sir Frederick Cook, Bart.*, London, 1913, I, p. 183, no. 156; Giorgio Nicodemi, *Girolamo Romanino*, Brescia, 1925, p. 200; Roberto Longhi, "Di un libro sul Romanino," *L'Arte*, XXIX, 1926, p. 149; Bernard Berenson, *Italian Pictures of the Renaissance*, Oxford, 1932, p. 488; M. W. Brockwell, *Cook Collection Catalogue*, 1932, no. 156, p. 32; Bernard Berenson, *Pitture italiane del rinascimento*, Milan, 1936, p. 419; William E. Suida, "The Samuel H. Kress Collection," *Philadelphia Museum Bulletin*, XLVI, Autumn 1950, pp. 12f.; Mina Gregori, "Altobello e Giovan Francesco Bembo," *Paragone*, 93, Sept. 1957, pp. 19f., fig. 12A; *Kress Collection*, Atlanta, 1958, pp. 34-36; M. L. Ferrari, *Il Romanino*, 1961, p. 23, pl. 23; E. Arslan, "La 'Madonna del libro' del Romanino," *Arte Lombarda*, IX, 1964, p. 103; *Mostra di Girolamo Romanino*, Brescia, 1965, p. 47; *Masterpieces*, Atlanta, 1965, p. 11; Shapley, II, 1968, p. 87, fig. 209; Bernard Berenson, *Italian Pictures of the Renaissance:*

Central Italian and North Italian School, London, 1968, I, p. 365; Fredericksen and Zeri, 1972, pp. 176, 553; Herbert Friedmann, *A Bestiary for Saint Jerome*, Washington, D.C., 1980, pp. 226-228, fig. 152.

Girolamo di Romano, known as *Il Romanino*, probably studied under Ferramola in his native Brescia. His earliest works, from 1510, were paintings for local churches. While little is known about the events of his life, a rough chronology of his major works has been established, revealing that Romanino was greatly influenced by the Venetian masters Titian and Giorgione, as well as by such north Italian contemporaries as Lotto, Moretto, Pordenone, and Altobello Melone.

Romanino appears to have left Brescia for Venice in 1513. His 1513 *Madonna Enthroned with Saints*, painted for the Church of San Giustina in Padua (and now in the Museo Civico), recalls the colors and forms of Titian's recently completed Santo frescoes. Romanino returned to Brescia by 1516, when he painted the altarpiece for the Church of San Francesco. In 1519-1520, he completed four frescoes in the nave of the Cathedral of Cremona depicting episodes from the Passion of Christ. These expressive frescoes owe a debt to the dramatic style of the Cremonese painter Altobello Melone. Romanino, however, adapted Altobello's style to suit his own needs, making it more fluid and sensitive.

In 1522, Romanino was in Brescia, working with Moretto on fresco decorations for a chapel in the Church of San Giovanni Evangelista. Titian's *Resurrection* was imported to Brescia that year and Romanino's work for the chapel recalls both Titian and Giorgione. One fresco, *St. Matthew and the Angel* (1521-24), seems to prefigure Caravaggio in its candlelight effects. The influence of Pordenone and Moretto on Romanino is evident in works such as a *Nativity* polyptych of 1525 and a *St. Anthony* of 1529. In his later work, Romanino's colors became more subdued and somber. His last dated work, however, *The Preaching of Christ to the Multitude*, painted for San Pietro in Modena in 1558, shows a return to the serenity of his earlier works.

The High Museum's exquisite altarpiece is one of several with the Virgin and Child and various saints that Romanino painted for churches in the region of Brescia during the decade from 1510 to 1520. Similar examples were produced for the Church of San Bernardino dei Minori Osservanti at Salò (now in the Duomo) and for the Church of San Francesco at Brescia (formerly in the Kaiser-Friedrich Museum,

Berlin).[1] The original location of the Museum's work is not known. Although Longhi compared it to the 1513 altarpiece in Padua, it shows less influence of the Venetian painters and more of Lotto, and thus probably predates Romanino's trip to Venice. Romanino employs *sfumato*, endowing the large figures and the landscape with a delicate beauty. The two saints in particular present an unusual combination of strength and tenderness. Commanding figures, they are humbled in the presence of Christ and Mary. To the left is the Apostle James the Greater with the attributes of a pilgrim: a staff and scallop shell. To the right, the Christ Child holds the Bible for St. Jerome, an allusion to the saint's translation of the Scriptures into Latin. Here Jerome is depicted as a hermit, accompanied by his chief attribute, the lion, and holding a rock for self-mortification. This type of St. Jerome, which occurs in other paintings by Romanino,[2] was probably derived from Boccaccio Boccaccino and was adopted by Moretto. The placement of a symbolic bird before the Virgin's throne is a detail which occurs in Romanino's Padua altarpiece as well as in other Venetian and North Italian paintings of the enthroned Virgin.[3] In this case it is the European jay, which, as Friedmann has recently observed, was sometimes associated with St. Jerome. Because of the supposed luminescence of its wings, the jay had come in the Middle Ages to symbolize inspiration.

[1]See Ferrari, 1961, pls. 19, 25.
[2]Ibid., pls. 24, 47.
[3]In the Padua altarpiece the two birds appear to be a variety of quail, a type of bird also seen in altar paintings by Cima and Benedetto Diana in the Accademia, Venice. Cristoforo Caselli included a parrot and a goldfinch in his *Enthroned Madonna* in Parma. Perhaps the most elaborate display of birds occurs in Francesco da Negroponte's painting in San Francesco della Vigna, Venice.

Benvenuto Tisi, called Il Garofalo
Ferrara, 1481-1559

Adoration of the Magi, ca. 1534
Oil on panel, 15⅛ x 23 inches (38.4 x 58.4 cm.)

Gift of the Samuel H. Kress Foundation, 1958.44.

Provenance: Comtesse de Lambert, Paris; Contini Bonacossi, Florence; Samuel H. Kress Foundation, 1950.

Bibliography: *Kress Collection*, Atlanta, 1958, p. 33; Shapley, II, 1968, p. 79, fig. 188; Fredericksen and Zeri, 1972, pp. 78, 553.

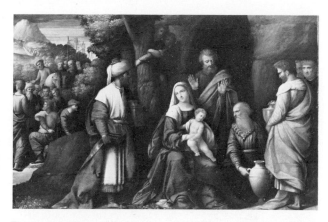

Benvenuto Tisi, called Il Garofalo, *Adoration of the Magi* (color plate, page 15)

Benvenuto Tisi, known as *Il Garofalo* (the Carnation), probably studied with the Cremonese painter Boccaccio Boccaccino, who was active in Ferrara in the later part of the fifteenth century. Garofalo may have visited Venice early in his career, for the influence of Giorgione on his painting of landscape is striking. According to Vasari, Garofalo twice visited Rome; paintings such as his 1512 *Neptune and Pallas* (Dresden) and his 1517 *Madonna del Baldacchino* (National Gallery, London), show his familiarity with the work of Raphael and mark a turn to a more classical style.

In Ferrara, Garofalo occasionally worked with the Dossi brothers and probably also with L'Ortolano, whose style is similar to his. During the second decade of the sixteenth century, Titian worked in Ferrara for Duke Alfonso d'Este, and his example may have led Garofalo to develop a greater intensity in his color. In the 1530s, Garofalo began to respond to the new mannerist style spreading north from Rome. His later works, such as the *Madonna Enthroned* in the Galleria Estense (Modena), display elongated figures and contorted poses reminiscent of Parmigianino.

Despite these various influences, Garofalo imparted a distinctive tenderness to all that he produced. Combined with his brilliant jewel-like colors and high finish, this manner gives his work a special charm. This style was particularly appropriate for such subjects as the Adoration of the Magi, and Garofalo and his workshop produced a good many of them. Other versions that have a vertical format and set the scene in front of a ruined classical arch are in the Rijksmuseum (Amsterdam), the Museo di Capodimonte (Naples), and the Pinacoteca Municipale (Ferrara). In the High Museum's painting, the setting of the scene before a cave and the elaborately turbaned magus recall works by Giorgione, such as his *Three Philosophers* (Vienna). The depiction of naive pleasure in the adoration of the divine child makes this small panel one of the artist's most affecting achievements.

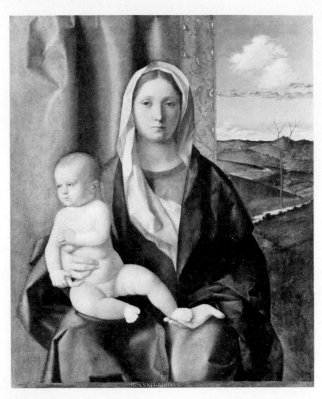

Giovanni Bellini, *The Madonna and Child* (color plate, page 16)

Giovanni Bellini
Venice, ca. 1426-1516

Madonna and Child, ca. 1510
Oil on panel, 37⅛ x 28¾ inches (94.3 x 73 cm.)
Signed in the middle of the parapet: *IOANNES BEL-LINVS*

Gift of the Samuel H. Kress Foundation, 1958.33.

Provenance: Jean-Baptiste Pierre Lebrun, Paris, 1809; Sir Thomas Baring, Bart., Stratton Park, Hampshire; Robert Holford, Westonbirt, Gloucestershire, 1843; William Coningham, London; Sale, Christie's, London, June 9, 1849, no. 47; Smith, London; Thomas Baring, Stratton Park, Hampshire; Thomas George, first Earl of Northbrook, Pursers Hall, Bramdean, Hampshire; Sale, Christie's, London, Dec. 12, 1919, no. 111; Duveen's, New York, 1925; Ralph Booth, Detroit; Duveen's, New York; Samuel H. Kress Foundation, 1957.

Exhibitions: Royal Academy, London, 1894, no. 148; *Venetian Art*, New Gallery, London, 1894-95; *Twentieth Anniversary Exhibition*, Cleveland Museum of Art, June 26-Oct. 4, 1936, no. 114; *Exhibition of Paintings by the Old Masters*, Flint Institute of Arts, Flint, Michigan, Sept. 15-Oct. 7, 1945, no. 2; *Art Treasures for America from the Samuel H. Kress Collection*, National Gallery of Art, Washington, D.C., Dec. 10-Feb. 4, 1962, no. 3.

Bibliography: Jean-Baptiste Pierre Lebrun, *Recueil de Gravures trait d'après un choix de tableaux de toutes les écoles*, Paris, 1809, I, p. 28, pl. XV; G. F. Waagen, "Collection of Sir Thomas Baring," *Treasures of Art in Great Britain*, London, 1854, II, p. 178; J. A. Crowe and G. B. Cavalcaselle, *A History of Painting in North Italy*, London, 1871, I, p. 187, n. 2; ed. T. Borenius, 2nd ed., London, 1914, I, p. 185, n. 4; J. P. Richter, *Catalogues of the Collection of the Earl of Northbrook*, 1889, no. 154; A. Venturi, *Storia dell'arte Italiana*, Milan, 1915, VII, pt. IV, p. 586; Georg Gronau, *Pinacotheca*, 1928, p. 67; Georg Gronau, *Giovanni Bellini*, 1930, p. 215, no. 157; Lionello Venturi, *Pitture Italiane in America*, Milan, 1931, no. 299; English ed., New York, 1933, II, no. 402; Raimond van Marle, *The Development of the Italian Schools of Painting*, The Hague, 1935, XVII, pp. 326f., fig. 197; Luitpold Dussler, *Giovanni Bellini*, Frankfurt, 1935, p. 146; 2nd ed., Vienna, 1949, p. 101, fig. 142; William Milliken, "The Cleveland Anniversary Exhibition," *The Art Digest*, June 13, 1936, p. 8; "Twentieth Anniversary Exhibition at the Cleveland Museum of Art," *Art News*, June 13, 1936, p. 8; Carlo Gamba, *Giovanni Bellini*, Milan, 1937, p. 152, fig. 167; French ed., n.d. (1937?), p. 163; Bernard Berenson, *Italian Pictures of the Renaissance, Venetian School*, London, 1957, I, p. 32; *Kress Collection*, Atlanta, 1958, pp. 42ff.; Fritz Heinemann, *Giovanni Bellini e I Belliniani*, Venice, 1962, I, pp. 19-20, no. 59; Felton Gibbons, "Giovanni Bellini and Rocco Marconi," *The Art Bulletin*, XLIV, 1962, pp. 128-130, fig. 1; *Masterpieces*, Atlanta, 1965, p. 10; Shapley, II, 1968, p. 45, fig. 105; A. Hyatt Mayor, *Prints and People*, New York, 1971, fig. 268; Fredericksen and Zeri, 1972, pp. 22, 553.

The son of the Venetian painter Jacopo and the brother of Gentile, Giovanni Bellini spent the early part of his career assisting them in the great decorative work for the Scuola di San Giovanni Evangelista, as well as working on processional banners and sepulchral monuments. His earliest independent works, which show the influence of Man-

tegna in their angular linearity, reveal a devotion to color, light, and expressive meaning. The *Agony in the Garden* (now in the National Gallery, London) was the first of his great landscape paintings to employ the dramatic and symbolic landscape which was to find its fullest flowering in his great *St. Francis* (Frick Collection). By the 1460s Bellini was receiving notable commissions, such as the series of saints for the Carità in Venice. He journeyed to Rimini to paint a moving *Dead Christ with Angels* for the Malatesta family.

When Bellini changed from tempera to oil paint—following the lead of Antonello da Messina, who visited Venice in 1472—his work became more brilliant. The richer harmonies he achieved are seen in his Frari *Madonna* of 1488. By the early 1500s Bellini had become official painter for the Doges, and Vasari records that he was an active portraitist. At the end of his life, Bellini was the most famous artist in Venice, with a large workshop which included among its students the young Giorgione and Titian.

One of the iconographic types which Bellini perfected was the Madonna and Child set before a landscape. The High Museum's example, with the Virgin looking directly out and the Child facing to the left, dates from about 1510. Variants, often with saints added, were painted by both Bellini and his assistants, and despite the fact that the Museum's version is signed by the artist in his usual Latin form, there has been a good deal of debate over its authorship. It was accepted as an autograph work by Gronau, Venturi (1933), van Marle, Dussler, Gamba, Berenson, and Heinemann. Felton Gibbons and Shapley have designated it as by Giovanni Bellini and his assistant Rocco Marconi. The present author, however, and most recently Everett Fahy (in conversation, 1980), find the work to be of extremely high quality and view it as an original—if somewhat skinned and repainted—work of the master himself.

One of the most impressive aspects of this composition is the landscape view out the window. This exquisitely beautiful scene, complementing the calm grandeur of the Virgin, also has a symbolic function. The single bare tree, a detail found in other pictures by Bellini, such as the *Virgin of the Assumption in Glory* (Murano) and *Christ Blessing* (Ottawa), probably refers to Christ's crucifixion and the arid state of mankind before salvation.

Nicolò Rondinelli
Ravenna, active 1480-1510

Madonna and Child with an Angel Playing a Lute
Oil and tempera on panel, 31¾ x 24¾ inches (80.7 x 62.9 cm.)

Gift of a Friend, 1951.21.

Provenance: Sold in Rome, 1913, to Sig. Cendra; Elia Volpi, Villa Pia, Florence; Sale, American Art Association, New York, Nov. 27, 1916, no. 1000; J. E. Aldred, New York; Private collection, New York.

Nicolò Rondinelli, *Madonna and Child with an Angel Playing a Lute*

Exhibition: Dayton Art Institute, 1952.

Bibliography: Corrado Ricci, "Uno Scolaro di Giovanni Bellini, Nicolò Rondinelli," *Venezia*, I, 1920, pp. 8, 28; Albert G. Hess, *Italian Renaissance Paintings with Musical Subjects*, New York, 1955, fasc. 11, pl. XCIb; Bernard Berenson, *Italian Pictures of the Renaissance, Venetian School*, London, 1957, I, p. 151, fig. 394.

Rondinelli, the leading painter in late fifteenth century Ravenna, took his subject matter—chiefly representations of the Madonna and Child set behind a ledge or in front of a curtain and a view of landscape —from his master, Giovanni Bellini. But Rondinelli painted with a heavier hand, so that the children in particular have a somewhat doughy quality. Examples similar to this one can be found in the Palazzo Doria (Rome), in the Fogg Art Museum (Cambridge), and in fresco fragments in Ravenna. Another painting with a lute-playing angel and an infant St. John the Baptist was sold at Sedelmeyer Gallery, June 3-5, 1907 (no. 178). This type of youthful Virgin appears in Rondinelli's masterpiece, *The Enthroned Madonna and Child with Saints* in the Brera, Milan.

The apples placed prominently in the foreground are an allusion to original sin. Rondinelli, again following Bellini, often displayed symbolic fruits in this way.[1]

[1]See the examples reproduced in Fritz Heinemann, *Giovanni Bellini e I Belliniani*, Venice, 1962, II, figs. 297, 298.

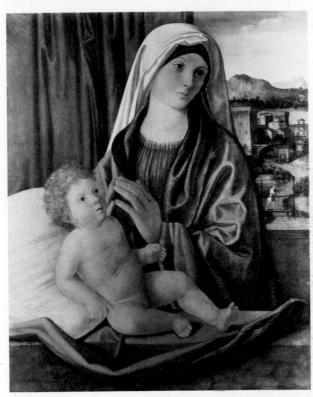

Attributed to Cristoforo Caselli, *Madonna and Child*

Attributed to Cristoforo Caselli
Parma and Venice, 1461-1521

Madonna and Child, ca. 1495
Oil on panel, 22½ x 18 inches (57.1 x 45.7 cm.)

Gift of Samuel H. Kress, New York, 1938.3.

Provenance: Contini Bonacossi, Florence; Samuel H. Kress, 1936.

Bibliography: Bernard Berenson, *Italian Pictures of the Renaissance, Venetian School*, 1957, I, p. 60; Shapley, II, 1968, pp. 61-62, fig. 148.

Cristoforo Caselli, called Cristoforo da Parma or *Il Temperello*, was an artist of the Venetian school who was influenced by Giovanni Bellini. From about 1488 to 1495, Caselli (along with Vivarini and others) assisted Bellini in the decoration of the Ducal Palace in Venice. He probably then returned to his native Parma; a signed altarpiece now in the Galleria Nazionale of Parma is inscribed with the date 1499.

This painting of the Virgin and Child is typical of Caselli's style but has been so extensively restored that a positive attribution is not possible. The composition is derived from a work by Bellini that was also copied by Rondinelli and Bartolommeo Veneto.[1]

[1]See Fritz Heinemann, *Giovanni Bellini e I Belliniani*, Venice, 1962, I, pp. 14-15; II, pls. 76, 295, 406.

Vittore Carpaccio
Venice, ca. 1460-ca. 1526

Temperance, ca. 1525
Oil on wood, 42⅝ x 21⅝ inches (108.3 x 55 cm.)

Prudence, ca. 1525
Oil on wood, 42⅝ x 21¾ inches (108.5 x 55.1 cm.)

Gifts of the Samuel H. Kress Foundation, 1958.35 and 1958.36.

Provenance: Bernasconi Collection, Milan; Contini Bonacossi Collection, Rome; Samuel H. Kress Foundation, 1928.

Exhibition: National Gallery of Art, Washington, D.C. 1941-56.

Bibliography: Giuseppe Fiocco, "Nuovi documenti intorno a Vittore Carpaccio," *Bollettino d'Arte*, XXVI, Sept. 1932, p. 125; Giuseppe Fiocco, "New Carpaccios in America," *Art in America*, XXII, 1934, pp. 115, 117; Bernard Berenson, *Pitture italiane del Rinascimento*, Milan, 1936, p. 116; *Preliminary Catalogue of Paintings and Sculpture*, National Gallery of Art, Washington, D.C., 1941, pp. 33f.; Bernard Berenson, *Italian Pictures of the Renaissance, Venetian School*, London, 1957, I, p. 59; Giuseppe Fiocco, *Carpaccio*, Novara, 1958, p. 34, no. 4; T. Pignatti, *Carpaccio*, Geneva, 1958, pp. 84, 114; *Kress Collection*, Atlanta, 1958, pp. 45-47; Jan Lauts, *Carpaccio*, London, 1962, pp. 29, 237, nos. 32, 33, pls. 78, 79; T. Pignatti, in *La Provincia di Treviso*, V, July-Oct. 1962, p. 11; M. Muraro, *Carpaccio*, Florence, 1966, p. CLXXX; Pietro Zampetti, *Vittore Carpaccio*, Venice, 1966, pp. 76, 99; Shapley, II, 1968, p. 54, figs. 126, 127; Guido Perocco, *Carpaccio*, 1969, pp. 69f.; Fredericksen and Zeri, 1972, pp. 47, 553; *Selected Works*, Atlanta, 1981, p. 12; Guido Perocco, *Tout l'oeuvre peint de Carpaccio*, Paris, 1981, p. 95, nos. 23a, 23b.

Vasari considered Carpaccio the first of the Venetian painters to produce "work of real importance." The son of a fur merchant, he was probably born in Venice, where he is known to have lived from 1472 onward. His early work shows the influence of Antonello da Messina. A *Salvator Mundi* of ca. 1480 in the Contini Bonacossi Collection (Florence) is signed with the Venetian form of the family name, "Veetor Scarpazzo," which, following the fashion of the day, was latinized to "Carpathius." The Italian form, "Carpaccio," first appears on one of eight large paintings done in the 1490s for the Scuola di Sant'Orsola (now in the Accademia, Venice). These paintings, with their profusion of detail and love of Venetian spectacle, are indebted to Gentile Bellini, but Carpaccio's inventive style is already evident.

In 1501 and again in 1507 Carpaccio worked on projects (now lost) in the Palazzo Ducale, which brought him into contact with Giovanni Bellini. This acquaintance, and perhaps a visit to Rome, influenced his style. He developed more feeling for space and light, more delicate coloring, and an interest in fanciful landscapes and inventive allegorical subjects. These concerns reached their fruition in a remarkable series of works devoted to the lives of St. Jerome

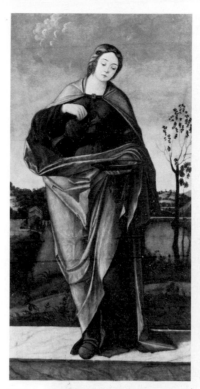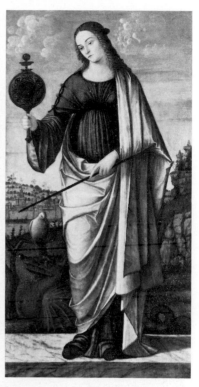

Vittore Carpaccio, *Temperance*
(color plate, page 17)

Vittore Carpaccio, *Prudence*
(color plate, page 17)

and St. George that Carpaccio painted for the Scuola degli Schiavoni in 1502 and 1507. In these paintings, lively narrative and humorous genre elements are combined with powerful religious feeling.

Carpaccio's renown was such that in 1507 he was one of those chosen to judge the value of Giorgione's deteriorating frescoes on the façade of the Fondaco dei Tedeschi on the Rialto, and in 1516 he painted the *Lion of St. Mark* for the Doge's Palace. Late in his life Carpaccio moved to Capodistria and executed many commissions in that region, but there is some falling off in the quality of his work.

These two allegorical representations of *Temperance* and *Prudence* were probably part of a set of the Four Cardinal Virtues (the other two are *Justice* and *Fortitude*). Since the Middle Ages, the Virtues had been represented as women, each with her distinguishing attributes. Temperance, or moderation, is shown carefully pouring liquid from one vessel into another—probably diluting wine with water to strike the correct balance. The virtue of Prudence, or practical wisdom, according to the Roman philosopher Cicero, combined memory, intelligence, and foresight. She was frequently depicted with a mirror, a snake, and sometimes a dove. The mirror was regarded as a means of observing the truth and of divining the future. Both the snake (or in this work, the dragon) and the dove are derived from Matthew 10:16: "Behold, I send you forth as sheep in the midst of wolves; be ye therefore wise as serpents and harmless as doves."[1]

These two allegories have received a wide variety of datings. Suida suggested they were from as early as 1480, which seems unlikely. Fiocco dated them around 1490; Lauts, about 1495-1500; but Berenson, Pignatti, and Shapley prefer a late dating, around 1520. This opinion seems justified by the paintings' similarity to a *St. Paul* in Chioggia which is signed and dated 1520 and shows the upright figure of the saint set against a panoramic landscape.[2] This format, as Pignatti has suggested, was probably adopted from the work of Cima da Conegliano.[3] It first appears in Carpaccio's depiction of four saints in an altarpiece at Zara.[4]

The sweet faces of these two virtues are characteristic of Carpaccio's female types. The face of Prudence was employed for a figure of a spectator kneeling next to the Virgin in his drawing of *The Presentation of the Virgin* at the Uffizi. A drawing of the head of a saint in the Donnigton Priory is very similar to Temperance,[5] which was also the model for a St. Lucy in a work of 1541 by the artist's son Benedetto.

[1]See Adolph Katzenellenbogen, *Allegories of the Virtues and Vices in Medieval Art, From Early Christian Times to the Thirteenth Century*, New York, 1964, pp. 55-56.
[2]See Zampetti, 1966, no. 77.
[3]See especially the *Justice* and *Temperance* of the School of Cima in the Accademia in Venice, reproduced in Peter Humfrey, *Cima da Conegliano*, Cambridge, 1983, pls. 165a, 165b.
[4]Zampetti, 1966, no. 3.
[5]See Terisio Pignatti, *Vittore Carpaccio*, Milan, 1972, pl. 11.

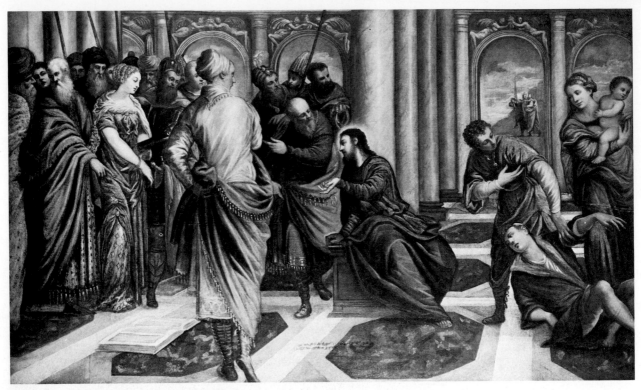

Follower of Jacopo Tintoretto, *The Woman Taken in Adultery*

Follower of Jacopo Tintoretto
Venice, 16th century

The Woman Taken in Adultery, ca. 1545
Oil on canvas, 64½ x 96⅛ inches (163.9 x 244.2 cm.)

Gift of the Samuel H. Kress Foundation, 1958.46.

Provenance: Mrs. John Keyes, London; International Financing Co., Panama City, Panama; Samuel H. Kress Foundation, 1956.

Bibliography: Rodolfo Pallucchini, *La Giovinezza del Tintoretto*, Milan, 1950, pp. 108-109, fig. 171; G. A. Dell'Acqua, "L''Adultera' del Tintoretto a Milano," *Paragone*, March 1957, p. 64; *Kress Collection*, Atlanta, 1958, pp. 50-53; J. Neumann, *The Picture Gallery of Prague Castle*, Prague, 1967, p. 263; Fredericksen and Zeri, 1972, pp. 199, 554; Shapley, III, 1973, p. 60, fig. 109; Rodolfo Pallucchini and Paola Rossi, *Tintoretto, Le opere sacre e profane*, Venice, 1982, I, p. 151.

Along with Titian and Veronese, Jacopo Robusti, called *Il Tintoretto* (the little dyer), was one of the greatest of the Venetian Cinquecento painters. During his very long career, spent almost entirely in Venice, he became the leading artist for producing enormous painted cycles in churches, palaces, and the various scuolas or private religious associations. To the typical Venetian richness of color he added his own mannerist elements, creating compositions of extraordinary complexity and brilliance.

The painter established a large workshop, employing his sons and daughters, and the present painting is clearly one of its products. Other versions of the subject are at the Archepiscopal Palace of Milan, the Dresden Gallery, the Rijksmuseum (Amsterdam), the Galleria Nazionale (Rome), and the Picture Gallery in Prague Castle. The High Museum's painting is closest to the Milan version, combining the main story with Christ healing the sick and lame. But some of the poses are taken from the Dresden and Rome paintings. In the process of adaptation, the copyist has lost the brilliance and spontaneity of the master's work, substituting a standard studio quality.

In Tintoretto's conception of the subject, the temple looks like a Roman Imperial hall, richly decorated with marble. The scholars at the left have forced Christ to turn away from the people coming to be healed. The adulterous woman, beautifully gowned, waits to hear if Jesus thinks she should be stoned for her sin. "But Jesus stepped down and with his finger wrote on the ground and when they continued asking him, he said unto them, 'He that is without sin among you, let him cast the first stone at her'" (John 3:2-7).

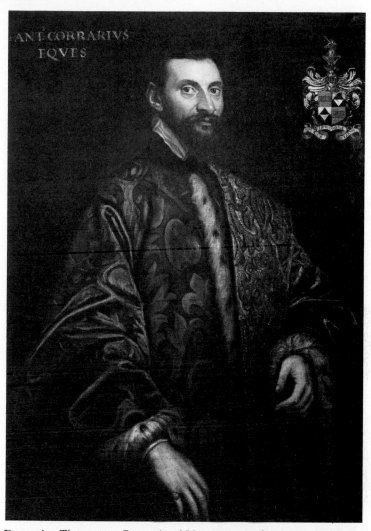

Domenico Tintoretto, *Portrait of Marcantonio Correr*

Domenico Tintoretto
Venice, 1560-1635

Portrait of Marcantonio Correr
Oil on canvas, 44¾ x 31¾ inches (113.7 x 80.7 cm.)
Inscribed at upper left: *ANTˢ CORRARIVS EQVES*

Gift of a Friend, 1953.14.

Provenance: Count Gianfrancesco Oliviero, Venice; Private collection, New York.

Exhibitions: *First International Loan Exhibition*, The Los Angeles County Art Association, 1937; *An Exhibition of Old Masters*, The Decatur Art Institute, Illinois, and The Quincy Art Club, Illinois, Nov.-Dec. 1940, no. 2; *Masterpieces of European Art*, The Springfield Art Association, Illinois, no. 16; *The Art of Renaissance Portraiture and Portraits Posed and Unposed*, Washington County Museum of Fine Arts, Hagerstown, Maryland, no. 11; *Old Masters*, The Parkersburg Fine Arts Center, West Virginia, Oct. 1945, no. 17.

Bibliography: *Art News*, May 16, 1931, p. 29, no. 33.

The son of the famous Venetian artist Jacopo Robusti Tintoretto, Domenico is best known for his por-traits. He painted large group portraits, such as the members of the confraternity of the Scuola dei Mer-canti, as well as many individual portraits of doges, senators, and other distinguished Venetians.[1] His style is somewhat dry and hard, and he had a ten-dency to rely on stock poses and garments painted in a rather coarse manner.

The present painting is similar to a portrait of a Senator formerly in a Bavarian collection,[2] and an-other at the Memorial Art Gallery, Rochester.[3] The attribution has been confirmed by George Gronau (opinion in Museum files), Burton Fredericksen (in a letter of April 11, 1980), and Paola Rossi (in a letter of April 24, 1982). Rossi suggests that the subject is Marcantonio Correr (1570-1638), who was a Vene-tian ambassador to England.

[1] See Carlo Ridolfi, *Le Meraviglie dell'Arte*, Berlin, 1924, II, pp. 260-261.
[2] Reproduced in *Connoisseur*, March 1936, p. 160.
[3] See Paola Rossi, "Alcuni Ritratti di Domenico Tintoretto," *Arte Veneta*, XXII, 1968, p. 67, fig. 91.

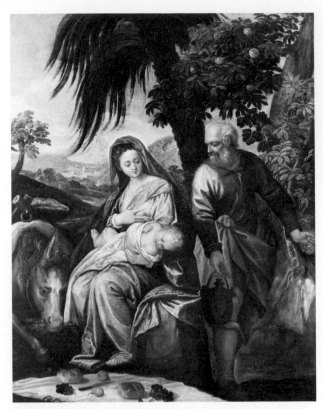

Studio of Paolo Veronese, *The Rest on the Flight into Egypt*

The son of a stonemason, Paolo Caliari became known as *Veronese*, after his native town of Verona. As a youth, Veronese studied modelling with his father and painting with his uncle, Antonio Badile. He probably travelled to Mantua and Parma, where he would have seen the paintings of Giulio Romano, Correggio, and Parmigianino. He first worked in Venice in 1551 and from 1553 to 1556 was commissioned to work on the decoration of several rooms of the Doge's Palace. Veronese painted allegories glorifying Venice, portraits of local dignitaries, and frescoes and altars for many churches.

In 1573 the artist was called before the Inquisition on charges of heresy for his grandiose banquet scene *Feast in the House of Levi*, but successfully defended himself. After painting a series of erotic allegories for Rudolph II about 1580, Veronese concentrated on religious subjects for the last years of his life. Veronese's two sons, Carletto and Gabriele, became painters and, along with their father's brother Benedetto, collaborated on many of the master's later works.

The subject of *The Rest on the Flight into Egypt* was a popular one with Veronese and his shop. This painting is very close to a drawing by the artist in the British Museum,[1] and another sheet with sketches for the figures is in the Cleveland Museum of Art. Other slightly different versions by Veronese and/or his workshop include a large vertical painting at the Ringling Museum, Sarasota (a related drawing is in Rotterdam),[2] and a horizontal work at the National Gallery of Canada.

Compared to the grace of the London drawing, the High Museum's painting is rather stiff in the depiction of the trees and the still life elements in the foreground are perhaps too precisely arranged, so that most recent writers have rightly credited the painting to the workshop of Veronese. The unusual pose of the child derives from the symbolic intent of the composition. The Christ Child turns from the proffered breast to gaze at the bread and grapes, emphasizing the redemptive meaning of these eucharistic symbols.

[1]See Antoine Orliac, *Veronese*, London, 1940, p. 53.
[2]See Richard Cocke, "Observations on Some Drawings by Paolo Veronese," *Master Drawings*, Summer 1973, p. 145, pl. 13.

Studio of Paolo Veronese
Venice, active ca. 1570-1585

The Rest on the Flight into Egypt, ca. 1570-80
Oil on canvas, 50 x 37¾ inches (127 x 95.9 cm.)

Gift of the Samuel H. Kress Foundation, 1958.34.

Provenance: Jean Krebs, Brussels and Paris; International Financing Co., Panama City, Panama; Sale, Sotheby's, London, Feb. 22, 1956, no. 170; Samuel H. Kress Foundation, 1956.

Exhibitions: *Mother and Child*, Winnipeg Art Gallery, Winnipeg, Canada, May 14-Aug. 13, 1967; *Veronese and His Studio in North American Collections*, Birmingham Museum of Art and Montgomery Museum of Fine Arts, Oct. 1-Dec. 31, 1972.

Bibliography: F. H. Meissner, *Veronese*, Leipzig, 1897, p. 8, ill. 5; *Kress Collection*, Atlanta, 1958, pp. 48-51; R. Marini, *L'Opera Completa del Veronese*, 1968, no. 55; David Rosand, "Three Drawings by Paolo Veronese," *Pantheon*, XXIX, 1971, pp. 204, 206, fig. 3; Idem, "Veronese and Company," in the exhibition catalogue *Veronese and His Studio*, Birmingham, Alabama, 1972, p. 7; Fredericksen and Zeri, 1972, p. 38; Shapley, III, 1973, p. 43, fig. 78; Terisio Pignatti, *Veronese*, 1976, I, no. A5, fig. 721; Kurt Badt, *Paolo Veronese*, Cologne, 1981, p. 413, fig. 17.

Follower of Caravaggio
Italian, late 17th century

Boy With a Carafe of Roses
Oil on canvas, 26½ x 20⅜ inches (67.3 x 51.8 cm.)

Great Painting Fund purchase, 1958.1.

Provenance: Private collection, England; Moussali Collection, Paris; Wildenstein & Co., Inc., New York.

Exhibitions: *Masterpieces of Painting Through Six Centuries*, Allied Arts Association, Houston, 1952, no. 12; *L'Age d'or espagnol*, Bordeaux, France, May 16-July

31, 1955, no. 1; *Still Life Paintings-from the XVI Century to the Present*, Atlanta Art Association, Jan. 10-29, 1958; Museum of Fine Arts, St. Petersburg, Florida, Feb. 6-March 7, 1965; *The Age of Caravaggio, 1590-1610*, Metropolitan Museum of Art, New York, and Museo di Capodimonte, Naples, Feb. 6-June 30, 1985.

Bibliography: Herman Voss, "Ein unbekanntes Frühwerk Caravaggios," *Die Kunst und das schöne Heim*, Aug. 1951, pp. 410-12; F. Baumgart, "Die Anfänge Caravaggios," *Zeitschrift für Kunstwissenschaft*, VI, 1952, p. 92; Roberto Longhi, *Il Caravaggio*, Milan, 1952, no. VIII; Denis Mahon, "Addenda to Caravaggio," *Burlington Magazine*, Jan. 1952, p. 19, n. 9b; F. Baumgart, *Caravaggio*, Berlin, 1955, pp. 18, 25, no. 6; A. Czobor, "Autoritratti del Giovane Caravaggio," *Acta Historiae Artium Academiae Scientiarum Hungaricae*, II, 1955, p. 213, n. 21; Pascal Pia, "Aventures et Tribulations du Caravage," *L'Oeil*, Feb. 1955, pp. 17-26; H. Wagner, *Michelangelo da Caravaggio*, Bern, 1958, p. 227; A. Berne Joffroy, *Le dossier Caravage*, Paris, 1959, p. 344; René Jullian, *Caravage*, Lyon and Paris, 1961, pl. 3; L. Venturi, *Caravaggio*, Novara, 1963, p. 68, no. 57; Paola della Pergola, "Nota per Caravaggio," *Bollettino d'Arte*, July-Sept. 1964, p. 252; M. Calvesi, "Buonasera Maestro," *Marcatré*, nos. 19-22; *Masterpieces*, Atlanta, 1965, p. 13; S. Bottari, *Caravaggio*, Florence, 1966, p. 15; A. Ottino della Chiesa, *L'Opera Completa del Caravaggio*, Milan, 1967, p. 86, no. 5; Alfred Moir, *The Italian Followers of Caravaggio*, Cambridge, Mass., 1967, I, p. 27, n. 20; II, p. 62, n. 4; Michael Kitson, *The Complete Paintings of Caravaggio*, New York, 1967, p. 85, no. 5, ill. p. 86; L. Salerno, "Caravaggio e i Caraveggeschi," *Storia dell'arte*, July-Dec. 1970, p. 235; Richard E. Spear, "A Note on Caravaggio's Boy with a Vase of Roses," *Burlington Magazine*, CXIII, 1971, pp. 470ff., fig. 53; M. Cinotti and G. A. Dell'Acqua, *Il Caravaggio e le sue grandi opera da San Luigi dei Francesci*, Milan, 1971, pp. 88, 90, 163 F 108, no. 213, 179-181; Donald Posner, "Caravaggio's Homoerotic Early Works," *The Art Quarterly*, XXXIV, no. 1, 1971, pp. 316, 317, 324; Fredericksen and Zeri, 1972, pp. 44, 554; F. Rossi and Mia Cinotti, *Immagine del Caravaggio*, 1973, p. 82; Maurizio Marini, *Michelangelo da Caravaggio*, Rome, 1973-74, pp. 19, 92, 338-39, no. 6; H. Röttgen, *Il Caravaggio*, Rome, 1974, p. 253, n. 157; Alfred Moir, *Caravaggio and His Copyists*, New York, 1976, p. 116, under no. 103; Benedict Nicolson, *The International Caravaggesque Movement*, Oxford, 1979, p. 34; M. Marini, *Caravaggio, Werkverzeichnis*, Frankfurt, 1980, p. 10, no. 4e; Howard Hibbard, *Caravaggio*, New York, 1983, pp. 284, 342; Mia Cinotti, *Michelangelo Merisi detto il Caravaggio*, Bergamo, 1983, p. 557, no. 72, p. 634, fig. 2; Maurizio Marini, "Equivoci del caravaggismo . . . ," *Artibus et Historiae*, 8, 1983, pp. 127-131, 149, figs. 9-12; Luigi Salerno "Caravaggio: A Reassessment," *Apollo*, June 1984, p. 439.

Michelangelo Merisi (1571-1610), called *Caravaggio* after his birthplace in Lombardy, arrived in Rome about 1592. His powerful representations of religious subjects placed in humble settings with dramatic contrasts of light and shade brought him fame in his lifetime and had international influence for centuries. At first, he made his living by painting still lifes. Then, taken under the patronage of Cardinal del Monte about 1594, he produced a series of homoerot-

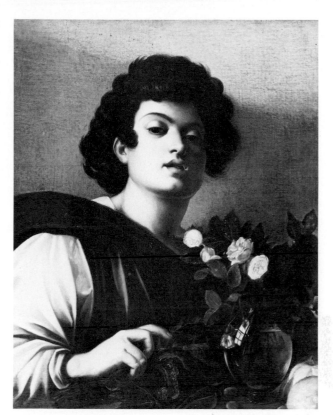

Follower of Caravaggio, *Boy with a Carafe of Roses* (color plate, page 18)

ic paintings of androgynous youths, including such outstanding examples as the *Lute Player* (The Hermitage), *Boy with Basket of Flowers and Fruit* (Galleria Borghese, Rome), and *Bacchus* (Uffizi, Florence), as well as the heavily restored *Musicians* in the Metropolitan Museum. In these works, young boys dressed *alla antica* give longing glances and make provocative gestures, accompanied by musical instruments, fruit, and flowers symbolic of sensual pleasure and sexual dalliance.[1]

The painting in the High Museum, possibly intended as an allegory of the sense of smell or of youth, is very similar to Caravaggio's painting of a *Boy Surprized by a Lizard*.[2] In both these subjects, the roses may be symbols of the difficulties of love.[3] Another version of the *Boy with a Carafe of Roses* was in the Borenius Collection, London,[4] and a miniature copy of the composition by Carlo Errani is dated 1830.[5] Both versions show the boy's left hand making an obscene sign with the middle finger, a detail which, as x-rays reveal, has been overpainted in the High Museum's example.

This painting was first attributed to Caravaggio by Venturi and first published as such by Voss in 1951, but there has been continued debate as to its

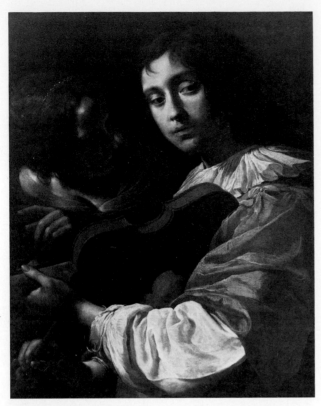

Giovanni Martinelli, *Youth with Violin* (color plate, page 18)

Giovanni Martinelli
Florence, ca. 1610-ca. 1668

Youth with Violin, ca. 1640-1650
Oil on canvas, 26⅛ x 20⅞ inches (66.3 x 53 cm.)

Gift of Mrs. Charles T. Hopkins in memory of her father, John Carroll Payne, 1955.161.

Provenance: Gillespie Galleries, Pittsburgh; Carl D. Bushnell; Mrs. Doris L. Bushnell; Mrs. Charles T. Hopkins, Atlanta, 1955.

Exhibition: *Florentine Baroque Art from American Collections*, Metropolitan Museum of Art, New York, April 15-June 15, 1969, no. 55.

Bibliography: W. Aubrey Cartwright, *Guide to Art Museums in the United States*, New York, 1958, p. 174; *Masterpieces*, Atlanta, 1965, p. 15; Ann Sutherland Harris, "Florentine Sunset," *Art News*, May 1969, p. 61; Howard Hibbard, "Introduction," *Florentine Baroque Art*, New York, 1969, p. 14.

Very little is known of Martinelli's life and career, as he was not studied by contemporary art historians. His earliest known works are a 1664 cycle of frescoes in the cloister of Santa Annunziata in Pistoia. These works show the influence of both Santi di Tito and Bernardino Poccetti. Martinelli was recorded in 1665 as a member of the Florentine Accademia di Disegno and continued to be listed until 1668.

A group of easel pictures attributed to Martinelli reflects the manner of such popular Florentine painters as Cesare Dandini and Francesco Furini; the elegant half-length allegorical figures are painted with vivid, often startling, colors. The *Youth with Violin*, possibly an allegory of the sense of hearing, has been attributed to Martinelli by Mina Gregori.[1] Comparable compositions are the allegorical representations of *Music* and *Beauty* in the Corsini Gallery, Florence.[2] Another *Allegory* has the same figure of a woman in the background.[3] Her position and attitude toward the violinist suggest the seductive power of music. In all these works, as well as in several other half-length allegorical figures by Martinelli, rich fabrics glimmer against the dark backgrounds.[4]

authenticity. Compared to the *Lute Player* or the *Boy Surprized by a Lizard*, this work seems to lack Caravaggio's grace of touch and mastery of light effects, particularly in the background and the treatment of the carafe. It therefore seems wisest to regard it and the other versions as copies after a lost original.

Maurizio Marini, basing his opinion on the x-rays of the painting, observed that since portions of the work are overpainted, it is possible that, as with the Metropolitan Museum's *Musicians*, the original painting by Caravaggio might be underneath. Recent scientific examination of the painting in the conservation laboratory of the Metropolitan Museum, however, has shown that the underpainting is not consistent with Caravaggio's work and is most likely a copy, dating perhaps as late as the eighteenth century.

[1]See Posner, 1971.
[2]There are two versions of this: one in the Korda Collection, the other in the Longhi Collection. See della Chiesa, 1967, p. 86, nos. 6a, 6b.
[3]See the discussion in Hibbard, 1983, p. 284.
[4]See Moir, 1976, no. 103b, fig. la, and Cinotti, 1983, p. 638, fig. 1.
[5]According to a letter of November 20, 1982, from Maurizio Marini.

[1]In a letter of February 2, 1968, and in the exhibition catalogue *Florentine Baroque Art*, Metropolitan Museum of Art, New York, 1969, p. 54.
[2]See Fiorella Sricchia, "Giovanni Martinelli," *Paragone*, 39, 1953, pl. 12.
[3]See the exhibition catalogue *Mostra dei tesori segreti*, Florence, 1960, no. 98, fig. 74b.
[4]See Mina Gregori, "Avant-Propos sulla Pittura Fiorentina del Seicento," *Paragone*, 145, 1962, p. 40, pls. 42, 43.

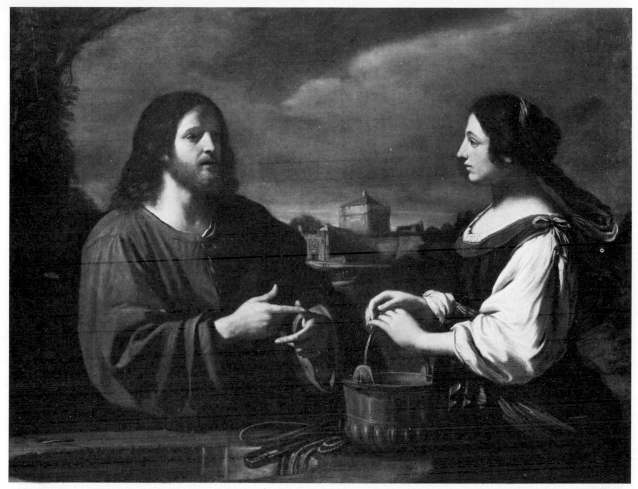

Giovanni Francesco Barbieri, called Il Guercino, and Workshop, *Christ and the Samaritan Woman*

Giovanni Francesco Barbieri, called Il Guercino, and Workshop
Cento, 1591-1666, Bologna

Christ and the Samaritan Woman, ca. 1650
Oil on canvas, 47¼ x 61½ inches (120 x 156.2 cm.)

Gift of Julie and Arthur Montgomery, 1980.56.

Provenance: Private collection, London; Bertina and Robert Manning, New York; M. Knoedler & Co., Inc., New York.

Exhibition: *Images by the Masters*, Birmingham Museum of Art, Alabama, Feb. 9-March 18, 1979.

Called *Il Guercino* ("the squinter"), this essentially self-taught artist began painting in Cento, a small town in the duchy of Ferrara. His first major commission was a work of 1613, now lost, for the Church of Spirito Santo. In addition to altarpieces for Cento, he painted a series of small decorative landscapes for the Palazzo Pannini from 1615 to 1617. Cardinal Alessandro Ludovisi recognized his ability and summoned him to Bologna in 1617. In 1618 he visited Venice. In 1619 and 1620 he worked for Cardinal Serra in Ferrara. The most important commission of

this period was a monumental Baroque altarpiece, *The Investiture of St. William of Aquitaine* (Pinacoteca, Bologna), for San Gregorio, Bologna, completed in 1620. The luminosity and flowing brushwork of Guercino's early pieces reflect the influence of the Ferrarese painter Scarsellino and the Bolognese painter Ludovico Carracci.

In 1621 Cardinal Ludovisi was elected Pope Gregory XV and brought the painter to Rome, where Guercino remained for the two years of the Pope's reign. During this time he painted the Santa Petronilla altarpiece for St. Peter's and the *Aurora* ceiling fresco for the Casino Ludovisi—works which displayed dramatic contrasts of light and vigorous figural compositions. In 1623 Guercino returned to Cento, where he established a studio that he maintained for nearly twenty years, filling commissions from all over Europe.

Following the death of Guido Reni in 1642, Guercino moved to Bologna and became the city's leading master. The influence of Reni was increasingly evident in his later, more placid treatments of religious subjects. Guercino was particularly noted for an oblong format with half-length figures, which was well suited to narrative depictions of scenes from the

Bible such as the meeting of Christ and the Samaritan Woman.

This story is told in John 4:7-30. Christ came to the city of Sychar in Samaria and, weary with his journey, he sat beside the well of Jacob. When a woman of the town came, Jesus asked her for a drink. She was surprised at the request because the Jews had no dealings with the Samaritans. In exchange for a drink of water, however, Jesus promised her the "living water," saying: "Everyone who drinks of this water will thirst again but whoever drinks of the water that I shall give him will never thirst. The water that I shall give him will become in him a spring of water welling up to eternal life." The woman realized that this stranger was a prophet when he told her that she had had five husbands and was living with a sixth. Jesus spoke to her of Salvation and, leaving her water jar, she went into the city to tell the people that she had met the Messiah. The implications of the episode are clear. The Samaritan woman symbolizes the Gentiles who by partaking of Christ will be saved. The water of the well of Jacob, used for purification, is to be replaced by the living water of Christian baptism.

Christ and the Samaritan Woman proved a popular subject in Renaissance and Baroque art, and notable versions were painted by Moretto, Bassano, Annibale Carracci, and Strozzi. The subject was treated by Guercino and his studio several times. The earliest example, probably from the 1620s, established the pattern: the half-length figures are shown in close-up, leaning on the edge of the well.[1] Two identical treatments of the subject probably date from the early 1640s: one in the Thyssen-Bornemisza Collection, Lugano,[2] and the other in the National Gallery of Canada, Ottawa.[3] There are also copies of this composition at the University of Notre Dame and in the Methuen Collection at Corsham Court.[4] These paintings show Christ in profile with his hand raised; the woman, holding her pitcher, is seen in three-quarter view. A similar relationship between the figures, but with Christ's hands on his chest and the water vessel resting on the edge of the well, is found in a painting formerly in the Chigi collection (Rome) and now in a private collection.[5] Denis Mahon has written (in a letter of August 29, 1981) that the Chigi work is probably the one for which Guercino received payment in January 1648. A preparatory drawing of the Chigi work is at Windsor Castle (no. 2791). In the drawing, Christ's hands are in the same position as in the High Museum's painting, which leads Mahon to conclude that the High Museum's painting was probably painted by an artist in Guercino's workshop familiar with both the Chigi painting and the preparatory drawing. Luigi Salerno has suggested (in a letter of October 27, 1981) that the painter of the Atlanta picture might be Gennari. It should be pointed out that both these scholars were judging the painting from black and white reproductions and that one of the work's most notable qualities is the delicate colora-

tion of the background sky. It is most likely that the work is the result of a collaboration between Guercino and one of his assistants.

[1] See *Catalogue of Paintings in the Permanent Collection of the Detroit Institute of Arts*, Detroit, 1930, p. 78, no. 90.
[2] See Gertrude Borghero, *Thyssen-Bornemisza Collection*, Lugano, 1981, p. 136, no. 122A.
[3] Formerly in the Clarke Collection and sold at Christie's, May 28, 1965, no. 32. See the *Annual Report, National Gallery of Canada*, Ottawa, 1966, p. 13.
[4] See Tancred Borenius, *A Catalogue of the Pictures at Corsham Court*, London, 1939, pp. 24-25, no. 43.
[5] See Nefta Grimaldi, *Il Guercino*, Bologna, 1968, pl. 184.

Unknown Italian
Venice, 1650-1700

Amnon and Tamar
Oil on canvas, 50½ x 55 inches (128.3 x 139.8 cm.)

Gift of Mrs. Thomas P. Hinman, in commemoration of the establishment of the High Museum School of Art by Dr. Thomas P. Hinman in April 1929, 1940.1.

Provenance: Private collection, New Jersey; Hal Beach of Albert du Vannes, New York.

The subject of this painting is taken from II Samuel 13:1-17. Amnon, one of the sons of King David, desired Tamar (his half-sister and also the sister of Absalom). He drew her to his chamber by pretending to be ill, and when she brought him special foods, he raped her. His desire turned to hatred and he had her dismissed by a servant. Absalom avenged his sister by killing Amnon. Although not popular, the subject had a sixteenth century iconographic tradition, evident in prints like one by Hans Sebald Beham as well as paintings such as a Flemish panel in the Walters Art Gallery, Baltimore (37.779), showing a naked man in bed attacking a woman bearing a tray of food.[1] The story was illustrated more often in the seventeenth century. Jan Steen's painting from the 1660s (now in the Wallraf-Richartz Museum, Cologne) probably reflects a popular play on the subject.[2] In Italy, the subject appeared as a pendant to other scenes of rape or abduction, most notably in Guercino's pairing of it with a depiction of the biblical story of Joseph and Potiphar's wife.[3]

When acquired by the High Museum, this painting bore an unlikely ascription to Luca Giordano. It is now generally thought that the work's deep colors and its focus on the two large figures mark it as a product of seventeenth century Venice. Although several possibilities have been put forward, none is entirely convincing. Egidio Martini (in a letter of July 4, 1981) declared it a fine work by Antonio Molinari (1655-1704): the figure of Tamar is quite close in pose and type to the chief female figure in that painter's *Battle of the Lapiths and Centaurs* (ca. 1698, now in the Museo Correr, Venice).[4] Other Venetian

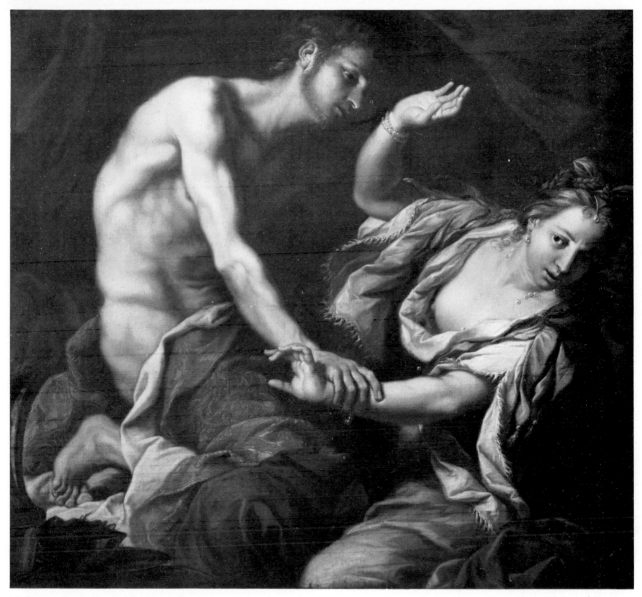

Unknown Italian, *Amnon and Tamar*

artists whose styles bear a passing resemblance to this work are Antonio Zanchi, who painted an *Amnon and Tamar* as a pendant to a *Rape of Helen* and whose painting of *Pluto and Proserpina* in Padua shows a nude man very similar to the High Museum's Amnon,[5] and Paolo Pagani, whose *Amnon and Tamar* is in the Museum of Braunschweig. Robert Simon (in conversation) has pointed out similarities to the work of the Paduan painter Luca Ferrari (1605-1654), especially to figures in his *Noli me Tangere* (Cavalieri Collection, Bologna) and *Queen Tomira with the Head of Cyrus* in Modena.[6] Homan Potterton (in conversation) has rejected the Molinari attribution, and Rodolfo Pallucchini (in a letter of July 4, 1982), while noting the similarity to Pagani and Molinari, is not convinced by either attribution and

prefers to call the work, for the time being, simply "Venetian Seicento."

[1]See A. Pigler, *Barockthemen*, Budapest, 1956, I, p. 154.
[2]See Baruch D. Kirschenbaum, *The Religious and Historical Paintings of Jan Steen*, New York, 1977, p. 117.
[3]See the example in Peter Tomory, *Catalogue of the Italian Paintings before 1800, The John and Mable Ringling Museum of Art*, Sarasota, 1976, p. 171, no. 192.
[4]See Carlo Doncelli and G. M. Pilo, *I Pitturi del Seicento Veneto*, Florence, 1967, pl. 317.
[5]See Alberto Riccoboni, "Antonio Zanchi," *Saggi e Memoria*, 5, 1966, figs. 85, 88.
[6]See Francesco Arcangeli, *Maestra della pittura del Seicento Emiliano*, Bologna, 1959, pp. 136-137, and Pier Luigi Fantelli, "Il Punto su Luca Ferrari," *Arte Veneta*, XXXII, 1978, pp. 313-318.

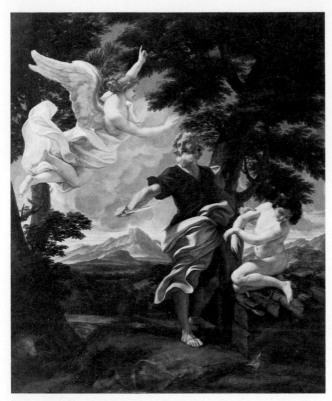

Giovanni Battista Gaulli, called Baciccio, *The Thanksgiving of Noah* (color plate, page 20)

Giovanni Battista Gaulli, called Baciccio
Genoa, 1639-1709, Rome

The Thanksgiving of Noah, ca. 1685-90
Oil on canvas, 64½ x 51¼ inches (163.8 x 130.2 cm.)

Abraham's Sacrifice of Isaac, ca. 1685-90
Oil on canvas, 63¼ x 51⅝ inches (161.3 x 131.2 cm.)

Gifts of the Samuel H. Kress Foundation, 1958.30 and 1958.31.

Provenance: Count Allessandro Contini Bonacossi, Florence; Samuel H. Kress Foundation, 1950.

Exhibitions: *Kress Collection*, Philadelphia Museum of Art, 1950-53, no. 15 (1958.31 only); *Genoese Masters*, Dayton Art Institute, Ringling Museum of Art, Sarasota, Wadsworth Atheneum, Hartford, Oct.-May 1963, no. 34 (1958.31 only); *Art in Italy, 1600-1700*, The Detroit Institute of Arts, April 6-May 9, 1965, no. 51 (1958.31 only); *Paintings, Bozzetti and Drawings by Giovanni Battista Gaulli*, Allen Memorial Art Museum, Oberlin College, Oberlin, Ohio, Jan. 16-Feb. 13, 1967, nos. 16, 17.

Bibliography: William E. Suida, "The Samuel H. Kress Collection," *Philadelphia Museum Bulletin*, XLVI, no. 227, Autumn 1950, p. 18; Robert Enggass, "Three Little Known Paintings," *Paragone*, 73, 1956, pp. 30-35, figs. 28, 30, 31; M. V. Brugnoli, "Inediti del Gaulli," *Paragone*, 81, 1956, pp. 26-27; *Kress Collection*, Atlanta, 1958, pp. 62-65; George Ferguson, *Signs and Symbols in Christian Art*, New York, 1961, pl. VI; Robert Enggass, *The Painting of Baciccio*, Pennsylvania State University Press, University Park, 1964, p. 121, figs. 126, 127; R. Enggass, "Addenda to Baciccio, I," *Burlington Magazine*, CVI, 1964, pp. 76-79, figs. 35, 36; Denis Mahon, "Stock-taking in Seicento Studies," *Apollo*, LXXXII, 1965, pp. 388-389, fig. 14; Ralph T. Coe, "Rubens in 1614: The Sacrifice of Abraham," *The Nelson Gallery and Atkins Museum Bulletin*, IV, Dec. 1966, pp. 20-21, no. 7, fig. 18; Brugnoli, *Il Baciccio–I Maestri del Colore*, Milan, 1966, no. 214; H. Lester Cooke, "An Exhibition of Paintings, Bozzetti and Drawings by Giovanni Battista Gaulli, called Il Baciccio," *Allen Memorial Art Museum Bulletin*, XXIV, No. 2, Jan.-Feb. 1967, pp. 85-86, nos. 16, 17; Stephen E. Ostrow, "Some Italian Drawings for Known Works," *MUSE, Annual of the Museum of Art and Archaeology*, University of Missouri, Columbia, no. 1, 1967, pp. 30-31; Hugh Macandrew and Dieter Graf, "Baciccio's Later Drawings: A Rediscovered Group Acquired by the Ashmolean Museum," *Master Drawings*, Autumn 1972, pp. 233, 241, 242; Shapley, III, 1973, p. 94, figs. 168-169; Dieter Graf, "Two Paintings by Giovanni Battista Gaulli, called Il Baciccio, and Some Related Drawings," *Burlington Magazine*, 824, Nov. 1974, p. 653; *Selected Works*, Atlanta, 1981, pp. 14-15.

In Genoa, Baciccio was a pupil of Luciano Borzone. He would have been familiar with the Genoese works of Rubens and van Dyck, but according to early biographers what most impressed him was the frescoes of Perino del Vaga in the Palazzo Doria del Principe. In the late 1650s, he went to Rome to study the work of Raphael. There he became the friend of Gian Lorenzo Bernini, whose influential patrons were soon commissioning both portraits and fresco decorations from the younger artist.

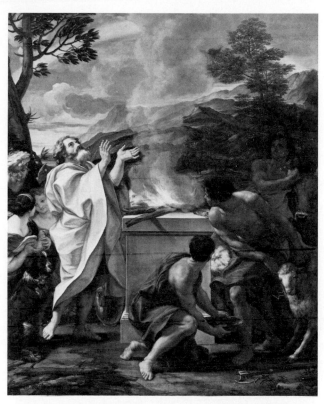

Giovanni Battista Gaulli, called Baciccio, *Abraham's Sacrifice of Isaac* (color plate, page 21)

In 1662 Baciccio was accepted into the Accadèmia di San Luca and was at work on his first public commission, an altarpiece in San Rocco, Rome, which depicted the Madonna and Child with St. Roch and St. Anthony Abbot. He took his figural movement from the sculptures of Bernini and his bright colors and illusionistic effects from the work of Pietro da Cortona. His *Pietà* of 1667, for the Chigis, the family of the reigning pope, displayed a fully developed Baroque style with highly controlled brushwork, intricate detail, and a light palette of cool colors.

Bernini recommended Baciccio for the fresco pendentive paintings of the Sant'Agnese in the Piazza Navona. Baciccio had never attempted the fresco technique or worked on such a large project, so to prepare for the task, he journeyed to Parma (and possibly Modena) to view frescoes by Correggio. Baciccio's pendentives, allegories of the Virtues, were a theatrical spectacle which led to his greatest achievement: in 1672, he was asked to paint the frescoes for the dome and vaults of Il Gesù, the Mother Church of the Jesuits in Rome. His plan for the dome depicting the *Triumph of the Name of Jesus* combined painting, plaster work, and sculpture. The completed decoration was dedicated on the last day of 1679.

With the decline of Roman patronage at the turn of the century, Baciccio received fewer major commissions and concentrated on portraiture and altarpieces painted in a delicate proto-rococo style.

His last major work was the enormous vault fresco *Christ in Glory Receiving Franciscan Saints* for Santi Apostoli in Rome.

The High Museum's two large companion paintings from Baciccio's mature Roman period of 1685-90 were probably painted for altars. Both deal with Old Testament stories of sacrifice that were regarded as prefiguring Christ's death and resurrection—Abraham's attempted sacrifice of Isaac (Genesis 22:8-13) and the Thanksgiving of Noah (Genesis 8:20). The monumental figures of Abraham and Noah clearly reflect the influence of the over-life-size sculptures of Bernini, notably his *St. Longinus* of 1629-38. Baciccio used similar figures in a number of other works—for example, Noah is very like Zacharias in his *Birth of St. John the Baptist* (Santa Maria in Campitelli, Rome). Other treatments of the Noah scene include one in the Palazzo Bianco, Genoa, which is in a horizontal format, and another, formerly in the Gasparrini Collection, Rome (sold at Sotheby's, London, November 17, 1982, along with its pendant, *The Worship of the Golden Calf*), which is vertical, but narrower and less well painted than the High Museum's.

A number of preliminary drawings for these compositions have also been identified. There are studies for Abraham, Noah, and the youth holding the ox in the Kunstmuseum, Düsseldorf. A drawing of the turbaned figure is at the University of Missouri, and other studies are in the Ashmolean Museum, Oxford.

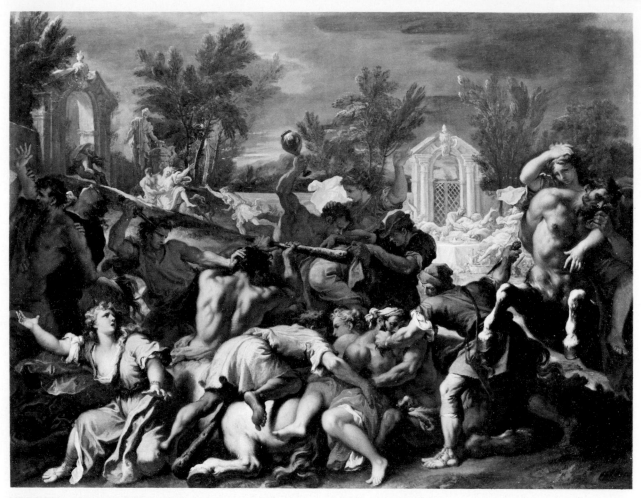

Sebastiano Ricci, *The Battle of the Lapiths and Centaurs* (color plate, page 22)

Sebastiano Ricci
Belluno, 1659-1734, Venice

The Battle of the Lapiths and Centaurs, ca. 1705
Oil on canvas, 54½ x 69⅝ inches (138.5 x 176.9 cm.)

Gift of the Samuel H. Kress Foundation, 1958.55.

Provenance: Sir Richard Colthurst, Bart., Blarney Castle, Cork, Ireland; David M. Koetser, New York; Samuel H. Kress Collection, 1953.

Exhibitions: *Art Treasures for America*, National Gallery of Art, Washington, D.C., Dec. 10-Feb. 4, 1962, no. 78; *Man: Glory, Jest and Riddle*, California Palace of the Legion of Honor, San Francisco, Nov. 10, 1964-Jan. 3, 1965, no. 216; *Sebastiano Ricci and Marco Ricci in America*, Brooks Memorial Art Gallery, Memphis, and the University of Kentucky Art Gallery, Lexington, Dec. 19, 1965-March 6, 1966, no. 14.

Bibliography: Bertina Suida Manning, *Paintings from the Collection of Walter P. Chrysler, Jr.*, Portland, 1956, p. 34; *Kress Collection*, Atlanta, 1958, p. 53; *Masterpieces*, Atlanta, 1965, p. 26; G. M. Pilo, "Sebastiano and Marco Ricci in America," *Arte Veneta*, XX, 1966, p. 305; Fredericksen and Zeri, 1972, pp. 174, 554; Shapley, III, 1973, p. 128, fig. 254; Jeffery Daniels, *Sebastiano Ricci*, Hove, Sussex, 1976, pp. 1-2, no. 5, fig. 4.

As a youth in Venice, Ricci studied with Federico Cervelli and possibly Sebastiano Mazzoni. By 1682 he was in Bologna, where he may have been a pupil of Giovanni Gioseffo dal Sole. From there he moved to Parma, where the Count of San Secondo employed him for the decorations of the Oratory of the Madonna del Serraglio, completed in 1687, in collaboration with Ferdinando Bibiena. The Duke of Parma, Ranuccio II Farnese, favored Ricci's work and granted him several commissions. The Duke also financed Ricci's sojourn in Rome from 1691 to 1694, housing him in the Farnese Palace. While in Rome Ricci worked for Pope Innocent XII at the Lateran Palace, frescoed a ceiling with an *Allegory of the Battle of Lepanto* for the Colonna family palace, an *Ascension of Christ* at Santi Apostoli, and collaborated again with Bibiena on scenery for two operas for the Carnival of 1694. After Ranuccio's death in that year, Ricci settled in Milan for perhaps four years, where he painted frescoes for the dome and pendentives of San Bernardino.

Ricci returned to Venice at the beginning of the eighteenth century and helped revitalize Venetian art by adopting Paolo Veronese's luminous, richly colored style and making it looser and more spontaneous. His canvases for San Marziale (ca. 1702-04) anticipate the

fluidity and elegance of the Rococo style; this tendency was developed further in his delicate decorations for a room in the Palazzo Pitti in Florence, executed in 1707-08. His later works, charming, sentimental, lightly brushed paintings, were a major influence on Tiepolo.

After 1708 Ricci frequently collaborated with his nephew Marco, who specialized in landscapes. From 1712 to 1716 Ricci worked in England; among his commissions there were a series of decorative panels for the original staircase at Burlington House and the ceiling for the palace of the Lord of Portland. Following a brief visit to Paris, he was made a member of the Académie Royale in 1718.

Ricci spent most of the rest of his life in Venice, employed by noble patrons throughout Italy. At his death, he was working on the *Assumption of the Virgin* commissioned by Emperor Charles VI for the Karlskirche in Vienna.

As Jeffery Daniels has pointed out, the strong influence of Luca Giordano in the High Museum's painting and the comparable *Rape of the Sabines* in the Palazzo-Barbaro Curtis (Venice) argues for an early dating, probably around 1705. A similar, but more freely painted depiction of the Battle of the Lapiths and Centaurs in the Rasini Collection (Milan) is dated by Daniels ca. 1710.[1]

The subject of these paintings is taken from Ovid's *Metamorphoses* XII. Pirithous, King of the Lapiths, invited most of the gods, heroes such as Theseus, and his neighbors, the Centaurs, to his wedding with Hippodamia. Spurred on by Mars, the only god who had not been invited, the centaur Eurythion drunkenly attempted to carry off the bride. A furious melée ensued, in which Pirithous and the other Lapiths defeated the Centaurs with the help of Theseus and Hercules. Ricci has treated the story with great verve, giving the intertwined figures a solid sculptural presence. The brilliant, fluidly painted landscape backdrop, where we see Theseus in pursuit of Eurythion and Hippodamia, contrasts with the violent action of the foreground.

[1]Daniels, 1976, p. 74. See also Egidio Martini, *La Pittura Veneziana del Settecento*, Venice, 1964, pl. 25.

Paolo de Matteis
Piano del Cilento, 1662-1728, Naples

St. Nicholas of Bari Felling a Tree Inhabited by Demons, ca. 1727
Oil on canvas, 34½ x 54⅝ inches (87.6 x 139.7 cm.)

Purchase with funds from the Fay and Barrett Howell Fund, 1982.21.

Provenance: Frederick Mont, New York; Newhouse Galleries, New York.

Born near Naples, de Matteis studied with the preeminent painter of that city, Luca Giordano. He moved to Rome in the early 1680s, and is recorded as having worked there with Giovanni Maria Morandi, a follower of Marrata. De Matteis enjoyed the patronage of the Spanish Ambassador to Rome, the Marchese del Carpio, and this arrangement continued even after de Matteis's return to Naples, where he was again associated with Giordano.

De Matteis developed an individual style combining elements of the exuberant Neapolitan baroque with the classicism he had learned in Rome. According to his biographer de Dominici, de Matteis was in Paris between 1702 and 1705 and received the patronage of both the Duc d'Estrées and the Dauphin.[1] Eventually his fame was such that he had important patrons all over Europe, including Pope Benedict XIII (for whom he returned to Rome), Count Daun, the Austrian Viceroy in Naples, Admiral Byng, Commander of the British Navy, Prince Eugene of Savoy, and Lord Shaftesbury (for whom he executed a notable series of arcadian mythological paintings).[2] De Matteis was known for the virtuosity of his paint handling, and he was said to have been even faster than his mentor "Fra Presto" Giordano.

St. Nicholas, a fourth century Bishop of Myra whose remains had been taken from Asia Minor to Bari in 1084, was one of the most popular saints in Europe. As the patron saint of sailors, he was especially beloved in port cities such as Naples.[3] The incident depicted here, showing the saint driving out a demon, is one of many miracles originally attributed to another St. Nicholas, a sixth century abbot of the monastery of Sion and the Bishop of Pincra near Myra.[4] This story was conflated with other tales in making the legendary character of Saint Nicholas—ultimately, Santa Claus. A Greek account describes the action in de Matteis's painting. A sacred tree (sometimes identified as a cypress) in the village of Plakoma was inhabited by a demon which terrorized the region and killed those who attempted to cut the tree down. The villagers begged the saint to help them. The saint approached the tree with a crowd and told the men to chop it down. When no one dared, he took the axe himself.

> When he was about to fell this sacred tree, the servant of God said, "Assemble up the slope on the North side." For it was expected that the tree would fall to the West. The unclean spirit thought at that moment to frighten the crowd.

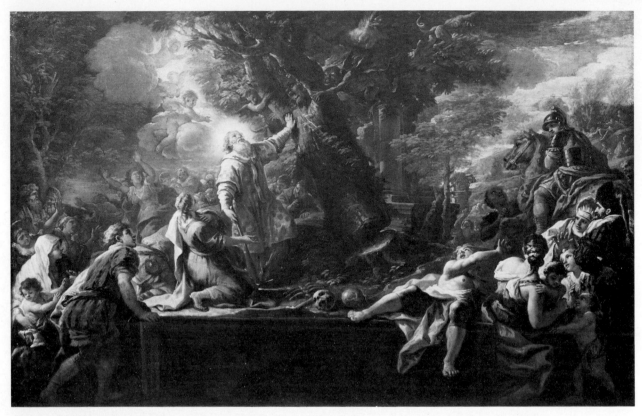

Paolo de Matteis, *St. Nicholas of Bari Felling a Tree Inhabited by Demons* (color plate, page 22)

And he made the tree lean toward the North where the crowd stood watching, so that they all screamed with fear, saying with one voice: "Servant of God, the tree is coming down on top of us, and we will perish." The servant of God Nicholas made the sign of the cross over the tree, pushed it back with his two hands, and said to the sacred tree: "In the name of Jesus Christ I command you: turn back [in the other direction] and go down where God has ordained you." Forthwith, the tree swayed by the will of God and moved toward the West, where it crashed. From that time on, the unclean spirit was no longer seen within those parts.[5]

In the post-Byzantine East, the story was often illustrated in Russian icons and the frescoes of sixteenth century Rumanian and Yugoslavian churches.[6] However, the full Greek account of the saint's life was not translated into Latin or Italian until much later, and the brief references to it in texts such as *The Golden Legend*, where the tree is described as sacred to the goddess Diana (Artemis), are not very complete.[7] Representations of the subject are scarce in Western art.[8]

De Matteis received many commissions from churches in and around Naples, and Erich Schleier (in a letter of March 12, 1984) suggests that this painting is a finished study for a large composition, possibly intended for the choir of San Nicola alla Carità, Naples, where there is a painting by de Matteis of *The Death of St. Nicholas*.[9] The High Museum's exuberant painting, as Mina Gregori has written (in a letter of December 30, 1981), is stylistically similar to works of 1727-28 in San Paolo d'Argon, Bergamo.[10]

[1]Bernardo de Dominici, *Vite dei pittori, scultori e architetti napoletani*, Naples, 1846 ed., IV, pp. 313-358.
[2]See Vega de Martini, "Introduzione allo Studio di Paolo de Matteis," *Napoli Nobilissima*, XIV, 4, 1975, pp. 221-222.
[3]See Louis Réau, *Iconographie de l'Art Chrétien*, Paris, 1958, III, pp. 980-988; and Giovanni Fallini, "Iconographia di S. Nicola nella Pittura italiana," *Fede e arte*, 5, 1957, pp. 166-174.
[4]See Nancy P. Sevcenko, *The Life of Saint Nicholas in Byzantine Art*, Turin, 1983, pp. 91-94.
[5]Translation supplied by Professor Sevcenko; to be published in 1986 by Hellenic College, Brookline, Mass.
[6]Sevcenko, 1983, pp. 91-94, pls. 185-187.
[7]See *The Golden Legend or Lives of the Saints as Englished by William Caxton*, London, 1900, p. 113.
[8]Earlier examples in Italian art include the altar at the Chiesa Madre in Milazzo (see George Kaftal, *Iconography of the Saints in Central and South Italian Schools of Painting*, Florence, 1965, c. 807, fig. 950); a predella by Piero di Cosimo in St. Louis (see Kaftal, *Iconography of the Saints in Tuscan Painting*, Florence, 1952, c. 760, fig. 851); and the silver relief of 1686 in the altar of the Basilica de S. Nicola in Bari (see Francesco Carabellese, *Bari*, Bergamo, 1909, p. 129, and *S. Nicola-l'Altare d'Argento*, Bari, n.d., Grafico Laterza, pp. 16-17).
[9]See L. V. Bertavelli, *Napoli e Dintorni*, Milan, 1938, p. 126.
[10]Lucia Dreoni, "Paolo de Matteis e altri pittori a San Paolo d'Argon," *Paragone*, 355, Sept. 1979, pp. 70-86.

Jacopo Amigoni, *Portrait of a Man*

Jacopo Amigoni
Naples, 1675-1752, Madrid

Portrait of a Man, ca. 1720-30
Oil on canvas, 36½ x 29½ inches (92.7 x 74.9 cm.)

Gift of the Samuel H. Kress Foundation, 1958.29.

Provenance: Contini Bonacossi, Florence; Samuel H. Kress Foundation, 1941.

Exhibitions: *Kress Collection*, Seattle Art Museum, 1952-54, no. 24; *Circle of Canaletto*, Allentown Art Museum, Allentown, Pennsylvania, Feb. 19-March 21, 1971.

Bibliography: *Kress Collection*, Atlanta, 1958, p. 57; Fredericksen and Zeri, 1972, pp. 6, 553; Shapley, III, 1973, p. 135, fig. 266.

Although born in Naples, Amigoni is regarded as a Venetian painter, having settled in Venice by 1711. His Neapolitan background, however, provided a foundation in the fluid styles of Solimena and Luca Giordano. Like several of his Venetian colleagues, he was a painter for all of Europe, able to work successfully in a variety of pleasing styles. Amigoni began his travels in 1719 in Bavaria, where he remained until 1728, painting ceiling frescoes at the Nymphenburg for the Elector Maximilian Emmanuel and engaged in decorative projects for other palaces. After a brief return to Italy, Amigoni was off again,

arriving in England in 1729 by way of Germany and Holland. The British taste for grandiose decoration was diminishing, so the painter turned to portraiture. In 1736 Amigoni was briefly in Paris, and the French rococo style combined with the influence of Sebastiano Ricci lent ever greater brilliance to his work after his return to Venice in 1739. There he painted church altars as well as easel pictures of biblical and mythological subjects. In 1747 Amigoni went to Spain, where he spent the remainder of his life as court painter to Ferdinand VI and director of the Royal Academy of San Fernando.

When acquired by the Kress Foundation, this unidentified portrait was attributed to Pietro Longhi, but Suida in 1952 assigned it to Amigoni.[1] The effete quality of the sitter suggested to Suida that it might be one of the famous singers of the time—especially since Amigoni was friendly with and several times portrayed the outstanding castrato Farinelli.[2] A drawing of a man by Amigoni in the Stanford University Museum of Art (70.142) shows a very similar elegant bewigged gentleman.

[1] W. E. Suida in exhibition catalogue *Kress Collection*, Seattle Art Museum, 1952.
[2] See the exhibition catalogue *Le Portrait en Italie au Siècle de Tiepolo*, Musée de Petit Palais, Paris, 1982, no. 22.

65

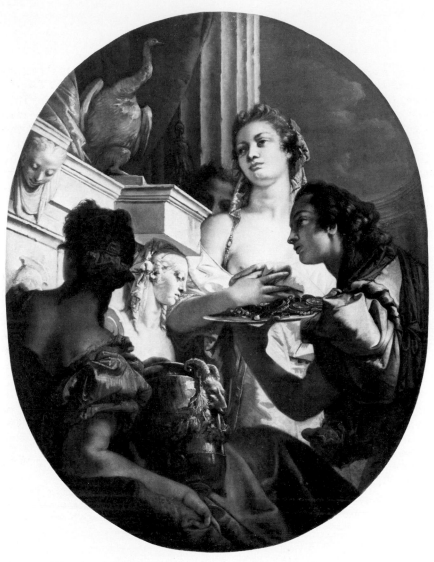

Giovanni Battista Tiepolo, *Vestals Making Offerings to Juno*
(color plate, page 23, and cover)

Giovanni Battista Tiepolo
Venice, 1696-1770, Madrid

Vestals Making Offerings to Juno, ca. 1745-50
Oil on canvas, 56⅞ x 44⅜ inches (144.5 x 112.7 cm.)

Gift of Samuel H. Kress, 1932.6.

Provenance: Palazzo Barbaro at San Vitale, Venice, until 1874; Sold and taken to Austria; Max Thedy, Weimar; Sold ca. 1900 to an American collector, probably Charles F. Dieterich, New York; Sale, Anderson Galleries, New York, April 8-9, 1920, no. 108; Dr. Muller; Count A. Contini Bonacossi, Florence; Samuel H. Kress, 1931.

Exhibitions: *Art Treasures for America*, National Gallery of Art, Washington, D.C., Dec. 10, 1961-Feb. 4, 1962, no. 92; *Art of Italy*, Miami Art Center, Inc., Oct. 23-Nov. 30, 1969; *The Tiepolos: Painters to Princes and Prelates*, Birmingham Museum of Art, Alabama, Jan. 8-Feb. 19, 1978, no. 15.

Bibliography: Alexandre de Vesme, *Le Peintre-Graveur italien, oeuvre faisant suite au peintre-graveur de Bartsch*, 1906, p. 421, no. 89; P. Molmenti, *G. B. Tiepolo*, Milan, 1909, pp. 268, 271, 276; Eduard Sack, *Giovanni Battista und Domenico Tiepolo*, Hamburg, 1910, pp. 150, 227, 336; *Paintings, Drawings, and Prints by the Two Tiepolos*, Art Institute of Chicago, 1938, p. 26, under no. 23; Antonio Morassi, *Tiepolo*, Bergamo, 1943, pp. 26, 46, fig. 68; Rodolfo Pallucchini, "La Mostra del bicentenario della Accademia Veneziana dei Belle Arti: Il Settecento," *Arte Veneta*, IV, 1950, p. 171; Giulio Lorenzetti, *Mostra del Tiepolo*, Venice, 1951, p. 87, no. 63; Umberto Pini, "Ancora Sulla Mostra Del 700 Veneziano," *Orrizonti Italiani*, Nov. 1955, p. 45; *Kress Collection*, Atlanta, 1958, pp. 58ff.; Antonio Morassi, *A Complete Catalogue of the Paintings of G. B. Tiepolo*, London, 1962, pp. 2, 44; Anna Pallucchini, *L'Opera completa di Giambattista Tiepolo*, Milan, 1968, p. 114, under no. 190B; Fredericksen and Zeri, 1972, pp. 195, 553; Shapley, III, 1973, pp. 145f., fig. 280.

The son of a Venetian trader, Tiepolo received his first training from the painter Lazzarini, but his earliest works, dated 1715-16, owe a debt to the dark, dramatic manner of Piazzetta. Then, through the influence of Sebastiano Ricci (who had returned to Venice in 1717) as well as the works of Veronese, Tiepolo began to lighten his palette. He eliminated the strong contrasts of light and shadow, and by the mid-1720s he had developed a brilliant, fresh style of his own, perfectly suited to the large fresco decorations which he was painting in Venice and throughout northern Italy. Beginning with *The Apotheosis of St. Theresa* in the Church of the Scalzi, he worked in Udine, Milan, Bergamo, and Padua. He returned to Venice to execute the ceiling of the Church of the Gesuati between 1737 and 1739.

In 1740 his ceiling decoration for the Palazzo Clerici in Milan established the format he would employ in later works in Germany and Spain: the figures were grouped at the outer edges, leaving the center space open for spectacular light effects.

In 1750, Tiepolo's international reknown led the Prince Bishop Carl Philipp von Grieffenklau to summon the artist and his sons, Domenico and Lorenzo, to Würzburg to embellish the Episcopal Palace. The ceiling frescoes, completed in 1753, with their multitude of graceful figures hovering against an expanse of blue sky and billowing clouds, perfectly complemented the architectural design of Balthasar Neumann, creating one of the consummate examples of rococo art.

From 1761 to 1762 Tiepolo worked on an *Apotheosis of the Pisani* for the Pisani family villa at Stra. This work had to be finished quickly when Charles III of Spain summoned him to decorate the Royal Palace at Madrid. Tiepolo devoted the remainder of his life to the painting of the royal palaces in Madrid and Aranjuez.

One of Tiepolo's many decorative projects in the Veneto was for the Palazzo Barbaro at San Vitale, about 1745-50. The scheme he devised had a central ceiling section depicting the *Glorification of Francesco Barbaro* (1398-1454), a distinguished soldier and writer. This is now in the Metropolitan Museum of Art in New York. Surrounding it were four large oval overdoor canvases on classical themes which, as Federico Zeri has observed, are linked in that they all relate to marriage—about which Francesco Barbaro had written a treatise entitled *De re Uxoria*.[1] The subjects of these oval works (now dispersed) are: *Betrothal* (Royal Museum of Fine Arts, Copenhagen), *Timocleia and the Thracian Commander* (Kress Collection, National Gallery of Art, Washington, D.C.), *Tarquin and Lucretia*, and *Vestals Making Offerings to Juno*. The last two compositions are both known in more than one version, and

there is continuing debate as to which are the original Barbaro panels and which are replicas by Tiepolo and/or his workshop. The best version of the *Tarquin and Lucretia* is in Augsburg. The Juno canvases include the one at the High Museum and one formerly in the Necchi Collection (Pavia), which is signed.[2] Both of these subjects were also etched by the artist's son Domenico in 1775,[3] and two drawings in Stuttgart are most likely his preparatory studies for the etchings.[4]

The most convincing argument for the authenticity of the High Museum's painting, as Pallucchini has pointed out, is the high quality of its execution, which indicates that it is by the master himself.

The subject of this painting has also been a source of debate. It has sometimes been identified as Cleopatra receiving gifts from Marc Antony. The present identification—as an offering to the Roman goddess Juno, sister and wife of Jupiter and protectress of marriage—seems justified by the prominent presence of her attribute, the peacock, at what is probably the base of her statue.

[1]Federico Zeri and Elizabeth Gardner, *Italian Painting . . . Metropolitan Museum . . . Venetian School*, New York, 1973, p. 56.
[2]Reproduced in Morassi, 1962, pl. 288.
[3]See Aldo Rizzi, *The Etchings of the Tiepolos*, London, 1971, pp. 20, 235, no. 104.
[4]See G. Knox and C. Thiem in the exhibition catalogue *Zeichnungen von Giambattista, Domenico, und Lorenzo Tiepolo*, Staatsgalerie, Stuttgart, 1970, nos. 66, 67.

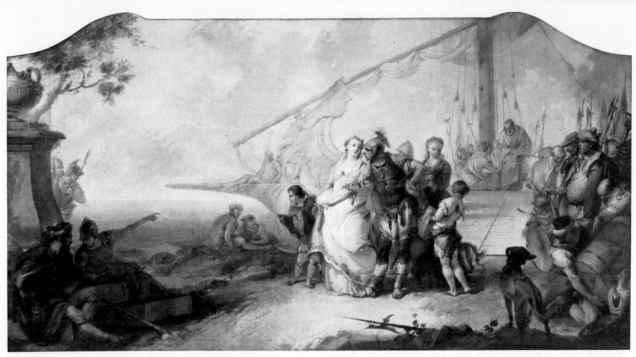

Francesco Zugno, *The Debarkation of Antony and Cleopatra*

Francesco Zugno
Venice, 1709-1787

The Debarkation of Antony and Cleopatra
Oil on canvas, 63¾ x 111¼ inches (162 x 282.6 cm.)

Gift of a Friend, 1950.33.

Provenance: Brummer Gallery Inc., New York, 1936; Private collection, New York.

Exhibitions: *Venetian Painting of the Eighteenth Century*, The City Art Museum of St. Louis, March 1-31, 1936, no. 44 (as Giovanni Domenico Tiepolo); Nelson Gallery of Art, Kansas City, 1937; *Paintings, Drawings, and Prints by the Two Tiepolos*, The Art Institute of Chicago, Feb. 4-March 6, 1938, no. 42; *Baroque Paintings of the Sixteenth to Eighteenth Centuries*, Norton Gallery and School of Art, Florida, Feb. 1949, no. 25; *Paintings and Sculpture: Gothic to Surrealism*, High Museum of Art, Atlanta, Jan. 8-Feb. 5, 1950, no. 15.

Bibliography: Giuseppe Fiocco, "Aggiunte di F. M. Tassis," *Rivista della Citta di Venezia*, April 1927, p. 7, fig. 3; *Bulletin of the City Art Museum of St. Louis*, March 1936, XXI, 2, p. 33, ill. p. 46; R. Pallucchini, *La Pittura Veneziana del Settecento*, Bologna, 1952, II, p. 26; Giuseppe Maria Pilo, "Francesco Zugno," *Saggi e Memorie*, 2, 1959, pp. 343, 344, 363, no. 31, fig. 34; Antonio Morassi, *A Complete Catalogue of the Paintings of G. B. Tiepolo*, Greenwich, 1962, p. 2; Giuseppe Maria Pilo, "Sui Margini Tiepoleschi Inediti di Francesco Zugno," *Studi di Storia dell'Arte in Onore di Antonio Morassi*, Venice, 1971, p. 337; Fredericksen and Zeri, 1972, pp. 214, 554.

A Venetian painter in the manner of Tiepolo, Zugno received many commissions from churches in the city, including a decorative scheme for the church of Saints Peter and Paul in 1742. In 1754, while the Tiepolos were engaged in the decoration of the main floor of the Villa Soderini-Berti at Nerveso near Treviso, Zugno frescoed one of the upstairs rooms with stories of Cleopatra. She had already appeared in his 1750 painting, the *Death of Cleopatra*, and the meeting of Antony and Cleopatra was to furnish the subject for several large paintings. The most impressive of these works (in the Gemäldegalerie, Wiesbaden) depicts small figures in a vast port scene which looks like a grandiose stage set.[1] The High Museum's painting gives more prominence to the elegant figures. Zugno's sweet rococo style combines elements from Tiepolo and Veronese. The large composition is held together by the diagonals of the soldier's outstretched arm and the mast of the ship. The balletic movements of the richly dressed figures are set against a brilliant sky. In its style and grandeur this work is comparable to Zugno's *Iphigenia Led to the Temple* (now in Staatsgalerie, Augsburg),[2] while its tinge of melancholy recalls his *Finding of Moses* (private collection, Milan).[3]

[1]Pilo, 1959, p. 344.
[2]Ibid., p. 346.
[3]Pilo, 1971, p. 336.

Francesco Zugno, *The Milliner*

Follower of Francesco Guardi, *Masqueraders at Florian's Café, Venice*

Francesco Zugno
Venice, 1709-1787

The Milliner, ca. 1745
Oil on canvas, 25½ x 20½ inches (64.8 x 52.1 cm.)

Gift of Dr. Wadley Raoul Glenn and Wilbur Fiske Glenn in memory of Agnes Raoul Glenn, 1946.2.

Provenance: E. & A. Silberman Galleries, New York.

Bibliography: *Pictures on Exhibit*, New York, Nov. 1945, p. 25; Giuseppe Maria Pilo, "Sui Margini Tiepoleschi: Inediti di Francesco Zugno," *Studi di Storia dell'Arte in Onore di Antonio Morassi*, Venice, 1971, p. 338, fig. 26.

In addition to his large-scale decorative schemes of religious and secular subjects, Zugno also painted portraits and smaller genre subjects. The latter category includes two representations of a *Flute Player*, one from the Kress Study Collection (Trinity College, Hartford, Conn.)[1] and the other in Trieste,[2] as well as *A Woman Sewing* (in a private collection, Venice).[3] Venturi attributed this painting to Allessandro Longhi (opinion of January 3, 1944, in Museum files). Both Morassi (in a letter of February 14, 1952) and R. Pallucchini (in a letter of May 30, 1952) have identified it as a work by Zugno, and it was published as such by Pilo.

[1]Shapley, III, 1973, pp. 156-157, fig. 293.
[2]Museo Civico Sartorio (Alinari photo 40177).
[3]See Egidio Martini, *La Pittura Veneziana del Settecento*, Venice, 1964, fig. 251.

Follower of Francesco Guardi
Venice, 18th century

Masqueraders at Florian's Café, Venice
Oil on canvas, 12 x 15½ inches (30.5 x 39.4 cm.)

Purchase, 1954.3.

Provenance: Victor Spark, New York.

Bibliography: Antonio Morassi, *Guardi, Antonio e Francesco Guardi*, Venice, ca. 1973, I, p. 351, no. 231; II, fig. 267.

Francesco Guardi (1712-1793) collaborated with his brother Antonio (d. 1760) and was influenced by the leading Venetian painters—Tiepolo (who was his brother-in-law), Canaletto, and Ricci. He is best known for his landscapes with ruins and views of Venice, but he also painted religious and genre subjects. In the latter category are a number of carnival scenes with masqueraders. Morassi points out that a depiction of *Il Ridotto* in the Ca' Rezzonico has masked figures with poses and costumes similar to these, and while he attributes the High Museum's painting to Guardi, he does so with the caveat that he has not seen the original. In fact, this painting lacks the brilliance and refinement of the Ca' Rezzonico work and other examples by Guardi, and is most likely by an imitator. It is nevertheless a charming memento of eighteenth century Venice. The setting is the famous Café Florian located in the Portico delle Procuratie Nuove, near the entrance to what is now the Museo Correr.

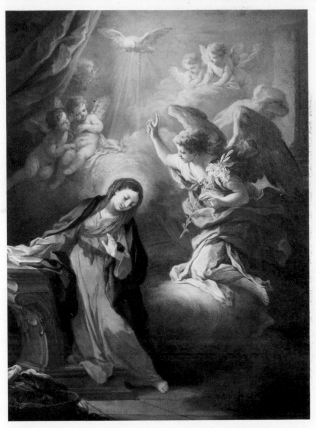

Sebastiano Conca, *The Annunciation* (color plate, page 19)

Sebastiano Conca
Gaëta, 1680-1764, Naples

The Annunciation, 1748
Oil on canvas, 37½ x 28½ inches (95.3 x 72 cm.)
Signed and dated: *Eques seb Conca fecit 1748*

Purchase with the Fay and Barrett Howell Fund, 1984.51.

Provenance: Victor Spark, New York; Sale, Christie's, New York, June 6, 1984, no. 186.

Exhibitions: *Portrait of the Madonna*, The Akron Art Institute, Dec. 1960, no. 9; *Neapolitan Masters of the Seventeenth and Eighteenth Centuries*, Finch College Museum of Art, New York, Oct. 31-Dec. 15, 1962, no. 42; *Christmas Exhibition*, IBM, New York, 1965; *Oil Sketches by Eighteenth Century Italian Artists from New York Collections*, Metropolitan Museum of Art, New York, 1971, no. 5; *Rome in the 18th Century*, University of Connecticut, Storrs, 1973, no. 38.

Bibliography: Anthony Morris Clark, "Agostino Masucci," *Essays in the History of Art presented to Rudolf Wittkower*, London, 1967, p. 263, pl. XXXVII, fig. 17; Giancarlo Sestieri, "Contributi a Sebastiano Conca," *Commentari*, June 1970, p. 89; *Conca*, exhibition catalogue, Gaëta, 1981, p. 302, pl. 109; A. M. Clark (ed. E. P. Bowron), *Studies in Roman Eighteenth Century Painting*, Washington, D.C., 1981, p. 96, fig. 16.

Of the Neapolitan artists who settled in Rome during the eighteenth century, Conca achieved the greatest prominence, becoming, as Anthony Clark wrote, "one of the most prolific, influential, and delightful European artists of the century."[1]

Born in the small town of Gaëta, Conca learned the essentials of his trade from the leading Neapolitan painter of the day, Francisco Solimena. Among his early commissions was the chapel of the now destroyed Montecassino Abbey. In 1707, accompanied by his brother Giovanni (also a painter), he went to Rome. He quickly absorbed the lessons of other painters there, including Passeri, Trevisani and Luti, and was especially responsive to the noble manner of Maratti. Conca remained in Rome for forty-five years, receiving many major commissions for church altarpieces and frescoes, such as one for Santa Clementa under the patronage of Clement XI. The great connoisseur Cardinal Pietro Ottoboni even gave Conca a studio in one of his palaces, and the painter produced many charming small works on copper for his patron.

Conca was especially favored by the Neapolitan-born Pope Benedict XIII. During Benedict's reign (1724-1730), Conca began his hold on the presidency of the Roman Academy, a post he held from 1729 to 1732 and again from 1739 to 1740. Conca also ran a private drawing academy which helped extend his influence. Among his outstanding pupils was Corrado Giaquinto. In 1731-32 Conca worked in Tuscany and painted the enormous fresco in the Ospedale, Siena. Back in Rome, he continued to receive commissions from all over Europe—including Germany, where his altarpieces were known and disliked by Mengs. In 1753, Conca returned to Naples and produced his late masterpiece, the ceiling decoration for the Church of St. Chiara (now destroyed).

This charming *Annunciation* shows Conca's warm bravura style at its best. It is a precisely signed and dated *modello* prepared for a competitive commission of 1748 for King John V of Portugal's chapel in San Roque, Lisbon. Conca lost the commission to another Roman painter, Agostino Masucci, whose *modello* is now in the Minneapolis Institute of Arts.[2] According to Clark, both paintings "derive from the *Annunciation* in Rome by Guido, and Lanfranco by way of a famous Maratti."[3] Ultimately, the composition and even Conca's brushy, Venetian treatment probably depend on a now-lost work by Titian.[4]

[1]Clark, 1981, p. 1.
[2]See *European Paintings from the Minneapolis Institute of Arts*, New York, 1971, pp. 462-463, no. 246.
[3]Clark, 1981, p. 97.
[4]Titian's *Annunciation* of 1537 painted for a church in Murano is recorded in an engraving by Caraglio. See Johannes Wilde, *Venetian Art from Bellini to Titian*, Oxford, 1974, pp. 160-161.

Pompeo Batoni
Lucca, 1708-1787, Rome

Portrait of Richard Aldworth Neville, later Second Baron Braybrooke
Oil on canvas, 36 x 28¾ inches (91.4 x 73 cm.)
Signed and dated at lower right: *P. BATONI PINXIT ROMAE ANNO 1773*; inscribed by a later hand: *L.*^D *BRAYBROOKE*

Gift of the Samuel H. Kress Foundation, 1958.32.

Provenance: Richard Neville, Billingbear and Butleigh Court, Glastonbury; Sale, Christie's, London, April 5, 1946, no. 37; Leger; Hon. Capt. F. C. C. Cavendish; Contini Bonacossi, Florence; Samuel H. Kress Foundation, 1950.

Exhibitions: Bristol Museum and Art Gallery, 1937-38; Philadelphia Museum, 1950-53.

Bibliography: R. Hassell, *A Series of Picturesque Views of Seats, 1823: A Catalogue of Portraits and Pictures at Butleigh Court . . . in the possession of Ralph Neville Grenville*, Tanton(?), 1865; J. Steegman, "Some English Portraits by Pompeo Batoni," *Burlington Magazine*, LXXXVIII, March 1946, p. 60, no. 58; William E. Suida, "Catalogue of the Samuel H. Kress Collection," *Philadelphia Museum Bulletin*, XLVI, Autumn 1950, p. 22, no. 26; *Kress Collection*, Atlanta, 1958, p. 66; Fredericksen and Zeri, 1972, p. 20; Shapley, III, 1973, pp. 120-121, fig. 239; Edgar Peters Bowron, *Pompeo Batoni (1708-1787)*, exhibition catalogue, Colnaghi, New York, 1982, p. 55, no. 45.

Pompeo Batoni, *Portrait of Richard Aldworth Neville, later Second Baron Braybrooke*

The son of a goldsmith, Batoni left Lucca in 1727 for Rome, where he settled permanently, establishing himself as a leading history painter and one of Europe's most popular portrait painters. Batoni studied the works of Raphael and Annibale Carracci, as well as ancient sculpture. The contemporary artists who helped shape his style were Sebastiano Conca, Agostino Masucci, and Francesco Imperiali. By 1732 Batoni had begun work on his first major altarpiece, for the Church of San Gregorio al Celio in Rome. Another of his important early commissions was the allegorical *The Triumph of Venice* (now in the North Carolina Museum of Art, Raleigh), painted in 1737 for Marco Foscarini, the Venetian Ambassador to Rome.

By the mid-1750s, Batoni's history pictures were so expensive that only the wealthiest European nobility could afford them. About this time, he began to paint more portraits. He specialized in painting high-ranking churchmen and distinguished visitors, especially members of the English aristocracy making the Grand Tour. Batoni emphasized his sitters' air of poised confidence and depicted them in Roman settings. Batoni's style, with its learned classicism, excellent draughtsmanship, and refined elegance, was to influence later artists who resided in Rome, notably David, Mengs, and Hamilton.

This portrait of Richard Aldworth Neville (1750-1825) is typical of Batoni's less expensive and less complex portraits produced for visiting Englishmen. Educated at Eton and Oxford, Neville succeeded to his father's estates of Stanlake and Billingbear in 1793. He became second Lord Braybrooke in 1797. On his trip to Italy in 1773-74, he was painted not only by Batoni but also was included in a conversation piece by an anonymous artist.[1] A comparable Batoni half-length portrait of the same year is that of John D. Eckersell (private collection, Rome).[2]

[1]Information from Edgars Peters Bowron in a letter of January 9, 1980.
[2]See the exhibition catalogue *Pompeo Batoni*, Lucca, 1967, no. 53.

Giambattista Bassi, *The Falls of Terni on the River Velino*

Giambattista Bassi
Massa, 1784-1852, Rome

The Falls of Terni on the River Velino, 1820
Oil on canvas, 39 x 28⅜ inches (99.1 x 72.1 cm.)
Signed and dated: *G. B. Bassi 1820*

Gift of the Kilpatrick children in memory of their mother, Mrs. Martin E. Kilpatrick, 1983.98.

Provenance: P. and D. Colnaghi and Co., Ltd., London.

Bassi, from Lombardy, trained with the landscape artist Vincenzo Martinelli at Bologna and settled in Rome. There he became friendly with the sculptors Canova and Thorvaldson.[1] Bassi painted both neo-classical and romantic landscapes and was renowned for his depictions of waterfalls. The falls of Terni near Perugia—created in Roman times by diverting the course of the Velino into the valley—were a popular tourist location, especially for visiting Englishmen. Views of the site were painted by Thomas Patch, George Knapton, and Turner.[2] In Bassi's sun-filled landscape, the soaring grandeur of the falls is contrasted with the tiny figures of the peasants.

[1]Lionello Venturi, "Giambattista Bassi," *Commentari*, 1951, pp. 124-126, figs. 135-140.
[2]Photographs in the Frick Art Reference Library. See also M. H. Grant, "Some 'Unexpected' Landscapes," *Connoisseur*, June 1952, p. 77.

Giovanni Maria Benzoni
Songavazzo, 1809-1873, Rome

The Veiled Rebekah, 1864
White marble, 64 x 23 x 19½ inches (162.6 x 58.4 x 49.5 cm.)
Inscribed on the base: *G. M. Benzoni F. Roma A 1864*

Gift of Mrs. John B. Gordon, 1927.23.

Provenance: General John B. Gordon, Kirkwood, Georgia, by 1899; Mrs. John B. Gordon, Atlanta.

Under the patronage of Count Tadini, Benzoni went from his native village near Bergamo to study in Rome at the school of Giuseppe Fabris in 1828. The young man quickly established a reputation as a leading sculptor in marble. Basing his style on that of Canova, he received commissions from churches in Rome such as St. Anastasis. He produced individual biblical figures, like his *Eve* (1859, now in Dublin), various funerary monuments, mythological figures (a *Cupid and Psyche* of 1845, in Milan), and many portraits of dignitaries (such as Pope Pius IX) and famous visitors to Rome, including the Sultan of Turkey and the Czar of Russia.

Benzoni's works were exhibited at London in 1851 and Paris in 1855. His sculpture of the veiled biblical heroine Rebekah was one of his most popular and was repeated several times by Benzoni and his workshop. One version, inscribed as representing "Rebekah in the attitude of presenting herself to her bridegroom Isaac" and dated 1866, was purchased by Colonel Robert Pomeroy and is now in the Berkshire Museum, Pittsfield.[1] According to Debra Balker (in a letter of August 3, 1981), another copy is in the Salar Jung Museum, Hyderabad, India.

The tour de force representation of a veiled figure was popular with Italian sculptors of the mid-nineteenth century. Notable examples include the *Circassian Slave* by Magni (exhibited 1851), the *Sleep of Sorrow* by Monti (1862, in the Victoria and Albert Museum, London), and the *Veiled Lady* by Pietro Rossi (Gibbes Art Gallery, Charleston, South Carolina).

[1] See *A Guide to the Collections*, The Berkshire Museum, Pittsfield, Massachusetts, 1968, p. 11.

Giovanni Maria Benzoni, *The Veiled Rebekah*

73

Spanish

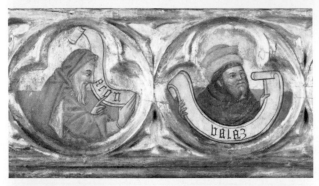

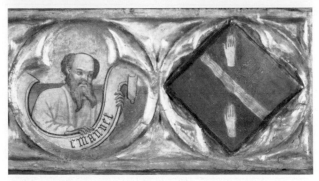

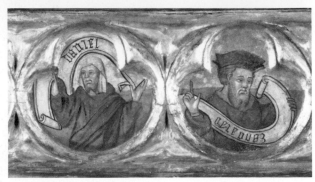

Unknown Spanish, *Prophets and Coat of Arms*

Unknown Spanish
Catalan School, 15th Century

Prophets and Coat of Arms
Tempera on panel, 10¼ x 48 inches (26 x 121.9 cm.)

Gift of French & Co., New York, 1957.29.

This panel contains six oculi in which are depicted a coat of arms and five Old Testament figures whose scrolls are inscribed with the names Aaron, Balaam, Daniel, one unidentified, and Emanuel. Judith Berg Sobre (in an opinion in Museum files) has observed that, judging from the style of the figures and the calligraphy, the painting is probably a Catalan work of the period 1430-50. She notes that the panel is probably half of that section of an altar painting called a *sotabanca* in Catalan which was placed beneath the predella, and which often displayed images of the prophets. The coat of arms has not been identified.

Blas de Ledesma
Granada, active late 16th to early 17th century

Still Life with Cherries, Lupin, and Iris, ca. 1610
Oil on canvas, 22⅛ x 30⅞ inches (56.2 x 78.5 cm.)
Signed at lower left: *BLAS DE LEDESMA, Ē. granada*

Great Picture Fund purchase in honor of Reginald Poland, 1957.11.

Provenance: Private collection, Barcelona, 1939; Durlacher Brothers, New York.

Exhibitions: *La Nature Morte de l'antiquité à nos jours*, Musée de l'Orangerie, Paris, April-Sept. 1952, no. 18; *Goya, Zurbarán and Spanish Primitives: An Exhibition of Spanish Paintings*, The Syracuse Museum of Fine Arts and The Atlanta Art Association, Feb.-March 1957, no. 15; *Still Life Paintings from the XVI Century to the Present*, Atlanta Art Association, Jan. 10-29, 1958; *Spanish Masters*, Fine Arts Gallery of San Diego, March 25-May 1, 1960; *Fête de la Palette*, John and Mable Ringling Museum of Art, Sarasota, and the Isaac Delgado Museum of Art, New Orleans, Nov. 19, 1962-Jan. 6, 1963, no. 41; *El Greco to Goya*, John Herron Museum of Art, Indianapolis, and Museum of Art, Rhode Island School of Design, Providence, Feb.-May 1963, no. 4; *The Golden Age of Spanish Still Life Painting*, The Newark Museum, New Jersey, Dec. 10, 1964-Jan. 26, 1965, no. 14; *The Golden Age of Spanish Still Life: 1600-1650*, Kimbell Art Museum, Fort Worth, and The Toledo Museum of Art, May 11-Nov. 2, 1985.

Bibliography: Julio Cavestany, "Blas de Ledesma, pintor de fruteros," *Arte Español*, XIV, 1943, pp. 16-18; Charles Sterling, *La Nature Morte de l'Antiquité à nos*

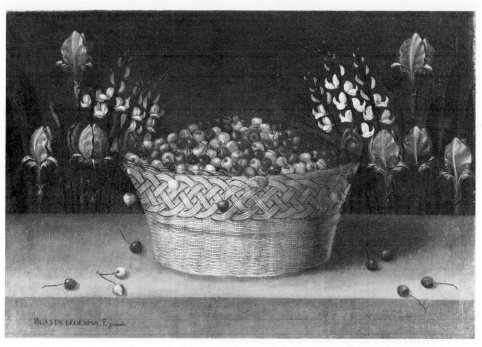

Blas de Ledesma, *Still Life with Cherries, Lupin and Iris* (color plate, page 24)

jours, Paris, 1952, p. 44, pl. 24 (English edition, New York, 1959, p. 49, pl. 24); José López-Rey, "The Variety of Spanish Painting," *Apollo*, June 1963, p. 512, fig. 2; José López-Rey, "Del Greco a Goya: Exposición de pintura española en los Estados Unidos," *Goya*, 54, 1964, p. 422, fig. 5; William Jordan, "Juan Van der Hamen y León: A Madrilenian Still-Life Painter," *Marsyas*, XII, 1964-65, p. 62, fig. 5; Ramón Torres Martín, *Blas de Ledesma, un pintor recien Descubierto*, Badajoz, 1967, fig. 16; Ingvar Bergström, "Maestros españoles de Bodegones y floreros del siglo XVII," *Insula*, Madrid, 1970, pp. 23-27; Ramón Torres Martín, *La naturaleza muerta en la pintura española*, Barcelona, 1971, p. 41, fig. 6; Peter Mitchell, *Great Flower Painters*, Woodstock, New York, 1973, p. 160; Ramón Torres Martín, "Blas de Ledesma y el origen del Bodegonismo español," *Goya*, 1974, pp. 218-219, no. 118; Eloise Spaeth, *American Art Museums: An Introduction to Looking*, New York, 1975, p. 112; Ramón Torres Martín, *Los Bodegones de Blas De Ledesma*, Seville, 1976, no. 46; Eric Young, "New Perspectives on Spanish Still-Life Painting of the Golden Age," *Burlington Magazine*, April 1976, p. 247; José Camón Aznar, "La pintura española del siglo XVII," *Summa Artis*, XXV, Madrid, 1977, p. 213; Bergström, etc., *Natura in Posa*, Milan, 1977, p. 197; Eric Young in *Trafalgar Galleries at the Royal Academy II*, London, 1979, under no. 12; H. W. Janson, *Form Follows Function–or Does It?*, The Gerson Lectures, Maarssen, The Netherlands, 1982, pp. 34-36, fig. 18; *Pintura Española de Bodegones y Floreros de 1600 a Goya*, exhibition catalogue, Museo del Prado, Madrid, 1983-84, pp. 70-71, 83, 210.

The oeuvre attributed to the still life painter Blas de Ledesma has grown considerably during the past two decades, but these attributions may include the works of several other artists. Ledesma, mentioned by Pacheco as a painter of architectural decorations, was apparently active in southern Spain from the second half of the sixteenth century into the first quarter of the seventeenth century. Because it bears a signature and an inscription revealing that it was painted in Granada, the High Museum's painting has become a touchstone for determining the painter's style. It has been dated variously between 1600 and 1620. The somewhat archaic symmetrical composition is similar to other paintings of fruit in baskets,[1] but it differs from the crowded arrangements of birds, fruits, and baskets in many works attributed to the artist by Torres Martin.[2] The painting owes much to the still lifes of Sanchez Cotan, who was in Granada by 1603. The "altar style" of still life, in which the elements (flowers and fruits with possible symbolic connotations) are dramatically isolated and presented with "sacramental solemnity,"[3] was adopted with more grace and power by Juan van der Hamen y León and especially by Zurbarán, who may have visited Granada and met Ledesma.

[1] See the examples in private Madrid collections reproduced in Torres Martin, 1978, pls. 101, 102, and the Prado exhibition, 1983-84, nos. 53, 54.
[2] Ibid., pls. 49-50, 55, 63.
[3] H. W. Janson, 1982, p. 34. Janson is the most recent author to suggest that the iris and cherries may have a mariological meaning.

Pedro Orrente, *The Crucifixion* (color plate, page 24)

Pedro Orrente
Monte Alegre, ca. 1570-1644, Valencia

The Crucifixion
Oil on canvas, 47¾ x 40⅜ inches (121.3 x 102.6 cm.)

Gift of the Samuel H. Kress Foundation, 1958.37.

Provenance: Conte de Nocé; Louis, Duc d'Orléans, ca. 1724-85; Louis Philippe (Egalité); Sold 1792 to Vicomte Edouard de Walckiers (Walkuers), Brussels; Laborde de Méréville, London; Jeremiah Harmann, London; Sold to a consortium of the Duke of Bridgewater, the Earl of Carlisle, and the Earl of Gower; John Maitland, Woodford Hall, Essex; Sale, Christie's, London, July 30, 1831, no. 94; David Baillie; Sale, Christie's, London, May 25, 1839, no. 58; Frank T. Sabin, London; David M. Koetser, New York; Samuel H. Kress Foundation, 1955.

Exhibitions: Lyceum, London, Dec. 26, 1798-end of Aug., 1799, no. 178; *Works of Holbein and Other Masters*, London, Royal Academy, 1950-51, no. 305; *Art in Italy 1600-1700*, The Detroit Institute of Arts, April 6-May 9, 1965, no. 170.

Bibliography: "Dubois de Saint-Gelais," *Description des tableaux du Palais Royal*, 1727, p. 31; P. Mariette, *Description des tableaux du Palais Royal*, 1742, p. 33; *Recueil d'estampes d'après les plus beaux tableaux (Recueil Crozat)*, Paris, II, 1742; William Buchanan, *Memoirs of Painting*, London, I, 1824, pp. 17ff.; Johann David Passavant, *Tour of a German Artist in England*, London, II, 1836, p. 184; G. F. Waagen, *Art Treasures*, London, IV, 1857, p. 456; Elias Tormó y Monzó, "El San Sebastian de Orrente," *Bolétin de la Sociedad Española de Excursiones*, XXIV, 1916, pp. 234-46; Casimir Stryienski, *La Galerie du Régent, Philippe Duc d'Orléans*, Paris, 1939, p. 170, no. 246; Enrique Lafuente Ferrari, "Pedro Orrente y el perdido retable de Villerejo de Salvanés," *Archivo Español de Arte*, XLVIII, 1941, pp. 503-16; Roberto Longhi, "Uno sguardo alle Fotografie della Mostra: 'Italian Art and Britain' alla Royal Academy di Londra," *Paragone*, XI, no. 125, 1960, pp. 59-61; *Masterpieces*, Atlanta, 1965, p. 12; Sabine Jacob, "Florentinische Elemente in der Spanischen Malerei," *Mitteilungen des Kunsthistorischen Institutes in Florenz*, XIII, 1967-69, pp. 133-136; Roberto Longhi, *"Me Pinxit" e Questi Caravaggeschi, 1928-1934*, Florence, 1968, p. 160, pl. 237 a, b; Diego Angulo Iñiguez, *Ars Hispaniae*, Madrid, XV, 1971, p. 68; Donald Posner, *Annibale Carracci*, London, 1971, II, p. 77, no. 181R; Diego Angulo Iñiguez and Alfonso E. Perez Sanchez, *Historia de la pintura española, Escuela Toledana*, Madrid, 1972, pp. 272, 318, no. 272, fig. 241; C. Eisler, *Paintings from the Samuel H. Kress Collection: European Schools Excluding Italian*, Oxford, 1977, p. 204, fig. 215; *Selected Works*, Atlanta, 1981, p. 13.

Little is known of the early career of Orrente, but the Italianate quality of his work, which seems to show the influence of Leandro Bassano and Caravaggio, makes it likely that he had travelled to Italy. Early biographers suggested that he had studied with Bassano, and his highly Italianate rustic subjects earned him the soubriquet "the Spanish Bassano." By 1612, when he had executed a *Jacob and Rachel at the Well* (Contini Bonacossi Collection, Florence), he had a thorough understanding of Venetian art. In 1616 Orrente was commissioned to paint a series of works for the Cathedral of Valencia, and a *St. Sebastian* survives. The following year he was working for the Cathedral in Toledo; it is presumed that he was familiar with El Greco. Later, in the 1640s, he was active in Cordoba and Seville. His work at the Palacio del Buen Retiro in Madrid brought him his greatest fame.

This *Crucifixion*, with its unusual perspective and juxtaposition of suffering religious figures with humble genre types such as the page, was believed to be by Annibale Carracci when it was in the Orléans Collection. Only in 1960 did Roberto Longhi correctly identify the artist. There are marked similarities between Orrente's treatment of the subject here and his Calvary paintings in the Prado and the Cathedral at Badajoz. The misattribution was undoubtedly due to the work's strongly Italianate characteristics—reminiscent of Tintoretto's *Crucifixion* at San Cassiano (Venice), Veronese's at San Sebastiano (Venice), and Carracci's 1594 work (now in Berlin). The emphasis placed here on the *titulus* (the sign placed over Christ's head), however, is typical of seventeenth century Spain. The boyish figure of the page appears in other subjects by Orrente, such as the *Feast of Cana* (La Guardia) and *Jacob Tending the Flocks* (North Carolina Museum of Art, Raleigh).

Follower of Ribera, *A Philosopher*

Follower of Ribera
Neapolitan, 17th Century

A Philosopher
Oil on canvas, 48⅛ x 37⅜ inches (122.2 x 95 cm.)

Gift of J. Bulow Campbell, 1981.113.

Provenance: Sale, Galerie Fischer, Lucerne, July 6-7, 1925, no. 261; Campbell family, Atlanta.

Jusepe de Ribera (1590-1652) was born in Spain but went early to Italy, settling permanently in Naples in 1616. He worked for the Spanish viceroys there and became one of the most important painters of the city. Ribera, influenced by the Caravaggesque manner, developed a distinctive and powerful style of depicting religious and allegorical subjects. Series of apostles, saints, and philosophers as picturesque beggars were frequent in the output of Ribera and his workshop.[1] In this painting the inscriptions on the man's papers are in a mock Hebrew script, suggesting that he is a religious figure. Oreste Ferrari has written (in a letter of July 16, 1974) that a version of this composition with some variants was in the Pilal Collection, Spain; both that work and the High Museum's painting probably derive from a lost prototype by Ribera.[2] Another variant of this figure (with a different face) was in a private collection in Brussels, and another was sold at Bonhams in London.[3] According to Ferrari, the High Museum's painting is of outstanding quality, comparable to the depictions of Heraclitus and Democritus in the Palazzo Durazzo Pallavicini in Genoa. Ferrari does not believe that the Neapolitan follower of Ribera who painted these works was the young Luca Giordano, although this artist painted a great many such subjects,[4] but this suggestion has been made (in conversation) by Nicola Spinosa. Raffaello Causa attributed the High Museum's work (in conversation) to Hendrick van Somer, a Dutch-born artist who worked in Ribera's atelier around 1635 and painted a number of saints and philosophers in the manner of Ribera during the 1640s and 1650s.[5]

[1]See E. H. Turner, "Ribera's Philosophers," *Wadsworth Atheneum Bulletin*, Spring 1958, pp. 5-14 and D. Fritz Darby, "Ribera and the Wise Men," *Art Bulletin*, 45, 1962, p. 298f.

[2]One of the closest prototypes is the *Philosopher* at Ferens Art Gallery, Kingston-upon-Hull, Yorkshire, England. See Alfonso Pérez Sánchez and Nicola Spinosa, *L'Opera completa del Ribera*, Milan, 1978, p. 99, no. 46.

[3]March 25, 1976, no. 40. See photograph in photo archives, National Gallery, Washington, D.C.

[4]See Oreste Ferrari and Giuseppe Scavizzi, *Luca Giordano*, Naples, 1966, III, pls. 21-33, 36-40.

[5]See G. J. Hoogewerff, "Hendrick van Somer," *Oud Holland*, LX, 1943, pp. 158-172.

Workshop of Zurbarán, *St. Veronica's Veil*

Workshop of Zurbarán
Spanish, 17th Century

St. Veronica's Veil, ca. 1631
Oil on canvas, 41 x 29¼ inches (104.2 x 74.3 cm.)

Anonymous gift, 1962.1.

Provenance: Private collection, Acija; Don Guillermo Bernstein, Madrid; Wildenstein & Co.,Inc., New York.

Exhibitions: *Zurbarán*, Palace of Charles V, Granada, June 1933, no. 12; *L'Age d'or espagnol*, Bordeaux, May 16-July 31, 1955, no. 90.

Bibliography: Martin Soria, *The Paintings of Zurbarán*, London, 1953, p. 147, under no. 63; P. Guinard, *Zurbarán*, Paris, 1960, p. 219, no. 84; J. J. Martín González, "La Santa Faz," *Goya*, no. 97, July 1970, p. 12; José Gudiol, *Zurbarán 1598-1664*, London, 1977, p. 123, no. 560.

Zurbarán, one of the greatest seventeenth century Spanish painters, worked primarily in Seville. He was able to animate objects and fabrics with a mysterious light, and to convey the ascetic spirituality of saints and monks. One of his most telling subjects was St. Veronica's veil, the Sudarium, which María Luisa Caturla has aptly characterized as "a still life on a divine theme."[1] Suspended before a dark background, this sacred relic, a cloth imprinted with the image of Christ's face, takes on a mystical sense of life. Zurbarán, inspired by the example of El Greco, developed several variants of this subject.

The High Museum's painting, in which the face is slightly turned to the left and very lightly indicated, closely resembles a work in the Angel Avile's Collection, Madrid, dated by Soria to about 1631. Other paintings of this type are in the Church of San Miguel (Jerez), the Church of San Sebastian (Madrid), the National Museum in Stockholm,[2] the Trafalgar Gallery (London, in 1979),[3] and with Stanley Moss & Company (New York, in 1980). Although formerly exhibited as a work by the master himself, the High Museum's version, with its disproportionate relationship between the face and the cloth and its weak execution, is most likely a product of the Zurbarán workshop.

[1]María Luisa Caturla, "La Santa Faz de Zurbarán," *Goya*, no. 64-65, Jan.-April 1965, p. 202.
[2]See Jonathan Brown, *Francisco de Zurbarán*, New York, 1973, p. 112.
[3]Reproduced in *Trafalgar Galleries at the Royal Academy II*, London, 1979, no. 28.

Northern European, English, and French

Northern European

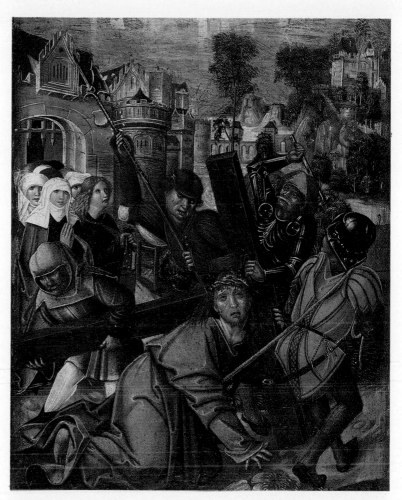

Unknown Austrian, *Christ Carrying the Cross*

Follower of Hieronymus Bosch, *Temptation of St. Anthony*

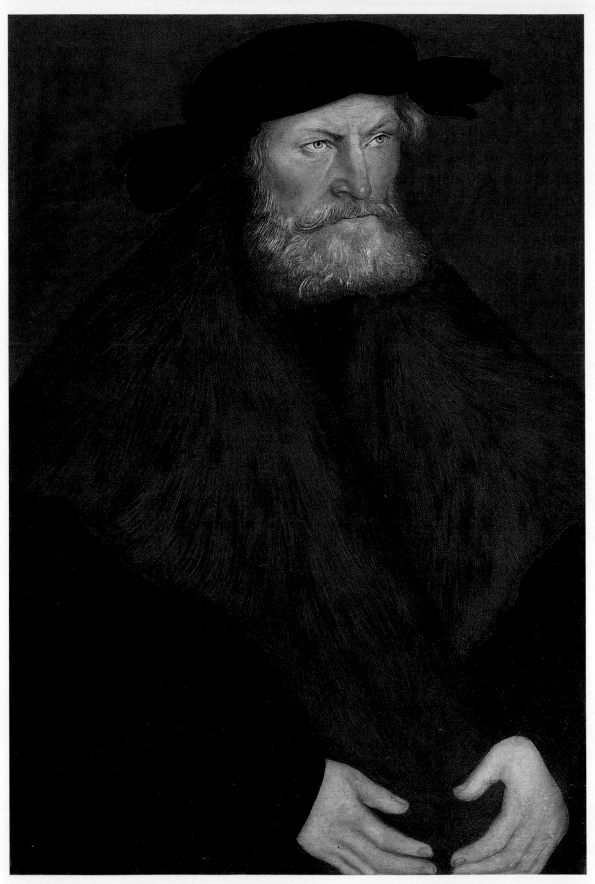

Lucas Cranach the Elder, *Portrait of Duke Henry the Devout of Saxony*

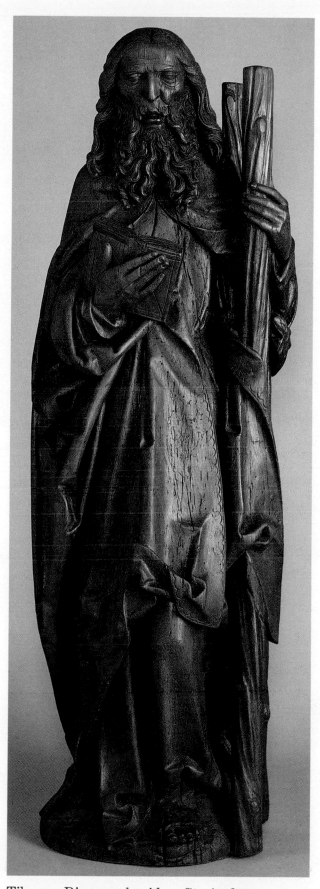

Tilmann Riemenschneider, *St. Andrew*

Dirck de Horn, *Still Life*

Barent Avercamp, *Games on the Ice*

84

Hendrick van Streek, *Still Life with Rug*

Sir Peter Lely, *Portrait of a Boy in a Hunting Costume*

French

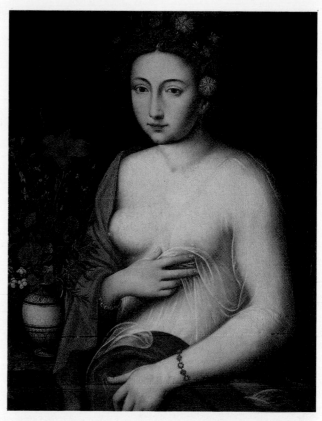

School of Fontainebleau, *Lady with a Red Lily*

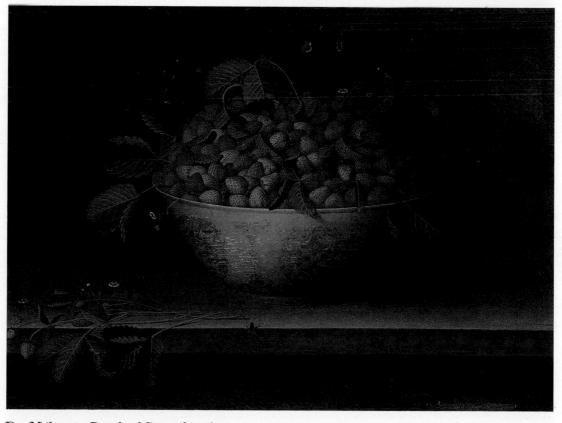

Du Mélezet, *Bowl of Strawberries*

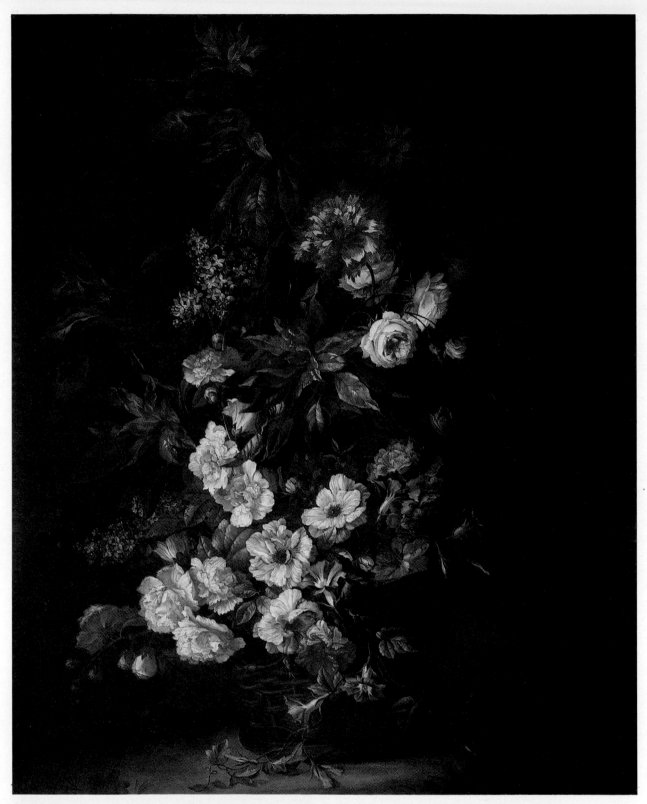

Jean-Baptiste Monnoyer, *Flowers in a Basket*

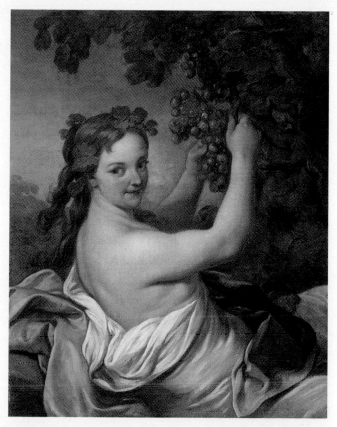

Carle van Loo, *Erigone*

Charles-Joseph Natoire, *Jacob and Rachel Leaving the House of Laban*

François-Xavier Fabre, *Portrait of Count Vittorio Alfieri*

Jean-Baptiste Camille Corot, *Ravine in the Morvan, near Lormes*

Eugène Fromentin, *Arabs on the Way to the Pastures of the Tell*

Eugène Boudin, *Still Life with Lobster on a White Tablecloth*

Frédéric Bazille, *Beach at Sainte-Adresse*

Camille Pissarro, *Bouquet of Flowers*

Edgar Degas, *Study of Two Dancers*

Luc-Olivier Merson, *"Je vous salue, Marie" ("Hail, Mary")*

94

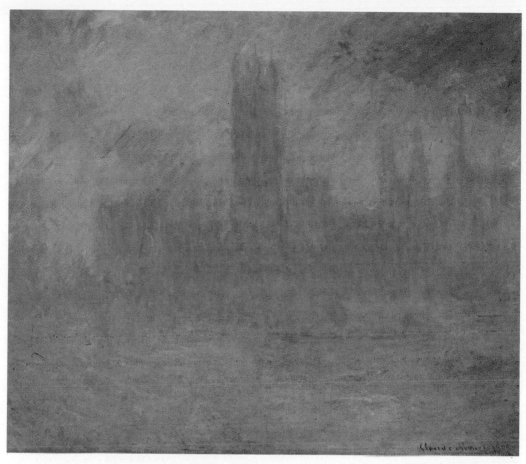

Claude Monet, *Houses of Parliament in the Fog*

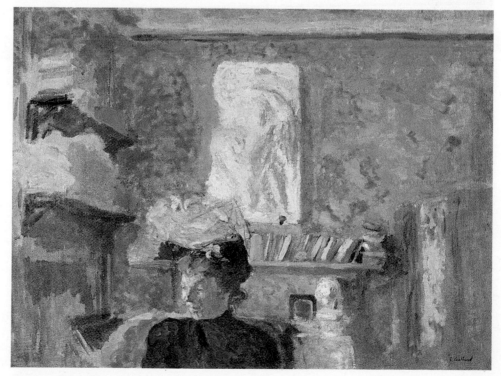

Edouard Vuillard, *Woman Before a Plaster Relief*

Max Ernst, *Tree of Life (L'Arbre de Vie)*

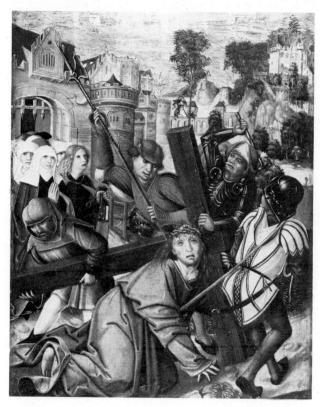

Unknown Austrian, *Christ Carrying the Cross* (color plate, page 81)

Follower of Hieronymus Bosch, *Temptation of St. Anthony* (color plate, page 81)

Unknown Austrian
Late 15th century

Christ Carrying the Cross, 1494
Tempera (?) on panel, 10¼ x 7⅞ inches (26.1 x 20 cm.)

Friends of Art purchase, 1944.12.

Provenance: Otto Karl Back, Grand Rapids, Michigan; E. & A. Silberman Galleries, New York.

Bibliography: Charles L. Kuhn, *A Catalogue of German Paintings of the Middle Ages and Renaissance in American Collections*, Cambridge, Massachusetts, 1936, p. 74, no. 321; Daniel Catton Rich, *Catalogue of the Charles H. and Mary F. S. Worcester Collection of Paintings, Sculpture and Drawings*, Chicago, 1938, p. 36.

This small painting is the companion piece to a *Crucifixion*, dated 1494, formerly in the Worcester Collection and now in the Art Institute of Chicago. The artist has never been determined. Kuhn simply called the work "Austrian School." Hanns Swarzenski (in a letter of August 16, 1951) suggested it might have been painted by the so-called "Hapsburg Master" who was active in the Tirol around 1500, and Ilse Hecht (in a letter of March 23, 1982) thinks that it is the work of "an anonymous painter in the vicin-

ity of the Hapsburg Master." Both panels are marked by a crude vivacity in the treatment of the figures. The composition of the High Museum's panel is taken from Schongauer's famous print of the same subject.

Follower of Hieronymus Bosch
Netherlands, 16th Century
Temptation of Saint Anthony
Oil on panel, 7¼ x 10¼ inches (18.5 x 26.1 cm.)

Friends of Art purchase, 1952.19.

Provenance: E. & A. Silberman Galleries, New York.

Exhibitions: *Paintings and Sculpture, Gothic to Surrealism*, High Museum of Art, Atlanta, Jan. 8-Feb. 5, 1950, no. 17.

This painting was previously attributed to Hendrick Met de Bles by de Tolnay (certificate in the Museum files). Luc Serck (in conversation, October 1982), who has made a study of Met de Bles, rejects this idea. While the composition of this painting is similar to some of his paintings of the Temptation of Saint Anthony, the style is different.

The subject had been popularized by Bosch and was treated by many of his followers.[1] This painting in particular recalls Bosch's *Temptation of St. Anthony* in Lisbon. His distinctive demons and detailed panoramic landscapes became the prototype for many variants such as this one. This work has been somewhat restored but reveals a very skilled hand.

[1]See Jacques Lassaigne and Robert Delevoy, *Flemish Painting*, New York, 1958, II, pp. 34-35, and Max J. Friedländer, H. Pauwels, and G. Lemmens, *Antonis Mor and His Contemporaries*, Brussels, 1975, pl. 40.

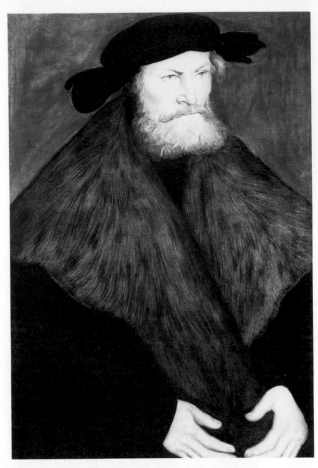

Lucas Cranach the Elder, *Portrait of Duke Henry the Devout of Saxony* (color plate, page 82)

Lucas Cranach the Elder
Kronach, 1472-1553, Weimar

Portrait of Duke Henry the Devout of Saxony, 1528
Oil on panel, 22½ x 15¼ inches (57.2 x 38.8 cm.)
Inscribed upper left with the artist's monogram and date

Gift of Mrs. Irma N. Straus in memory of her husband, Jesse Isidor Straus, 1963.5.

Provenance: A. Contini Collection, Rome; Jesse Isidor Straus, New York; Mrs. Jesse I. Straus, New York.

Bibliography: Max J. Friedländer and Jakob Rosenberg, *Die Gemälde von Lucas Cranach*, Berlin, 1932, no. 256; *Masterpieces*, Atlanta, 1965, p. 17; Max J. Friedländer and Jakob Rosenberg, *The Paintings of Lucas Cranach*, revised ed., Ithaca, 1978, p. 131, no. 319.

Lucas Cranach, one of the leading German painters of the sixteenth century, adopted the name of his birthplace (Kronach in North Franconia) instead of his family name of Müller. He received his early training from his father. By 1500 he had gone to Vienna, where he worked for three years for the Hapsburg Emperor Maximilian I, becoming famous for his woodcuts and his paintings, especially portraits.

The Elector of Saxony, Frederick the Wise, called Cranach to Wittenberg in 1505, and he remained there for the rest of his life as court painter, providing altarpieces and decorative schemes for the palaces (notably hunting scenes and nude goddesses) and, of course, portraits of the Elector, his family, and his successors. Cranach also created crests and emblems for their weaponry, and made careful studies of the animals killed during their hunts.

Cranach was an early supporter and friend of Martin Luther and other leaders of the Protestant Reformation, whose ideas he attempted to embody in his religious works and whose portraits he painted. He also, however, continued to receive commissions from Catholics. His reputation was such that in 1537 he was elected burgomaster of Wittenberg. As his commissions multiplied, Cranach's workshop flourished, employing many pupils, including two of his sons, Hans and Lucas the Younger. More than four hundred paintings by the master survive—one of his last works was a self-portrait done in 1550, three years before he died.

On Three Kings Day in 1508, Cranach was granted the emblem of a crowned yellow winged serpent as his coat of arms by the Elector Frederick. Cranach frequently used this emblem as his signature on paintings. Following the death of his son Hans in 1537, the serpent was painted with folded wings. The High Museum's work is signed with the serpent and is clearly dated 1528. Although Cranach had employed rich landscape backgrounds in his earlier Viennese period portraits, by this time he usually reduced the backgrounds to flat areas of blue, grey, or green which served to heighten the somber objectivity of his treatment of the faces.

Cranach painted three images of Duke Henry the Devout of Saxony (1473-1541). The earliest is a full-length standing version of about 1514 (Dresden Gemäldegalerie) which shows him as a young, unbearded man.[1] The Duke succeeded his older brother, George the Bearded, as reigning duke of the Albertine domains and was responsible for introducing the precepts of the Reformation. A much later standing portrait, inscribed and dated 1537 (formerly at Dresden), was destroyed during the Second World War.[2] It showed the Duke with full beard and receding hair and makes the identification of the man in the High Museum portrait quite convincing. Other versions of this portrait of Duke Henry are one cropped to just the head and shoulders in the Gemäldegalerie, Kassel, and one formerly in the Harris Collection, London.[3]

[1]Friedländer and Rosenberg, 1978, no. 60.
[2]Ibid., no. 352.
[3]Ibid., nos. 318, 319a. See also Dieter Koepplin and Tilman Falk, *Lukas Cranach*, Basel, 1976, II, p. 696, no. 618.

Tilmann Riemenschneider
Osterode, ca. 1460-1531, Würzburg

St. Andrew, ca. 1505
Lindenwood, formerly polychromed, 40½ x 13½ x 8¼
inches (102.9 x 34.3 x 21 cm.)

Gift of the Samuel H. Kress Foundation, 1958.57.

Provenance: Justus Bier, Widdersburg, 1930s; Confis-
cated and sold, Hamburg, 1940s; Museum für Kunst und
Gewerbe, Hamburg; Returned to Justus Bier, Louisville;
Paul Drey Gallery, New York; Samuel H. Kress Founda-
tion, 1955.

Exhibition: *Sculptures of Tilmann Riemenschneider*,
North Carolina Museum of Art, Raleigh, Oct. 6-Nov. 11,
1962, no. XV.

Bibliography: Justus Bier, "St. Andrew in the work of
Tilmann Riemenschneider," *Art Bulletin*, Dec. 1956, pp.
215-23, pls. 8-10; *Kress Collection*, Atlanta, 1958, pp. 68-
70; J. Bier, "Beiträge zur Riemenschneider-Forschung,"
Mainfränkisches Jahrbuch für Geschichte und Kunst, II,
Würzburg, 1959, pp. 110-20; Middeldorf, 1976, pp.
125-26, fig. 212; J. Bier, *Tilmann Riemenschneider, His
Life and Work*, Lexington, 1982, pp. 53-55, pls. 7A-B.

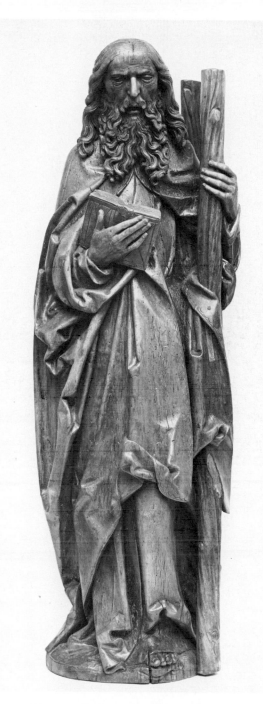

The greatest of late medieval German sculptors,
Tilmann Riemenschneider was the son of a miller
and mint master from Osterode who settled in
Heiligenstadt. Little is known of his early artistic
training. It is possible that he studied in Erfurt, a
center for stone and alabaster carving, and then
went to the region of Strassburg and Ulm, where the
leading sculptor in wood, Michel Erhart, had his
workshop.

Late in 1483 Riemenschneider settled as a jour-
neyman sculptor in the city of Würzburg, where his
uncle Nicholas had been a curate of the Cathedral;
the artist himself may have taken lower orders. In
1485 he married the well-to-do widow of a goldsmith
and thus became both a citizen and an independent
master. He quickly established his fame, receiving
important commissions from the prince-bishops of
Würzburg for tomb monuments and from the city
council for the embellishment of the Marienkapelle.
Recognition from outside the city came with the 1499
commission from the bishop of Bamberg for a tomb
sculpture in Bamberg Cathedral for the imperial
saints Emperor Henry II and his wife Cunegund.
Frederick the Wise, Elector of Saxony, employed
Riemenschneider for an over-life-size *Crucifixion* for
the Stiftskirche in Wittenberg (destroyed in 1760).

In the early sixteenth century, the sculptor exe-
cuted his most significant projects—complex carved
altars for a number of churches—including the *As-
sumption of the Virgin* for Creglingen (1505-10), the
Crucifixion at Dettwang (1512-13), and the *Lamen-
tation* at Maidbronn (1519-23). In these same years
Riemenschneider's involvement with the local gov-
ernment deepened. Commencing in 1504 when he
was elected to the city council, Riemenschneider
held a number of official posts, and finally was ap-
pointed burgomaster in the years 1520-21.

Tilmann Riemenschneider, *St. Andrew* (color plate,
page 83)

During the Peasant Revolution of 1525 Riemen-
schneider, possibly out of religious conviction, sided
with the peasants against the nobility and bishops;
when the princes triumphed, he was imprisoned and
tortured, barely escaping execution. Although he re-
sumed his career, he no longer received major com-
missions. Riemenschneider had four wives and sev-
eral of his children became artists. Georg, his son by
his second marriage, was trained in his father's shop
and in 1531 carved his father's tombstone, recording
the sculptor's features.

99

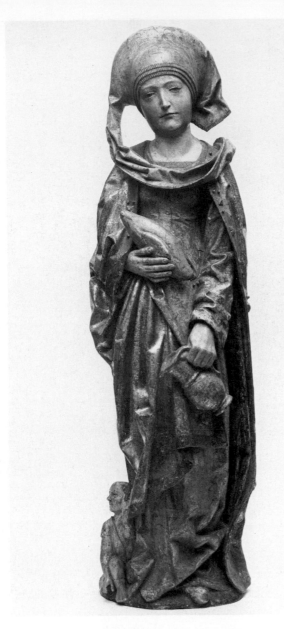

Workshop of Tilmann Riemenschneider, *St. Elizabeth*

Koberger in the 1488 edition of his *Heiligenleben* (*Lives of the Saints*). St. Andrew is there called "the worthy apostle who loved God and served Him with diligence by day and night, with praying and fasting, with staying awake, and with much other good exercise."[1] Here the saint appears as a venerable bearded figure, reading aloud from his book. With bare feet, he strides forth, holding the X-shaped cross that is the instrument and the symbol of his martyrdom.

Originally polychromed, this piece has lost its coloring; the light lindenwood was dyed a dark shade to resemble oak. Nevertheless, the figure, with its powerful contrasts of light and dark and voids and solids, is comparable in impact to Riemenschneider's stone Apostles for the Marienkapelle in Würzburg and the wooden ones in the Creglingen *Assumption*.

[1] See Bier, 1982, p. 54.

Workshop of Tilmann Riemenschneider

St. Elizabeth, ca. 1490
Polychromed lindenwood, 37¾ x 10½ x 9¾ inches (95.9 x 26.7 x 24.8 cm.)

Gift of the Samuel H. Kress Foundation, 1958.58.

Provenance: Carlo von Weinberg, Frankfurt; Rosenberg and Stiebel, New York, 1955; Samuel H. Kress Foundation.

Bibliography: *Kress Collection*, Atlanta, 1958, p. 71; Justus Bier, "Beiträge zur Riemenschneider-Forschung," *Mainfränkischer Jahrbuch für Geschichte und Kunst*, II, Würzburg, 1959, pp. 110-13, pl. xb; Middeldorf, 1976, p. 126, fig. 213.

Riemenschneider had an extensive workshop and his powerful style had wide impact. One assistant, whose particular style has been identified by Justus Bier, carved a similar *St. Elizabeth* for the high altar of Munnerstadt. He also carved the Annunciation group in the church of Bibra and is thus sometimes referred to as the Master of the Bibra Annunciation.[1]

St. Elizabeth, the daughter of Andrew II, King of Hungary, was born in 1207 and married in 1221 to Louis IV, Landgrave of Thuringia. Instructed by her confessor in the ascetic ideals of St. Francis, she became renowned for her charity and concern for the poor. After her husband's death, she became a nun and continued her austerities until her death in 1231. The miracles and visions attributed to her led to her canonization by Pope Gregory IX in 1235. Her cult was widespread in Hungary and Germany. Typically, she is represented either as a princess wearing a crown or as a member of the Franciscan order. She sometimes carries bread and a jug of water to succor the poor and outcast, such as the beggar or leper who appears at her feet in this example.

[1] See the exhibition catalogue *Tilmann Riemenschneider—Frühe Werke*, Würzburg and Berlin, 1981, p. 131, no. 16.

Riemenschneider's work is remarkable not only for its technical facility but also for the power of direct expression with which he endowed his figures. In place of the excesses of late Gothic carving, he created simple compositions conveying devout faith. This is evident especially in a sculpture such as the High Museum's *St. Andrew*. This work from an unknown location has been dated by Justus Bier to around 1505. Riemenschneider executed three other depictions of the saint: a sandstone figure for the Marienkapelle in Würzburg (ca. 1500), a painted wooden version found in the chapel of the Ehehaltenhaus, Würzburg (ca. 1505), and a lindenwood sculpture for the Church of St. Kilian in Windsheim (1509). As Bier has observed, the High Museum's work best fits the description published by Anton

Unknown Dutch, *Children in a Kitchen*

Unknown Dutch
Early 17th century

Children in a Kitchen
Oil on canvas, 44¼ x 39½ inches (112.4 x 100.3 cm.)

Bequest of Elwyn de Graffenried in memory of Erminete de Graffenried Nunnally, 1959.35.

Provenance: Leo C. Collins, New York.

Exhibitions: *Fêtes de la Palette*, Isaac Delgado Museum of Art, New Orleans, Jan.-Feb. 1963, no. 45.

As Julius Held has pointed out (in a letter of March 31, 1980), the figures in this work are reminiscent of the style of the Dutch painter Gerrit Pietersz. (1566-before 1645). Haverkamp-Begemann has suggested (in a letter of October 10, 1980) that it might be by the Dutch genre painter Jan de Bont (d. 1653), who painted mostly fish still lifes. The work may actually be a collaboration between two artists, one a specialist in painting figures and the other in still life, for there is some disparity in the handling of these two elements. This subject of a boy and a girl in a kitchen was popular in seventeenth century Dutch and Flemish art.[1] Works of this type often contain symbolic meanings. In the present case, the girl is perhaps making a choice between the life of the spirit represented by the grapes and the life of the flesh represented by the dead birds.[2]

[1]See, e.g., an early seventeenth century kitchen scene in the Metropolitan Museum of Art, New York (06.288).
[2]Suggested by Jeffrey Harrison in a letter of 1980. See, e.g., E. de Jongh, "Grape Symbolism in Paintings of the 16th and 17th Centuries," *Simiolus*, VII, 1974, p. 183, with reference to Snyders's *Kitchen Maid with Grapes*.

Follower of Jacob de Backer, *Allegory of The Sense of Hearing*

Follower of Jacob de Backer
Flemish, late 16th century

Allegory of the Sense of Hearing
Oil on canvas, 29⅛ x 41½ inches (74 x 105.5 cm.)

Gift of Mr. and Mrs. Francis Storza, 1962.3.

Provenance: In the trade, Brussels; Mr. and Mrs. Francis Storza, Atlanta.

Bibliography: Suzanne Boorsch, "Jacob de Backer's Drawing for the Sense of Smell," *Leids Kunsthistorische Jaarboek*, Delft, 1982, p. 5.

The sixteenth century Antwerp artist Jacob de Backer painted a series of allegories of the senses which were then copied in etchings.[1] Other painters drew from these sources for their own representations of the senses. In this case, the basic composition is taken from de Backer's original but set into a more elaborate landscape.

The seated female figure with the lute and deer, an animal renowned for its sensitive hearing, is not only the embodiment of the sense, but can be identified as Polyhymnia, the muse of music. Other aspects of the painting combine the themes of hearing and music. In the background, the flute player is Mercury putting Argus to sleep, as described in Ovid's *Metamorphoses* (I, 668-717). Music is further suggested not only by the scores, but also by the birds, the brook, and the distant church belfry.

[1]See Agnes Czobor, "'The Five Senses' by the Antwerp Artist Jacob de Backer," *Nederlands Kunsthistorische Jaarboek*, 23, 1972, pp. 317-27. See also F. W. H. Hollstein, *Dutch and Flemish Etchings, Engravings and Woodcuts: ca. 1450-1700*, Amsterdam, 1949, I, 1-5, no. 52.

Nicolaes Pietersz. Berchem, *The Nurture of Jupiter*

Nicolaes Pietersz. Berchem
Haarlem, 1620-1683, Amsterdam

The Nurture of Jupiter
Oil on panel, 8¼ x 9½ inches (21 x 24.1 cm.)

Gift of Julie and Arthur Montgomery, 1980.57.

Provenance: Sale, Christie's, London, Nov. 19, 1971, no. 157; Richard L. Feigen Gallery, New York; Private collection, Connecticut; M. Knoedler & Co., Inc., New York.

Son of the Haarlem still life painter Pieter Claes., Berchem was the pupil and assistant of a number of artists, including Jan van Goyen, one of the first major naturalistic landscape painters. Later, he worked with Jan Baptiste Weenix and Johannes Wils, painters of picturesque landscapes. Wils's daughter became his wife. He joined the Haarlem painters guild in 1642.

Berchem became a master of the "Italianate landscape," romantic southern views bathed in a warm golden light, but there is no record of his having made a trip to Italy. Possibly he accompanied Weenix to Rome in 1642. His work of this type most closely resembles that of Pieter van Laer and Jan Both. In addition to landscapes, he painted subjects such as the 1661 *Allegory of the Growth of Amsterdam*, as well as many religious and mythological works.

The subject of the High Museum's small painting is Jupiter fed by Amalthea's goat, a tale told in Ovid's *Fasti*. Following his birth, Jupiter was hidden by his mother Rhea on the island of Crete to prevent his father Saturn from devouring him. There the naiad Amalthea hid Jupiter in the woods where she had a great she-goat that suckled the infant god. One of the goat's high curving horns broke on a tree and was picked up by Amalthea. She wrapped it in flowers, filled it with fruits, and brought it to Jupiter. When the god attained his full power, he transformed his goat nurse and the horn of plenty into stars.[1]

The subject of Jupiter nursed by the goat was popular with seventeenth century artists. Poussin and Jordaens did several versions,[2] and Berchem painted several larger depictions which are in the Wallace Collection, The Hague, and Schleissheim.[3] The free touch and loose execution of this small work suggest that it may be a preparatory sketch for one of the larger compositions.

[1]Ovid, *Fasti*, English translation by J. G. Frazer, London, 1901, p. 296, book V, 111-128.
[2]See Pigler, 1956, II, pp. 131-132.
[3]C. Hofstede de Groot, *Holländische Maler*, Esslingen, 1926, IX, pp. 62-63, nos. 42-46.

Dirck de Horn, *Still Life* (color plate, page 84)

Barent Avercamp, *Games on the Ice* (color plate, page 84)

Dirck de Horn
Leeuwarden, 1626-ca. 1681

Still Life
Oil on panel, 26¾ x 23¼ inches (67.9 x 59.1 cm.)
Signed at the lower left: *Dirck de Horn*

Gift of Julie and Arthur Montgomery, 1980.58.

Provenance: Private collection, Holland; M. Knoedler & Co., Inc., New York.

De Horn, a native of the northern Netherlands province of Friesland, worked in the town of Leeuwarden. His specialty was still lifes of dead game, birds, and vegetables, usually arranged on the edge of a thick wooden counter. The backgrounds are dark and the profusion of objects in the foreground is spotlighted for a strong dramatic effect. Works such as this one and others in the Friesmuseum have a brooding quality and a mastery of textures reminiscent of Spanish painting.[1]

[1]See, e.g., *Still Life with Dead Birds and Pears*, ill. in L. J. Bol, *Holländische Maler des 17 Jahrhunderts*, Braunschweig, 1969, p. 280, fig. 265, and *Friesmuseum Catalogue*, Haarlem, 1978, p. 54, and also a still life of dead rabbits and a side of meat signed and dated 165(8) (Friesmuseum, ref. no. 1958.13).

Barent Avercamp
Kampen, 1612-1679

Games on the Ice, 1654
Oil on panel, 10¾ x 17⁷/₁₆ inches (27.3 x 44.3 cm.)
Signed at the lower left: *Avercamp*

Gift of Mr. Rolf R. Roland, 1961.8.

Provenance: D. Dumbar, 's-Gravenhage; Mrs. A. Dumbar-Schimmelpenninck; J. Borghouts, Utrecht, 1855; Nystad, The Hague; R. Roland, Mt. Kisco, New York.

Exhibitions: Zwolle, 1882, no. 1158; *Tentoonstellung van Oude Schilderkunst*, Utrecht, 1894, no. 254; *Landscape Into Art*, Atlanta Art Association, Feb. 1962, no. 15; *Old Masters, American and European from Southern Collections*, Hunter Gallery, Chattanooga, Sept. 1969; *Dutch Life in the Golden Century*, Museum of Fine Arts, St. Petersburg, and High Museum of Art, Atlanta, 1975, no. 13.

Bibliography: Clara J. Welcker, *Hendrick Avercamp . . . en Barent Avercamp*, Doornspijk, 1979, p. 328, no. B.A.S.1, pl. XXXIV, fig. LVII; *Masterpieces*, Atlanta, 1965, p. 19.

Barent Avercamp was a pupil of his uncle Hendrick (1585-ca. 1663) and adopted his characteristic subject matter of small lively genre scenes set in and around Kampen. Hendrick Avercamp was one of several early seventeenth century painters who, inspired by

Thomas Heeremans, *River Scene*

Pieter Brueghel the Elder, painted scenes of winter activities and games. These paintings include details like the ones seen here: bearded burghers looking on somewhat disapprovingly, a well-dressed woman in her horse-drawn sleigh, and younger men playing *kolf*, a form of ice golf.[1]

For his compositions Barent adopted a somewhat lower viewpoint than his uncle's and compressed his figures into more tightly knit groups. As in this work, he usually filled the space at one side with a tree and depicted a view of Kampen in the background.[2] The painter frequently repeated themes and figures and a similar painting was in Leipzig.[3]

The High Museum painting originally had as a pendant a scene of men fishing in a river which is dated 1654.[4] The two works thus served to contrast both the seasons of the year and activities of work and pleasure.

[1]See, e.g., Welcker, p. 212, S 52.1, pl. VA.
[2]See, e.g., Welcker, p. 331, B.A.S.9, pl. XL, fig. LXVI.
[3]Photograph in the file of the Frick Art Reference Library.
[4]Welcker, p. 328, B.A.S.2, pl. XXXIV, fig. LVIII. Formerly in the collection of Dr. H. A. Wetzlar, it was sold at Sotheby Mak van Waay, Amsterdam, May 31, 1977, no. 42.

Thomas Heeremans
Active at Haarlem, 1660-1697

River Scene, 1688
Oil on canvas, 31⅝ x 26⅜ inches (80.3 x 67 cm.)
Signed and dated on rail at lower middle: *Hmans 1688*

Gift of Mrs. Harry Ward and Harry E. Ward, Jr., 1961.33.

Exhibition: *Landscape Into Art*, Atlanta Art Association, Atlanta, Feb. 6-25, 1962, no. 16.

Working primarily in Haarlem, Heeremans was a follower of Claes Molenaer and was indirectly influenced by the great master Salomon van Ruysdael. Heeremans painted canal landscapes, beach and river scenes, and village activities—themes depicted by these older artists but painted by Heeremans in a somewhat coarser manner, with many small genre figures added. The paintings were often done in pairs—for example, a spring or summer scene contrasted with a winter one. A painting by Heeremens with a similar setting, dated 1684, was sold at Christie's (London, July 30, 1934, no. 130) and another with the composition reversed, dated 1686, was sold at Christie's (London, November 19, 1948, no. 3). All these works reveal Heeremans's special ability to capture reflections of buildings and boats in the water.

Attributed to Philips Wouverman, *Battle Scene with Cavalry*

Attributed to Philips Wouverman
Haarlem, 1619-1668

Battle Scene with Cavalry
Oil on panel, 8⅝ x 12¾ inches (21.9 x 32.4 cm.)

Gift of Mr. and Mrs. Robert Bunzl in honor of the opening of the Atlanta Memorial Arts Center, 1968.15.

Provenance: Marquess of Hastings, 1829; Max Strauss Collection; Sale, Vienna, March 22, 1926, no. 44; Mr. and Mrs. Robert Bunzl, Atlanta.

Bibliography: C. Hofstede de Groot, *Catalogue Raisonné*, London, 1909, II, p. 501, no. 775.

From a family of painters, Wouverman was trained in Haarlem and became a specialist in the painting of horses, landscapes, and genre subjects. His early landscapes reveal the influence of Verbeeck, but gradually his works became more Italianate and richer in figures. The artist's most frequent subjects were scenes of horsemen, stables, and cavalry engagements—usually crowded compositions filled with the lively action of flailing and shooting men and rearing horses.

As J. Nieuwstraten has pointed out (in a letter of November 19, 1982), the High Museum's painting appears to be a fragment when compared to similar battle scenes in Dresden and Chantilly. Hofstede de Groot accepted it as a work by Wouverman, but it may have been painted by one of his many imitators, perhaps Jan van Huchtenburgh (1647-1733).

Pieter van Boucle, *Still Life with Fruit and Game*

Pieter van Boucle
Antwerp, before 1610-1673, Paris

Still Life with Fruit and Game, ca. 1650
Oil on canvas, 38 x 50½ inches (96.5 x 128.3 cm.)

Gift of Van Diemen-Lilienfeld Galleries, New York, 1958.2.

Exhibition: *Still Life Paintings from the XVI Century to the Present*, Atlanta Art Association, Jan. 10-29, 1958.

Bibliography: Jacques Foucart, "Un peintre flamand à Paris, Pieter van Boucle," in *Etudes d'Art français offertes à Charles Sterling*, Paris, 1975, pp. 240, 243, no. 3, fig. 153; *La peinture française du XVIIᵉ siècle dans les collections américaines (France in the Golden Age: Seventeenth Century French Paintings in American Collections)*, exhibition catalogue, Paris and New York, 1982, p. 346.

Van Boucle (sometimes spelled Boeckel), the son of an Antwerp engraver, was in Paris by the 1620s. He may have associated with the French painters Vouet, Moillon, and Baugin, but his most charac-teristic works show the influence of the Flemish school, notably Jan Fyt and Frans Snyders.[1] His still lifes, often of fish, were very popular. Van Boucle's works were even bought by the King, but the artist, known for his extravagances, seems to have died impoverished.

Pierre Rosenberg first identified the High Museum's painting as a work by van Boucle.[2] Its depiction of the pears, grapes, and basket is very similar to a signed and dated still life (1649) in The Toledo Museum of Art.[3] The richness of the composition and such animating details as the goat eyeing the grapes recall the robust creations of Snyders, but this work has a French sense of elegance and grace.

[1]See Michel Faré, *La Grand Siècle de La Nature Morte en France*, Paris, 1974, pp. 98-103.
[2]In conversation (March 1965) and in a letter of May 12, 1965.
[3]*The Toledo Museum of Art: European Paintings*, Ohio, 1976, p. 28, pl. 185.

Anthonie Palamedesz., *Portrait of an Old Woman*

Anthonie Palamedesz.
Delft, 1601-1673, Amsterdam

Portrait of an Old Woman, 1667
Oil on canvas, 38½ x 31½ inches (97.8 x 80 cm.)
Signed and dated at middle of left side: *APalamedesz pinxit 1667*

Friends of Art purchase, 1942.13.

Provenance: Sale, Dorotheum, Vienna, June 13-19, 1935, no. 186; Frohlich, Vienna, 1938; E. & A. Silberman Galleries, New York.

Exhibitions: *Masterpieces of Dutch Art*, Grand Rapids Art Gallery, Michigan, 1940; *Five Centuries of Painting*, The Muhlenberg College Museum, Allentown, Pennsylvania, Nov.-Dec., 1941.

A painter of both genre scenes and portraiture, Palamedesz. studied with Mierevelt in Delft. His early works—conversation pieces depicting dining, drinking, gambling, and music-making—are in the style of Codde, Duck, and Dirck Hals. While these works are painted in a lively manner with detailed settings, his portraits, primarily of Amsterdam mat-rons, are dark and serious. This characteristic portrait, reflecting the style of Terborch, is quite similar to another one by Palamedesz. sold at Christie's (London, March 6, 1925, no. 134) that was signed and dated 1664. In both paintings, the woman in severe garments and the chair are isolated against a somber background, so that nothing distracts from the sitter's fixed stare at the viewer.

Isaac Luttichuys, *Portrait of a Woman*

Isaac Luttichuys
London, 1616-1673, Amsterdam

Portrait of a Woman, ca. 1662
Oil on canvas, 44 x 36½ inches (111.8 x 92.8 cm.)

Gift of Mrs. Howard C. Candler and Mrs. Charles Moody in memory of Florella Harper Glenn, 1941.2.

Provenance: Prince Elie Parma-Bourbon, Castle Schwarzau, Austria, 1938; E. & A. Silberman Galleries, New York.

Exhibitions: *Dream of Fair Women*, Brooks Memorial Art Gallery, Memphis, 1935-36; *Texas Centennial Exposition*, 1936; *Loan Exhibition of International Art*, Los Angeles Art Association, 1937; *Dutch Seventeenth Century Portraiture, The Golden Age*, John and Mable Ringling Museum of Art, Sarasota, Dec. 4, 1980-Feb. 8, 1981, no. 41.

Bibliography: W. R. Valentiner, "Isaac Luttichuys, A Little-Known Dutch Portrait Painter," *The Art Quarterly*, Summer 1938, p. 178, no. 32, fig. 23.

Isaac Luttichuys, like his older brother Simon, was an active portraitist in Amsterdam, where he settled prior to 1638. Luttichuys's works of the 1640s show some influence of Rembrandt, but his style is closer to that of Bartholomeus van der Helst and Terborch, without showing their flair. In his portraits of well-to-do burghers, the sitter, often with a curiously morose expression, is usually silhouetted against a dark background. Details such as the clothing, jewels, lace, and delicate hands are carefully delineated, but there is little insight into the character of the subject. Luttichuys frequently repeated the formats of his portraits. Women in poses nearly identical with the pose in the High Museum portrait appear in a painting formerly in the London Art Market[1] and another in the Mauritshuis, The Hague.[2] Lia de Bruyn (in a letter of January 25, 1980) has written that the woman's clothes appear to date from 1662.

[1]See Valentiner, 1938, fig. 24.
[2]See *Mauritshuis . . . illustrated general catalogue*, The Hague, 1977, no. 722.

J. de Langhe, *Portrait of a Gentleman*

J. de Langhe
Active in The Hague, 1674-1692

Portrait of a Gentleman, 1674(?)
Oil on canvas, 32 x 24⅞ inches (81.3 x 63.2 cm.)
Signed and dated at the upper right corner: *J. de Langhe fecit 1674*(?)

Bequest in memory of Mrs. Caro duBignon Alston, 1960.37.

Provenance: Koudacheff Collection; Prince Tatarsky, St. Petersburg; Sale, Frederick Muller & Cie., Amsterdam, June 27, 1905, no. 18; Casa di Vendite Gherardalli, Florence, 1931; Robert Alston, Atlanta.

The discovery of the signature on this painting dispelled the notion that it was by Ferdinand Bol. Little is known of de Langhe except that he was a portraitist active in The Hague. Another portrait by de Langhe, of a woman from the van der Does family, was in the Donk collection, The Hague, in 1924.[1] This portrait of a man, reminiscent in its elegance of van Dyck and similar in style to works by J. de Baen and Paulus Lesire, is probably the work which Hofstede de Groot recorded in the two Russian collections listed in the provenance.[2]

[1] Photograph in the Rijksbureau, The Hague.
[2] Information in a letter from Lia de Bruyn, Oct. 21, 1981.

Jan van Kessel, *Butterflies, Other Insects, and Flowers* *Butterflies, Caterpillars, Other Insects, and Flowers*

Jan van Kessel
Antwerp, 1626-1679

Butterflies, Other Insects, and Flowers
Oil on copper, 4½ x 5¾ inches (11.4 x 14.7 cm.)
Signed and dated at lower right: *J. v. kessel fecit A 16(59)*

Butterflies, Caterpillars, Other Insects, and Flowers
Oil on copper, 4½ x 5⅝ inches (11.4 x 14.7 cm.)
Signed and dated at middle corner edge: *J. v. kessel fecit 16(59)*

Purchases in memory of Dr. and Mrs. De Los Lemuel Hill, 1958.19 and 1958.20.

Provenance: Morel Collection(?); Victor D. Spark, New York, 1958.

Exhibition: *Insects and Us*, Museum of Arts and Sciences, Macon, Georgia, Jan. 24-June 28, 1981.

Jan van Kessel was a member of a widespread family of painters. His father had worked for the Archduke Maximilian of Austria, and had collaborated with Jan (Velvet) Brueghel, whose daughter he married. Jan van Kessel, one of five children, studied with his father as well as with Simon de Vos and his uncle, Jan Brueghel II. In 1645 he was registered as a member of the Antwerp Guild of St. Luke as a painter of

flowers. Like members of the Brueghel family, he specialized in detailed paintings of flowers, still life, and animals. His works, usually painted on panel or copper, often have the appearance of scientifically arranged groups of insects, flowers, or snakes. Such panels were on occasion used to decorate elaborate pieces of furniture.[1] The two works in the High Museum's collection, both signed and dated, reveal how van Kessel could combine the motifs of butterflies, insects, and flowers into ever new patterns.[2] There has been some restoration, particularly on 1958.20, in which the bug at the lower left corner has been given stripes.

[1]A cabinet with inlaid paintings by van Kessel was sold at Sotheby's, London, Nov. 3, 1964, no. 66.
[2]For comparable works, including one in which the artist uses snakes and caterpillars to spell out his name, see the exhibition catalogue *Bruegel, une dynastie de peintres*, Palais des Beaux-Arts, Brussels, 1980, pp. 329-331, nos. 276-281. Similar examples are found in H. Gerson and J. W. Goodison, *Catalogue of Paintings, I–Dutch and Flemish*, Fitzwilliam Museum, Cambridge, 1960, nos. 309, 312; and Edith Greindle, *Les Peintres Flamands de nature morte au XVIIe siècle*, Brussels, 1983, pp. 156-157, pls. 81, 82.

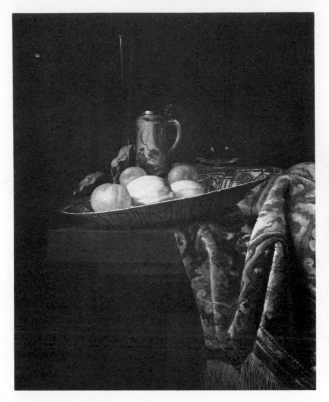

Hendrick van Streek, *Still Life with Rug* (color plate, page 85)

Attributed to Philipp Sauerland, *Still Life with Sea Shells*

Hendrick van Streek
Amsterdam, 1659-after 1719

Still Life with Rug
Oil on canvas, 40 x 32½ inches (101.6 x 82.6 cm.)
Signed at lower left: *H.V. Streek*

Purchase with special funds allocated by the Atlanta Arts Alliance Board of Trustees, 1973.52.

Provenance: Paul Rewmert; Anna Borg; Sale, Rasmussen, Copenhagen, May 1969, no. 527; H. Shickman Gallery, New York.

Exhibitions: *Stilleben Kunstforeningen*, Copenhagen, 1965, no. 78; *With a Little Help From Our Friends*, Mississippi Museum of Art, Jackson, April 22-July 16, 1978, no. 29.

Hendrick van Streek followed in the footsteps of his father, Juriaen (1632-1687), becoming a painter of still life in the manner of Kalf. As in this example, Delft and oriental vases, fruits, Venetian glass, and richly patterned rugs were all combined in opulent compositions of colorful harmonies before muted backgrounds.[1]

[1]Similar compositions by Juriaen are illustrated in Walther Bernt, *The Netherlandish Painters of the Seventeenth Century*, New York, 1970, III, pls. 1142, 1143, and also in Herman Wengraf, exhibition catalogue, London, Winter 1972-73, no. 7.

Attributed to Philipp Sauerland
Danzig, 1677-ca. 1750, Breslau

Still Life with Sea Shells
Oil on canvas, 12⅜ x 15 inches (31.3 x 38.1 cm.)

Purchase with funds from the Henry B. Scott Fund, 1959.15.

Provenance: Victor D. Spark, New York.

Exhibition: *Still Life Painting*, Milwaukee Art Institute and Cincinnati Art Museum, Sept.-Oct. 1956, no. 51.

Philipp Sauerland, who was long active in Breslau before establishing himself in Berlin, specialized in still lifes. The attribution of this work to the artist is made on the basis of a signed still life of sea shells.[1] This particular subject matter had been made popular by such Dutch masters as Balthasar van der Ast (before 1590-after 1656).[2]

[1]Formerly at the Arcade Gallery, London, reproduced in *Die Weltkunst*, Jan. 1954, p. 10.
[2]See Charles Sterling, *Still Life Painting*, Paris, 1959, pl. 21.

112

Moritz Michael Daffinger, *Portrait of Count O'Donnell* Karl von Saar, *Portrait of Mr. Lagousius* (?)

Moritz Michael Daffinger
Vienna, 1790-1849

Portrait of Count O'Donnell, 1813
Watercolor on ivory, 2¹¹/₁₆ x 2⅛ inches (6.8 x 5.5 cm.)
Signed and dated at right center: *Daffinger 1813*

Gift in memory of Robert and Nellie Bunzl by their children, 1981.31.

Daffinger was the son of a painter in the porcelain factory of Vienna. He entered the factory in 1801 as an apprentice, and was trained there by Johann Weixlbaum. The following year he enrolled in the Vienna Academy and in 1804 won a first prize for drawing. He remained as a painter at the factory until 1812, but had already begun a career as a portrait miniaturist. Both Isabey and Thomas Lawrence visited Vienna and influenced his work. He made many copies in miniature of Lawrence's portraits.

Daffinger received the patronage of Archduchess Sophie and produced miniatures of most of the Imperial Family. He also painted the Viennese aristocracy and bourgeosie, and was particularly famous for his depictions of Viennese "beauties." In 1836 he was made a member of the Academy of Vienna. During his last years, in addition to portraits, he painted botanical studies. The High Museum's miniature, an early work, shows the influence of Isabey's romantic style.

Karl von Saar
Vienna, 1797-1853

Portrait of Mr. Lagousius(?), 1830
Watercolor on parchment, 3 x 2½ inches (7.7 x 6.4 cm.)
Signed and dated at the left: *v. Saar 1830*

Gift in memory of Robert and Nellie Bunzl by their children, 1981.23.

Von Saar studied at the Academy of Vienna from 1811 to 1817, and he exhibited miniatures and portraits in watercolor there from 1822 to 1838. Later in his career he also painted oil portraits and printed lithographs. He was one of the most expressive of the Viennese miniaturists and painted in a broader, less detailed manner than many of his contemporaries.

Albert Emil Kirchner, *Heidelberg Castle*

Albert Emil Kirchner
Leipzig, 1813-1885, Munich

Heidelberg Castle, 1854
Watercolor on paper, 19 x 17¼ inches (48.3 x 44.5 cm.)
Signed at the lower right: *Emil Kirchner/ Munchen/ 1854*

Gift of the Phoenix Society of Atlanta, 1972.41.

Provenance: Empress Eugénie, Paris; Trouillon, Paris; Shepherd Gallery Associates, Inc., New York.

Exhibition: *Reality, Fantasy and Flesh*, The University of Kentucky Art Gallery, Lexington, Oct. 28-Nov. 18, 1973, no. 40.

Kirchner studied at the Dresden Academy with Johan-Christian Dahl, a noted Norwegian landscape painter, and Caspar-David Friedrich, the leading romantic landscape painter. He travelled and studied in northern Italy in the 1830s. The artist spent several summers in Heidelberg and made many paintings of the architecture around the old city, especially the Imperial Palace, in the early 1850s.

Kirchner's works, all done with great skill and bold coloring, reveal a mixture of realistic observation and romantic sensitivity. The scene depicted in this watercolor is the courtyard of the Heidelberg Castle. The building in the background with the ar-caded balcony is the Hall of Mirrors, a festive hall once lined with mirrors of Venetian glass, built by Friedrich II. The facade on the right is the Ottohein-rich Building, an outstanding example of German Renaissance architecture. The castle had at times been used as a fort and ammunition dump. The poor condition of the fountain in the foreground was the result of a massive gunpowder explosion in the early 1800s.

English

Sir Peter Lely, *Portrait of a Boy in a Hunting Costume*
(color plate, page 86)

Sir Peter Lely
Soest, 1618-1680, London

Portrait of a Boy in a Hunting Costume, ca. 1675
Oil on canvas, 50 x 40 inches (127 x 101.6 cm.)

Gift of Mrs. Emory L. Cocke, 1967.40.

Provenance: James S. Floyd, Atlanta; Mrs. Emory L. Cocke, Atlanta.

Born Pieter van der Faes, the painter left his native Westphalia to study in Haarlem with Frans Pietersz. de Grebber. He adopted the name Peter Lely after de Lelye, the section of The Hague where his family had a home. Originally a painter of arcadian landscapes and history subjects, Lely devoted himself primarily to portraiture after his move to England in about 1643. He was employed in 1647 by the Earl of Northumberland to paint royal portraits, including those of Charles I and the Duke of York. While in the Earl's employ, he was able to study the family's collection of portraits by Sir Anthony van Dyck, whose painterly and elegant works made a strong impression. Lely often relied on poses created by van Dyck.

Lely's dexterity and ability to flatter his sitters gained him many royalist patrons; in 1661, after the Restoration, he became Principal Painter for Charles II. He received extensive commissions, such as the series of "Windsor Beauties" commissioned in the 1660s by the Duke of York and the set of Admirals at Greenwich (1666-67). His popularity led to the development of a large workshop which produced repetitions following the master's catalogue of poses. At its best, as in the "Windsor Beauties," Lely's rendering of the rich textures of silks and satins compensates for a certain blandness of characterization. The figures in his works, often costumed in allegorical dress, were set in pastoral landscapes of great delicacy. Lely was knighted the year before his death.

Lely's paintings of children, like those by van Dyck, were some of his most appealing and natural portraits. This painting has been accepted by both Oliver Miller (letter of September 9, 1970) and Douglas Stewart (letter of August 21, 1970) as a good example of the artist's style of the 1670s. Roy Strong (letter of February 26, 1968), however, has suggested the painting might be by Lely's assistant, John Greenhill, and Ross Watson (letter of June 18, 1968) has noted that several portraits by Wissing (including one of Edward Rich, Earl of Warwich and Holland, engraved by W. Richardson in 1794) are very similar in format to this painting.

The portrait follows the pattern of several other works by Lely in which a young boy in a landscape is shown in arcadian costume—as a shepherd or even a young Adonis. See, for example, the *Portrait of a Boy* (Dulwich College Picture Gallery) and *Portrait of Henry Siding, Earl of Romney* (Viscount de l'Isle) in which the boy is also accompanied by a dog.[1]

[1]Reproduced in Oliver Miller, *Sir Peter Lely, 1618-80*, exhibition catalogue, National Portrait Gallery, London, 1978, nos. 28, 19.

115

Sir Godfrey Kneller, *Portrait of a Gentleman*

Sir Godfrey Kneller
Lübeck, 1646-1723, London

Portrait of a Gentleman
Oil on canvas, 49½ x 40⅛ inches (125.7 x 102 cm.)

Gift of Mrs. Emory L. Cocke, 1967.41.

Provenance: James S. Floyd, Atlanta; Mrs. Emory L. Cocke, Atlanta.

After studying mathematics at the University of Leyden, Kneller turned to painting about 1662. He studied with Ferdinand Bol and possibly with Rembrandt. Kneller's earliest known work is a 1666 *Portrait of the Archbishop and Elector of Mainz*. Portraiture became his specialty, and when he was in Italy (1673-75), he executed many portraits of Venetian nobility.

In 1676 Kneller went to England, where, following in the tradition of van Dyck and Lely, he had a highly successful career. Charles II sent Kneller to France in 1687 to paint Louis XIV, and in 1688 William and Mary appointed Kneller and John Riley as Principal Painters. Following Riley's death in 1691, Kneller had sole possession of the title. He was knighted by the King in 1692, and was chosen as first

Governor of the first London Academy of Painting. Among his major series of works were the "Hampton Court Beauties" painted for Queen Mary in 1690-91 and forty-two portraits of members of the Kit Cat Club painted from 1702-1717. These large works, with their expressive features and robust style, were to serve as a model for such later painters as Hogarth and Gainsborough.

This portrait of an unknown gentleman has been accepted as a Kneller by Oliver Miller (in a letter of September 9, 1970) and J. D. Stuart (in a letter of July 1970), but Roy Strong (in a letter of February 26, 1968) has suggested that it might be by Michaël Dahl (1656-1743). The attitude and features of the bewigged gentleman are typical of Kneller's work and are also remarkably like those of Kneller himself in portraits such as one in the National Portrait Gallery, London (ca. 1715) and the frontispiece to the engravings of the "Beauties." The composition and costume are nearly identical (but reversed) with those in a *Portrait of Sir Walter Yonge* that was in the Hartford Collection, Sherman Oaks, California.[1]

[1]Photograph in the archives of the National Gallery of Art, Washington, D.C.

Attributed to Richard Wilson, *Italian Landscape*

Attributed to Richard Wilson
Penegoes, 1714-1782, Colommendy

Italian Landscape, ca. 1749-1755
Oil on canvas, 36½ x 34 inches (92.7 x 88.9 cm.)

Gift of Mrs. Thomas K. Glenn in memory of Thomas K. Glenn, 1947.21.

Provenance: Thomas Agnew & Sons, London; General André W. Brewster, U.S.A.; Doll & Richards, Boston, 1947; M. Knoedler & Co., Inc., New York; Mrs. Thomas K. Glenn, Atlanta.

Exhibitions: American British Art Center, New York, 1946; *Three Centuries of Painting*, Milwaukee Art Institute, Oct. 18-Dec. 1, 1946.

Bibliography: W. G. Constable, *Richard Wilson*, Cambridge, Massachusetts, 1953, p. 237, pl. 145a; *Masterpieces*, Atlanta, 1965, p. 23.

Richard Wilson was one of the leading British landscape painters of the eighteenth century. The son of a Welsh clergyman, he was sent to London in 1729 to study with the portrait painter Thomas Wright. He developed a clientele of important patrons, but on a visit to Italy in 1730 he was advised by the Venetian painter Francesco Zuccarelli (1702-1788) to abandon portraiture and concentrate on landscapes. Wilson painted some exquisite Neapolitan views for Lord Dartmouth and upon returning to England devoted himself exclusively to outdoor views, often based upon the sketches he had made in Italy. Wilson became widely respected, and in 1768 was one of the founding members of the Royal Academy, of which he became the librarian in 1776. The popularity of his work led to many copies and imitations. The present painting, with its tiny figures set in an airy Italianate landscape, poses a problem as to attribution. In his catalogue of the artist's work, W. G. Constable designated it as "perhaps Wilson."

John Constable, *Water Street, Hampstead*

John Constable
East Bergholt, 1776-1837, London

Water Street, Hampstead, ca. 1832
Watercolor on paper, 5¾ x 7½ inches (14.6 x 19.1 cm.)
Inscribed on the verso: *Water Street, Hampstead/ To: Mr. John Allen, East Bergholt, Suffolk/ With the sincere regards of his friend/ John Constable, R.A./ November 22, 1832*

Gift of Mr. and Mrs. Alfred W. Jones, 1961.54.

Provenance: John Allen, East Bergholt; Mr. and Mrs. Howard E. Coffin, Detroit, ca. 1910-ca. 1928; Mr. and Mrs. Alfred W. Jones, Sea Island, Georgia.

Exhibitions: *Constable, Symposium and Exhibition*, Art History Museum, The University of Wisconsin, Milwaukee, April 1-14, 1976, no. 7; *Drawings from Georgia Collections: 19th and 20th Centuries*, High Museum of Art, Atlanta, and Georgia Museum of Art, Athens, May 14-Aug. 23, 1981, no. 32.

Constable, the son of a prosperous Suffolk miller, went to study at the Royal Academy in 1799. Although he was to spend much time in London, he retained strong links with the Suffolk countryside of his childhood, even settling his family in Hampstead in 1820. Constable frequently sketched in the area, and produced watercolors of a freshness and immediacy sometimes lacking in his more finished oil paintings.

This study combines some of his favorite motifs. There is the comfortable cottage nestling amidst the trees, resembling the home of Willy Lott, which frequently served as his inspiration.[1] The cattle are the Suffolk breed to which Constable was so partial that, according to his first biographer, C. R. Leslie, he included them no matter what the location of his subject.[2]

In 1831 the artist made a group of sketches of this size. The Water Street referred to in the inscription has not been located. Perhaps it is the same as the Water Lane, Stratford St. Mary, Suffolk, in a drawing of 1827.[3] From November 8 to December 13, 1832, Constable was back in East Bergholt to attend the funeral of his young friend Johnny Dunthorne; during that time he gave this drawing to John Allen, a captain in the Royal Navy who was probably Constable's cousin. Allen was born ca. 1782 and was still living in 1849.[4]

[1]See the exhibition catalogue *Constable: Paintings, Watercolors, and Drawings*, Tate Gallery, London, 1976, no. 294.
[2]See Freda Constable, *John Constable: A Biography 1776-1837*, Lavenham, 1975, p. 68.
[3]*Constable*, Tate, 1976, no. 252.
[4]See R. B. Beckett, ed., "John Constable's Correspondence: The Family at East Bergholt, 1807-1837," *Suffolk Records Society*, IV, 1962, pp. 145, 200, 321.

Attributed to George Lambert, *Landscape with Ruins*

Attributed to George Lambert
Kent, 1710-1765

Landscape with Ruins
Oil on canvas, 35½ x 40⅛ inches (90.3 x 102 cm.)

Gift of Sonia W. Schwartz and Harriet W. Goldstein, 1977.2.

This arcadian landscape was tentatively attributed to Lambert by Marcel Roethlisberger, who pointed out (in a letter of April 15, 1980) its marked similarity to a signed and dated work of 1725 sold at Christie's, London, on April 11, 1980 (no. 172). Another painting of this type by Lambert had been sold at Christie's, London, on July 25, 1952 (no. 71).

Lambert, who was born in Kent, was a student of Hassel and Wootton. He gained a considerable reputation in London as a painter of theater sets, and these seem to have influenced his picturesque landscapes.

119

Sir Henry Raeburn, *Portrait of Sir Charles Colville*

Sir Henry Raeburn
Stockbridge, 1756-1823, Edinburgh

Portrait of Sir Charles Colville, 1818
Oil on canvas, 29⅜ x 24⅜ inches (74.6 x 62 cm.)

Gift of friends of J. J. Haverty in his memory, 1940.6.

Provenance: Commissioned by William Mure of Caldwell and by descent in the Mure family until 1912; Edward Lowe; M. Knoedler & Co., Inc., New York; E. & A. Silberman Gallery, New York, 1940.

Exhibitions: *Victorian Exhibition*, New Gallery, London, 1891-92, no. 274; *Five Centuries of Painting*, High Museum of Art, Atlanta, Feb., 1940.

Bibliography: Walter Armstrong, *Sir Henry Raeburn*, London, 1901, p. 99; Edward Pinnington, *Sir Henry Raeburn*, London, 1904, p. 223, no. 130; James Greig, *Sir Henry Raeburn*, London, 1911, p. 42; W. Roberts, *General The Honourable Sir Charles Colville, G.C.B., by Sir Henry Raeburn, R.A.*, London, Oct. 1920; *Art Digest*, Aug. 1, 1940, p. 11; John Colville, *The Portrait of a General*, Salisbury, 1980, pp. vii-ix and frontispiece.

Henry Raeburn was raised in Stockbridge, near Edinburgh, by his older brother following the deaths of their parents. He left school at fifteen and was apprenticed to a goldsmith. His first lessons in drawing were provided by a seal-engraver, and Raeburn

soon after began to paint miniatures in watercolor. He received instructions in oil from the leading Edinburgh portraitist, David Martin. His earliest known full-length oil portrait is *George Chalmers* (1776). By the age of twenty-one, Raeburn was an established portrait painter for the distinguished families of the expanding city of Edinburgh. His 1778 marriage to the widow of Count Leslie gave him three stepchildren and substantial means.

On his way to Rome in 1785, Raeburn studied in London at the studio of the leading portraitist, Sir Joshua Reynolds, who provided him with introductions to Gavin Hamilton and James Byers in Rome. After two years studying ancient art and masterpieces of the Renaissance and Baroque, he returned to Edinburgh to settle down as the city's most fashionable portraitist. In 1810 he visited London again, perhaps with the intention of moving there. He returned to Edinburgh, however, and became a regular contributor to the Royal Academy, of which he was elected an associate in 1812 and a full member in 1815. Raeburn was knighted by George IV when the King visited Edinburgh in 1822.

Raeburn was a prolific portraitist, but unfortunately he did not keep diaries or sign or date most of his works. In the composition of his portraits, he favored strong theatrical lighting to illuminate the

William Collins, *Study for "The Morning Lesson"*

faces and upper torsos of his sitters, leaving the lower portion and background in chiaroscuro. Sometimes, like Reynolds and Gainsborough, he portrayed his sitters against a landscape, but generally he preferred a neutral ground. His portraits present the intellectual leaders of Scotland—historians, scientists, philosophers, soldiers—as well as elegant women of society.

The subject of this portrait, Sir Charles Colville (1770-1843), entered the army at age sixteen, served in the West Indies, Ireland, and Egypt, and became one of Wellington's favorite generals. In 1818, at the age of forty-eight, he married Jane, eldest daughter of William Mure of Caldwell in Ayrshire. The bride's father commissioned Raeburn to paint pendant portraits of the couple. The portraits remained in the Mure family until 1912, when they were sold. The portrait of Lady Jane Colville is now in the collection of her great-grandson John Colville.

In this half-length portrait, the stern general is shown in full military dress. He wears the Peninsular Gold Cross around his neck and the sash of knighthood of the Grand Cross of the Order of Bath, which is also the top decoration on the right. Below that decoration are the breast Star of the Order of Tower and Sword (Portugal) and the breast Star G.C.H. (Knight Grand Cross of the Royal Hanoverian Guelphic Order). The portrait was engraved in mezzotint by G. T. Payne following the death of the general.

William Collins
London, 1788-1847

Study for "The Morning Lesson," 1834
Oil on panel, 13⅝ x 11⅜ inches (34.6 x 28.9 cm.)

Gift of Mrs. James Carmichael in memory of her husband, 1978.113.

Collins is a significant minor figure in the history of English painting. He helped establish the tradition of picturesque rustic landscapes which had been begun by his first teacher, George Morland. The young Collins entered the Royal Academy School in 1807 and began exhibiting his work that same year. He was elected to the Royal Academy in 1820. In 1822 he married the daughter of the Scottish painter Andrew Geddes. Encouraged by his friend, the painter Wilkie (for whom he named his son, the famous novelist), Collins travelled to Holland and Belgium in 1828, Italy in 1836-38, and Germany in 1840. Collins's rustic landscapes and scenes of sentimental pastimes became very popular. A typical and well-known work is *The Morning Lesson*, one of two works exhibited by the artist in 1834. Wilkie Collins's description of it is equally applicable to the small preliminary study now in the High Museum:

> "The Morning Lesson," with its fresh, open, dewy landscape, its tranquil Cumberland distance, its "misty mountain tops," mingling with the delicate airy clouds, and its group of three foreground figures (a rosy girl teaching a little child at her knees to read the alphabet, and repressing the importunate playfullness of an idle boy behind her) . . . [shows] the capacity as well as the ambition of the painter to sustain the variety in production which is an essential requisite of successful Art.[1]

[1] W. Wilkie Collins, *Memoirs of the Life of William Collins, Esq., R.A.*, London, 1848, II, p. 42.

French

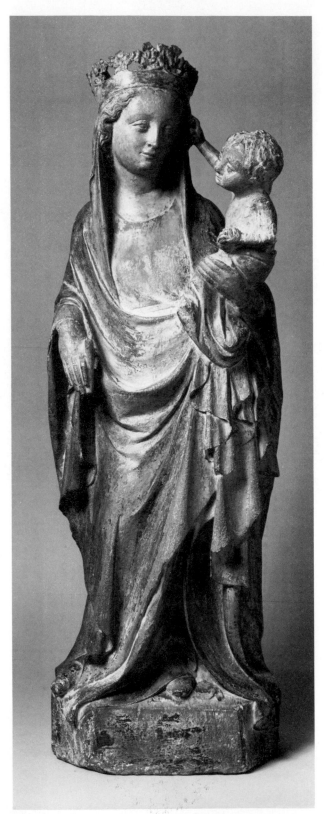

Unknown French, *Madonna and Child*

Unknown French
Late 14th century

Madonna and Child
Limestone with traces of polychrome, 31¼ x 9½ x 6½ inches (79.4 x 24.1 x 16.5 cm.)

Friends of Art purchase, 1950.32.

Provenance: R. Stora and Company, Paris and New York, 1940.

Exhibitions: *A Medieval Treasury from Southeastern Collections*, William Hayes Ackland Memorial Art Center, Chapel Hill, North Carolina, April 4-May 23, 1971, no. 35; *Songs of Glory: Medieval Art from 900-1500*, The Oklahoma Museum of Art, Oklahoma City, Jan. 21-April 29, 1985.

This graceful Madonna and Child is a type developed in the Ile-de-France in the late fourteenth century. As Michael Ward has pointed out (in a letter of November 21, 1983), the calligraphic style of the drapery is reminiscent of miniatures by André Beauneveu, such as those in the *Psalter of Jean de Berry*, ca. 1390. Although this type of sculpture was popular in Paris, this piece is most likely provincial in origin, possibly from the region of Champagne. The charming intimacy between mother and child is particularly well delineated.

Unknown French
15th Century

A Deacon Saint
Wood with polychrome, 42 x 15 x 9 inches (106.7 x 38.1 x 22.9 cm.)

Gift of the Samuel H. Kress Foundation, 1958.59.

Provenance: Sir Wernher Beit, London; Oscar Homberg, Paris; Dr. Jacob Hirsch, New York; Samuel H. Kress Foundation, 1955.

Bibliography: *Kress Collection*, Atlanta, 1958, p. 73; Middeldorf, 1976, p. 89, fig. 60.

This sculpture of an unidentified saint with a tonsured head and wearing a deacon's dalmatic is of uncertain origin. At one time it was called School of Avignon. It has been compared to another statue of a deacon saint in the Louvre, probably of Burgundian origin, by Charles Avery.[1]

[1]See M. Aubert and M. Beaulieu, *Musée National du Louvre, Description Raisonnée des Sculptures, vol. I: Moyen-Age*, Paris, 1950, p. 230, no. 342.

Unknown French, *A Deacon Saint*

School of Fontainebleau, *Lady with a Red Lily* (color plate, page 87)

School of Fontainebleau
France, 16th century

Lady with a Red Lily
Oil on panel, 26 x 19½ inches (66.1 x 49.5 cm.)

Anonymous gift, 1961.56.

Provenance: Marquis de Biencourt; Wildenstein & Co., Inc., New York.

Exhibitions: *L'Ecole de Fontainebleau*, Wildenstein & Co., Paris, Dec. 1939, no. 9; *The School of Fontainebleau*, Wildenstein & Co., Inc., New York, Oct. 31-Nov. 30, 1940; *Nude in Painting*, Wildenstein & Co., New York, Nov. 1-Dec. 1, 1956, no. 6.

Bibliography: René Huyghe, "L'Ecole de Fontainebleau," *Beaux-Arts*, Dec. 1, 1939, pp. 12-13; Alexander Watt, "Notes from Paris," *Apollo*, Feb. 1940, p. 46; Julius S. Held, "Flora, Goddess & Courtesan," in *De Artibus Opscula XL: Essays in Honor of Erwin Panofsky*, ed. Millard Meiss, New York, 1961, I, p. 217; II, p. 74, fig. 22; *Masterpieces*, Atlanta, 1965, p. 20.

The School of Fontainebleau refers to the French mannerist style that developed in the sixteenth century Valois court and flourished until the end of the reign of Henri IV in 1610. Mannerism was imported by François I in 1528 when he undertook the conversion of his medieval hunting lodge at Fontainebleau into a grandiose royal residence. He invited leading Italian painters—beginning with Leonardo da Vinci and following with Rosso Fiorentino, Luca Penni, and Francesco Primaticcio—to guide the transformation. French artists who quickly adopted the mannerist style were François Clouet, Jean Cousin, and Antoine Caron.

One aspect of the Fontainebleau School's style was a taste for eroticism. Scenes of nude gods and goddesses as well as the court favorites at their bath were popular subjects. The High Museum's painting of a woman at her toilette displays the Fontainebleau ideal of feminine beauty. The chiseled body appears to be made of pearl or enamel. The mask-like face is ornamented with elaborate flowers and jewelry. This half-length treatment of the female nude is one of a large number of Fontainebleau pictures which ultimately derive from a frequently copied nude version of Leonardo's *Mona Lisa*.[1] Most of these works are thought to represent various royal mistresses, although perhaps the most famous, Clouet's signed work in the National Gallery (Washington), has been identified as a satire of Mary Queen of Scots.[2] In Clouet's work (and variants at Dijon, Basle, and Worcester), the woman at her dressing table is facing right, has a jeweled brush and a mirror, and there is a servant in the background.[3] The High Museum's example is one of several after a slightly different prototype: the woman, facing left, is set against a plain background with varying attributes. In a painting in a private collection in Paris, she is holding a mirror,[4] while in another in the Musée de Bar le duc there is an ovoid jewel casket to her left.[5] In all three versions, the placement of the hands, the drapery, and the bracelets are identical, but the woman's expression varies.

The High Museum's painting is distinguished by the importance given to the flowers, both in the woman's hair and in the vase. These have led Julius Held to identify the woman as a personification of the goddess of spring, Flora, pointing out that from the time of Boccaccio she was a figure of questionable morals.[6] She figured prominently in the imagery of the Fontainebleau School,[7] and this picture is undoubtedly in the tradition of Titian's famous *Flora* (Uffizi), showing a contemporary courtesan in the guise of Flora.[8] In this case the red lily serves to emphasize the woman's immoral nature.

[1]See André de Heresy, "L'histoire véridique de la Joconde," *GBA*, July-Aug. 1952, pp. 5-26.
[2]See Roger Trinquet, "L'Allégorie politique dans la peinture française au XVIe siècle: La Dame au Bain du François Clouet (Washington)," *Bulletin de la Société de l'histoire de l'art français*, 1966, pp. 99-119.
[3]See the exhibition catalogue *Fontainebleau*, The National Gallery of Canada, Ottawa, 1973, no. 244.
[4]In the photo archives of the Documentation du Louvre.
[5]See Guy Blazy, *Musée de Bar le duc, Catalogue des peintres*, Bar le duc, 1979, no. 226.
[6]Held, 1961, I, p. 217.
[7]See the Ottawa exhibition catalogue, 1973, no. G.
[8]Held, 1961, II, p. 12, fig. 15.

Du Mélezet, *Bowl of Strawberries* (color plate, page 87)

Du Mélezet (?)

Bowl of Strawberries, 1639
Oil on panel, 13½ x 22 inches (34.3 x 55.9 cm.)

Promised gift of Mrs. Francis Storza, Atlanta.

Provenance: Weinberger, Paris, 1937; Arnold Seligmann and Rey, New York, 1938; Harry G. Sperling, New York, 1947; F. Kleinberger & Co., New York, 1947.

Exhibitions: *The Painters of Still Life*, The Wadsworth Atheneum, Hartford, 1938, no. 64; *French Painting of the Time of Louis XIIIth and Louis XIVth*, Wildenstein & Co., Inc., New York, 1946, no. 31; *La peinture française, du XVIIᵉ siècle dans les collections américaines (France in the Golden Age–Seventeenth Century French Paintings in American Collections)*, Galeries Nationales du Grand Palais, Paris, Metropolitan Museum of Art, New York, The Art Institute of Chicago, Jan. 29-Nov. 28, 1982, no. 66.

Bibliography: Kurt Benedict, "A propos de Quelques natures mortes de l'époque Louis XIII," *Maandblad voor beelende kunsten*, 2, 1948, p. 32, ill. p. 35; Kurt Benedict, "Petits maitres de la nature morte en France," *L'Oeil*, July-Aug. 1962, p. 44; Michel Faré, *La nature morte en France*, Geneva, 1962, I, pp. 90, 324, no. 289; II, pl. 129; Jacques Thuillier and Albert Châtelet, *La peinture française de Le Nain à Fragonard*, Geneva, 1964, pp. 41-42; Michel Faré, *Le Grand Siècle de la nature morte en France*, Fribourg, 1974, p. 45, pl. 146.

This exquisite example of seventeenth century French still life has posed problems of identification since its first appearance in the Paris art market. At that time, and until the panel was cradled sometime before 1946, an inscription was visible on the verso. Rosenberg has made the following translation of it:

> Du Mélezet painted these strawberries the first days of the month of October 1639, the king being at Grenoble. The natural fruit was gathered from the mountain of the Grande Chartreuse by a peasant who chose them specifically with the plants, fruits, and flowers just as you can see them in this painting. Mélezet.[1]

King Louis XIII did journey to Grenoble with Cardinal Richelieu in 1639, remaining there from September 21 to October 9. Whether the artist du Mélezet was a native of Grenoble or had gone there as part of the king's retinue is not clear. The quality of the work, however, makes it apparent that the painter was familiar with current trends of still life painting in Paris. There is a marked similarity to the detailed and severe representations of fruit by Louise Moillon and François Garnier of the 1630s.[2] Du Mélezet's one known work reveals a brilliant handling of both the light and trompe-l'oeil effects. The fly placed on the edge of the table adds a charming note of verisimilitude.

[1]Quoted in the catalogue *France in the Golden Age*, 1982, p. 284.
[2]See the examples in Faré, 1974, pp. 44, 62.

Jean-Baptiste Monnoyer, *Flowers in a Basket* (color plate, page 88)

Jean-Baptiste Monnoyer

Lille, ca. 1636-1699, London
Flowers in a Basket, ca. 1695
Oil on canvas, 50 x 40 inches (127 x 101.6 cm.)

Gift of Mrs. Newdigate B. Owensby and Mr. and Mrs. Ogden Geilfuss, 1957.16.

Provenance: Scudamore Collection, Herefordshire; Hirschl & Adler Gallery, New York, 1957.

Exhibitions: *Still Life Paintings, XVI Century to the Present*, Atlanta Art Association, Jan. 10-29, 1958; *Masterpieces from Southern Museums*, Norfolk Museum of Arts and Sciences, Oct.-Dec. 1969; *La peinture française du XVIIe siècle dans les collections américaines (France in the Golden Age: Seventeenth Century French Paintings in American Collections)*, Galeries nationales du Grand Palais, Paris, Metropolitan Museum of Art, New York, and The Art Institute of Chicago, Jan. 29-Nov. 28, 1982, no. 74.

Bibliography: *Masterpieces*, Atlanta, 1965, p. 22; Sydney H. Pavière, *Jean-Baptiste Monnoyer, 1634-1699*, London, 1966, p. 18, no. 25, pl. 27.

Jean-Baptiste Monnoyer went to Paris as a young man to study painting. He was elected to the Académie Royale in 1665. His earliest works were history paintings, but he soon became a specialist in flower painting. Monnoyer collaborated with Lebrun and other artists on the decoration of Louis XIV's residences at Versailles, Vincennes, the Louvre, Marly, and the Tuileries. He had wealthy patrons such as Fouquet, and worked for the Savonnerie and Gobelins tapestry factories. Lord Montagu, British ambassador to the French court, invited the painter to England in 1690. There he produced ornamental works for Montagu House, and continued to paint prolifically until his death.

Famous in his lifetime, Monnoyer was considered by eighteenth century connoisseurs the equal of Flemish flower painters such as van Huysum. Dezallier d'Argenville, for example, wrote in 1762:

> He imparted a freshness and a truth so perfect to all he painted that one was convinced that nothing was lacking in these beautiful flowers but the scent they seemed to exhale. This great painter . . . painted everything after nature. He rendered them so precisely that we also see the dew that clings to flowers and lasts into the day.[1]

Monnoyer's work typically represented elaborate arrangements of precisely painted flowers in vases, urns, or baskets, often with bunches of grapes or other fruits, and set before draped fabrics or architectural fragments. As can be seen in this example, the painter was especially conscious of the delicate color relationships among the various flowers, contrasting the vivid red and white of the large blooms with the surrounding harmonies of green. The massive bouquet is perhaps rather too grand for its simple wicker basket. Pierre Rosenberg has suggested that this work, with its English provenance, probably dates from the artist's late period.[2]

[1]A. J. Dezallier d'Argenville, *Abrégé de la vie des plus fameux peintres . . .*, Paris, 1762, IV, pp. 181-182.
[2]Pierre Rosenberg, *La peinture française . . . dans les collections américaines*, Paris, 1982, p. 293.

Carle van Loo

Nice, 1705-1765, Paris

Erigone, ca. 1747
Oil on canvas, 39⅝ x 31½ inches (100 x 79.8 cm.)

Gift of Harry Flackman, 1966.14.

Provenance: Collection of the painter Peters, Brussels; Madame de Jullienne, Paris; Sale, Paris, Nov. 5, 1778, no. 43; Boyer de Fonscolombe, Aix-en-Provence; Sale, Paris, Jan. 18, 1790, no. 79; Sale, Munier-Jolain, Hôtel Drouot, Paris, April 17, 1920, no. 54; Harry Flackman, New York.

Exhibition: *The Rococo Age: French Masterpieces of the Eighteenth Century*, High Museum of Art, Atlanta, 1983, no. 14.

Bibliography: Pierre Rosenberg and Marie-Catherine

Sahut, *Carl van Loo, Premier Peintre du Roi*, exhibition catalogue, Nice, 1977, p. 65, no. 108.

Born in Nice to Dutch parents, Charles-André (called Carle) van Loo was to become the most famous member of an extensive family of artists. After the death of his father, Abraham Louis, in 1712, his brother Jean-Baptiste became his teacher, and they travelled together to Rome in 1716. There Carle also studied with the painter Benedetto Luti and the sculptor Pierre Legros. Returning to Paris, he worked on the restoration of the Galerie of François I at Fontainebleau and was painting independent works by 1723. The next year he won the Prix de Rome of the Académie, but since it lacked funds he was not sent to Rome. Having raised his own money by painting portraits, he was able to make the trip in 1728. He was well received in Italy—the Pope honored him in 1729—and in 1732 he was invited to work for the King of Sardinia, Charles-Emmanuel III, at Turin.

When he returned to Paris in 1734, his brilliant reputation preceding him, van Loo lived in the *hôtel* of the Prince de Carignan and was *agréé* by the Académie. He was *reçu* the next year and was even allowed to choose the subject of his reception piece, *Apollo Flaying Marsyas*. Van Loo received his first royal commission in 1736, and the same year became a *professeur* at the Académie. He was made *gouverneur* of the Ecole Royale des Elèves Protégés in 1749, ennobled in 1750, made *recteur* of the Académie in 1752, appointed *Premier Peintre du Roi* in 1762, and then director of the Académie in 1763.

During his lifetime, van Loo, who benefitted from the early deaths or departure to Rome of most of his potential rivals, was regarded as one of the greatest of French masters. He was able to work in several styles and mastered all areas of painting, from portraiture to religious and mythological subjects and *fêtes galantes*. His many commissions included royal portraits, decorations for Madame de Pompadour's rooms at Bellevue (1753), and a painting of the actress Mademoiselle Clarion as Medea for the Princess Galitzine, which was the sensation of the Salon of 1759.

Van Loo participated in the *Concours* of 1747, exhibiting a *Drunkenness of Silenus* which showed a heartiness of color and sensuality clearly inspired by the works of Rubens and Jordaens. The *Erigone* is in the same vein. The subject is taken from Ovid's *Metamorphoses*. The god of wine, Bacchus, conquered the nymph Erigone by transforming himself into a grape which she ate. As Panofsky has shown, the subject was given currency in the seventeenth century through glosses in French such as one illustrated by an engraving by Sebastien Le Clerk and by a painting by Guido Reni (a version of which in the collection of the Regent Philippe II d'Orléans

Carle van Loo, *Erigone* (color plate, page 89)

was made well known through an engraving).[1] Reni's work depicted the semi-nude nymph lifting the cloth off a bunch of grapes on a table.

In van Loo's treatment, Erigone is in an outdoor setting, coyly eyeing the viewer as she reaches for the luscious fruit. Van Loo's painting was engraved by P.-Ch. Levesque as *La Gaieté*, when, as the inscription records, it was in the "*cabinet de M. de Peters, Peintre de S. A. Le Prince Charles, Gouverneur des Paybas.*" Van Loo's original painting was believed lost until Pierre Rosenberg identified it as the work in the High Museum. The subject, with its erotic overtones, certainly must have appealed to eighteenth century taste. Natoire treated it in a painting exhibited at the Salon of 1747. Van Loo's work was copied by other artists, including J.-S. Berthélemy, who also painted two versions of his own.[2]

[1]Erwin Panofsky, *A Mythological Painting by Poussin*, Stockholm, 1960, pp. 23-33.

[2]Berthélemy's copy is in the Musée Municipal, Laon; his own signed version was sold at the Galerie Georges Petit, Paris, April 23-24, 1974, no. 54, and a variant of it, attributed incorrectly to Jean-François de Troy, is at the Sterling and Francine Clark Art Institute, Williamstown, Massachusetts. See the illustrations in Nathalie Volle, *Jean-Simon Berthélemy*, Paris, 1979, figs. 5, 18, 19. An *Erigone* by an anonymous eighteenth century French artist is also at the Musée de Picardie, Amiens.

Charles-Joseph Natoire, *Jacob and Rachel Leaving the House of Laban* (color plate, page 89)

Charles-Joseph Natoire
Nimes, 1700-1777, Castelgandolfo, Rome

Jacob and Rachel Leaving the House of Laban, 1732
Oil on canvas, 39½ x 56 inches (100.3 x 142.3 cm.)

Dedicated to Mrs. Newton Clark, President of the Members Guild, 1983-84. Purchase with gifts from Miss Frances Barnes, Esmond Brady Bequest, Corrie H. Brown Bequest, Dr. Robert P. Coggins, Hirschl & Adler Galleries, Mr. and Mrs. Arnold Kaye, Mrs. James D. Robinson, Sr. and Mrs. James D. Robinson, Jr., 1983.1.

Provenance: Louis-Antoine de Gondrin de Pardaillan, duc d'Antin (d. 1736) from 1732; Eglise de Saint-Antoine, Compiègne, sold in 1857; M. de Laporte, Senlis; Private collection, New York.

Exhibition: *The Rococo Age: French Masterpieces of the Eighteenth Century*, High Museum of Art, Atlanta, Oct. 5-Dec. 31, 1983, no. 4.

Bibliography: F. Boyer, "Catalogue Raisonné de l'oeuvre de Charles Natoire," *Archives de l'Art Français*, 1949, p. 34, under no. 3, p. 63, no. 235 (as lost); Patrick Violette, "Chronologie," *Charles-Joseph Natoire*, exhibition catalogue, Troyes, Nimes, Rome, 1977, p. 41.

Natoire received his first training from his father, an architect and sculptor in Nimes. He went to Paris in 1717 to continue his studies, working first with Gal-loche and then with Lemoyne. He won the Prix de Rome in 1721 for his *Sacrifice of Manoah*, enabling him to stay at the French Académie in Rome from 1723 to 1729. The director Vleughels had Natoire copy works by Veronese and Pietro da Cortona. Natoire was awarded the first prize of the Accademia di San Luca in 1725 for his drawing *Moses Descending from Mt. Sinai*.

In September 1730, not long after his return to France, Natoire was *agréé* as a history painter. In 1731, he painted two works devoted to the history of Clovis (Musée de Troyes) for Philibert Orry, the newly appointed *directeur des bâtiments*, who was trying to revive interest in subjects taken from French history. Even before being *reçu* by the Académie in December 1734, Natoire received a royal commission for allegorical subjects for the rooms of the Queen at Versailles. Boucher was *reçu* in the same session, and both artists received the status of *professeur* in 1735. Boucher and Natoire had similar styles and conducted a friendly rivalry, collaborating on a number of major decorative schemes at royal and aristocratic residences, notably the Hôtel de Soubise. There, between 1737 and 1739, Natoire painted the *Histoire de Psyche* in the *Salon ovale*, a room which represents the epitome of a rococo interior in its architecture, *boiserie*, and painting. Natoire's decorative skills were also dis-

played in drawings for the Gobelins and Beauvais tapestry manufacturers. His *Histoire de Don Quichote*, for Beauvais, is particularly distinguished.

Natoire exhibited frequently at the Salons, primarily with mythological subjects, but also on occasion with a portrait such as his 1749 likeness of the Dauphin. In 1751, he was appointed director of the Académie de France at Rome, replacing J.-F. de Troy. This was a great honor, and for a short period the artist continued to be highly regarded in France. Following administrative problems at the Académie de France and the departure of Marigny, Natoire was forced to resign his post in 1775. He remained in Italy, however, residing at Castelgandolfo. He had outlived his era, but his sweet, elegant style was adapted for more modern tastes by his students, especially Pierre and Vien.

The High Museum's painting is from one of Natoire's earliest decorative schemes; it was one of three paintings (for which the artist received 850 *livres* on December 10, 1732) commissioned by the influential duc d'Antin for his Paris *hôtel*. The other two paintings are *The Meeting of Jacob and Rachel at the Well* (private collection, New York), which forms a pendant to the High Museum's painting, and *Hagar and Ishmael in the Desert* (Louvre). Lemoyne, who had previously worked for the duc d'Antin, may have recommended his former student for this commission. The young artist responded by producing paintings of entrancing delicacy and refinement.

The story of Jacob had long been an attractive one for artists, because of the opportunities for painting caravans, landscapes, animals, and lovely women. The subject is taken from Genesis 31, especially verse 17: "Jacob arose and set his sons and his wives on camels and he drove away all his flocks." Natoire depicts the commanding figure of Jacob and his two wives, Rachel and Leah, as well as their serving women (by whom Jacob also had children). Prominence is given to the mottled goat which represents the large flock that Jacob, despite the machinations of his father-in-law Laban, was able to breed. A preliminary drawing at the Musée de Strasbourg shows the composition already well established.

The fluency of Natoire's brushwork, the bright palette, and even the composition reveal his study of Pietro da Cortona. Natoire was probably also aware of the style of contemporary Italian painters such as Pellegrini and Ricci, both of whom passed through Paris. As pointed out by Roger Clisby (in a letter of February 23, 1984), a preparatory drawing for the figure of Rachel is in the collection of the Crocker Art Museum, Sacramento.

Unknown French, *Girl with a White Cat*

Unknown French
18th Century

Girl with a White Cat
Oil on canvas, 25⅛ x 20⅞ inches (63.8 x 53 cm.)

Gift of Mr. and Mrs. Arthur N. Francke in memory of their daughter, Elizabeth Ellen, 1940.5.

Provenance: Count Henri Greffuhle, Paris; Countess Greffuhle and the Duke and Duchess de Gramont; Sale, Sotheby's London, July 22, 1937, no. 69; M. Knoedler & Co., Inc., New York.

This charming painting, recalling the type of child's portrait made popular by Drouais, was attributed to N. B. Lépicié when it was sold in 1937. It then came to the High Museum as a work by the niece of Drouais, Catherine Lusurier (1753-1781). This attribution seems to have been made on the basis of other oval portraits of children by Lusurier, including *A Girl with a Cat*, formerly at the Trotti Gallery, Paris.[1] Comparison with the few signed works of Lusurier, however, makes this attribution insupportable. The painting's surface has lost much of its original finish, making positive attribution unlikely.

[1]Photograph in the Frick Reference Library. Also see the example reproduced in Th.-E. Sainte-Beauve, "Une Portraitiste du XVIIIe siècle, Catherine Lusurier," *GBA*, 16, July-Aug., 1927, pp. 80-86.

François-Xavier Fabre, *Portrait of Count Vittorio Alfieri*
(color plate, page 90)

François-Xavier Fabre
Montpellier, 1766-1837

Portrait of Count Vittorio Alfieri, 1794
Oil on canvas, 36½ x 28½ inches (92.7 x 72.5 cm.)
Signed and dated at lower right: *FX Fabre/Florentiae 1794*

Dedicated to Albert J. Bows, Acting President, Board of Directors of the Museum, 1980-82; President, 1982-84. Purchase with gifts from James C. Barrett, Byron C. Harris Bequest, Miss Mary Haverty, friends and family of Mrs. Stacey E. Hill, Mrs. Walter C. Hill, Mrs. Thomas P. Hinman, Edgar B. Hollis, Jr., Mrs. Arnold Kaye, Charles Loridans, Mrs. Louise H. Moss, Eugene O'Karma, Mrs. Leonora S. Raines, Mrs. James D. Robinson, Sr., Mrs. Malcolm Therrel, Mrs. Harry E. Ward, Harry E. Ward, Jr., and Mr. and Mrs. Sidney Wien, 1983.71.

Provenance: Jean-Jacques de Sellon, Geneva, 1794; by descent in the de Sellon family; M. Bertrand de Muralt, Geneva; Sale, Sotheby Parke-Bernet & Co., London, June 15, 1982, no. 2; Colnaghi & Co., London, 1983.

Bibliography: Ferdinand Boyer, "Les Portraits d'Alfieri par François-Xavier Fabre," *Bulletin de la Société de l'Histoire de l'art français*, 1960, pp. 24-25; Pierre Rosenberg, *Pittura francese nelle collezioni pubbliche fiorentino*, Florence, 1977, p. 204.

Fabre received his first training in his native city of Montpellier and then entered the Paris studio of Jacques-Louis David. In 1783, on the recommenda-tion of Joseph-Marie Vien, he was admitted to the Ecole of the Royal Academy, and in 1787 he won the Prix de Rome. In Rome, Fabre produced religious and historical works in the neoclassical Davidian manner. A *Death of Abel* painted in 1790 was a great success when shown at the Salon the following year. The unrest in Rome following the execution of Louis XVI and the disruption of Fabre's stipend by the French Revolution led him to flee to Florence in January of 1793. There a community of French émigrés provided him with commissions for his striking portraits as well as historical and mythologi-cal subjects.[1]

In Florence Fabre soon became friends with Count Vittorio Alfieri and his mistress, Louise, Countess of Albany. Alfieri, whose tragic verse made him one of the most celebrated poets of the era, was born in 1745 to a noble Piedmontese family from Asti. His liaison with the Countess of Albany, a Dutch aristo-crat who had left her husband, Charles Edward Stuart, pretender to the English throne, added to Alfieri's notoriety as a romantic figure. Alfieri and the Countess commissioned several works from Fabre, including their own portraits. The Countess of Albany also commissioned Fabre's most important history painting, *Saul Crazed by Remorse* (Musée Fabre, Montpellier), which was inspired by Alfieri's famous tragedy *Saul*, published in 1784.[2]

Fabre's earliest portraits of the pair, painted in 1793, were willed by the poet to the Countess in 1803. Upon her death in 1824, Fabre, who had be-come her confidant, donated them to the Uffizi.[3] In 1794 Fabre painted a replica of his 1793 portrait of Alfieri which was acquired by Jean-Jacques de Sellon of Geneva, an uncle of Count Cavour, who was then residing in Florence and who recorded the purchase in his diary. This painting descended in the de Sellon family and is the work now in Atlanta. Later por-traits with different poses of Alfieri are in Montpel-lier, Turin, and Asti.[4]

With the ascendancy of Napoleon, Fabre worked for the Emperor's sister, the Grand Duchess of Tus-cany, and then moved back to Paris. He exhibited both religious subjects and official portraits at the Salons of 1806 and 1810. Among those whose por-traits he painted were Lucien Bonaparte and the poet Ugo Foscolo. These later paintings are in a more romantic vein, often with landscape back-grounds.

Following the Countess of Albany's death in 1824, Fabre returned to Montpellier, taking with him an extensive art collection which became the foundation of the Musée Fabre. He was the first director of the museum and of the Ecole des Beaux-Arts in Mont-pellier.

Fabre's Florentine period portraits show the neoclassical influence of David and are characterized by brilliant colors and a precise rendering of the figure with little background matter. In this ex-ample, he captures Alfieri's proud and fiery nature and emphasizes his calling as a poet by the promi-nence given to the cameo ring bearing the profile of

Dante. Alfieri was enchanted by this vision of himself and addressed a sonnet to the 1793 portrait, lauding the work and its subject:

> Sublime mirror of truth
> which shows me what I am
> bodily and spiritually
> with pure red hair ringing the forehead
> of noble stature with the head held high
> A thin figure with a frank gaze
> white skin, and blue eyes, and a pleasing
> appearance
> A good nose, fine lips, and faultless teeth
> A pale face rather like a king on his throne . . .
> Always angry but never evil . . .
> Man, are you great or vile?
> Only death will tell.[5]

[1]See the exhibition catalogue *French Painting 1774-1850, The Age of Revolution*, Paris, Detroit, New York, 1974-75, pp. 410-411.
[2]Ibid., no. 56.
[3]See James Lees-Milne, *The Last Stuarts*, London, 1983, pp. 205, 225.
[4]Boyer, 1960, pp. 21-25.
[5]Quoted in Rosenberg, 1977, p. 204.

Alexandre-Evariste Fragonard
Grasse, 1780-1850, Paris

Bradamante at Merlin's Tomb (?)
Oil on canvas, 13 x 9½ inches (33 x 24.2 cm.)

Purchase, 1983.70.

Provenance: Cailleux Gallery, Paris.

The son of the famous Jean-Honoré Fragonard, Alexandre-Evariste combined the rococo pictorial effects of his father with a neoclassicism received from his teacher, Jacques-Louis David. The young artist's first publicly exhibited work was a drawing shown at the Salon of 1792. He exhibited portraits and historical and mythological subjects in the Salons of 1796, 1799, and 1800. Reflecting political trends, he depicted various Napoleonic subjects such as the *Triumph of the Emperor*, shown at the Salon of 1808. He also worked as a sculptor, lithographer, and designer of patterns for Sèvres.

Beginning in 1819, Fragonard exhibited many paintings in the *gothique troubadour* manner: picturesque and romantic historical subjects rendered with great freedom and often with dramatic light effects. These included religious subjects for churches, literary themes, and such quasi-historical incidents as the *Vivant Denon Returning the Bones of El Cid to His Tomb* (Musée A. Lecuyer, Saint-Quentin).[1]

The High Museum's small painting has tentatively been identified by Marianne Roland Michel (in a letter of July 8, 1983) as a scene from Ariosto's *Orlando Furioso*. This sixteenth century epic poem about the war between the Christians and the Saracens for control of Jerusalem has many heroic and fantastic characters. The poem was extremely popular in the

Alexandre-Evariste Fragonard, *Bradamante at Merlin's Tomb* (?)

eighteenth century, and Alexandre-Evariste's father had devoted a large series of illustrations to it.[2] The episode which may be depicted in this painting occurs in Canto Three, verses 20-77, when the heroine Bradamante comes to the tomb of the magician Merlin and a vision of her descendants is conjured by the sorceress Melissa. Jean-Honoré Fragonard had treated this theme with many different details—notably a suit of armor for Bradamante—in two of his drawings, so this identification of the subject cannot be considered definite.[3]

Dreams, visions, and apparitions were favorite subjects of the younger Fragonard, and this painting may be related to such fantastic inventions as his lithographs entitled *Les Ombres* and *Le Songe*, which also depict young girls in churchyards or cemeteries with ghostly figures in the sky. The theatrical quality of the supernatural light and the sketchy application of paint in this painting are also found in Fragonard's *Don Juan and the Statue of the Commendatore* (Musée des Beaux-Arts, Strasbourg), which was probably painted in the 1820s.[4]

[1]See the exhibition catalogue *French Painting 1774-1830, The Age of Revolution*, Detroit and New York, 1975, no. 57, pl. p. 218.
[2]E. Mongan, P. Hofer, and J. Seznec, *Fragonard Drawings for Ariosto*, New York, 1945, pp. 21-25, 39-49.
[3]Ibid., pls. 14, 15.
[4]*French Painting 1774-1830*, no. 58, pl. p. 269.

Jean-Baptiste Isabey,
Portrait of a Man in a Black Coat

Jean-Baptiste Isabey,
Portrait of a Lady

Jean Urbain Guerin,
Portrait of an Unknown Man

Jean-Baptiste Isabey
Nancy, 1767-1855, Paris

Portrait of a Man in a Black Coat, 1831
Watercolor on paper, 5½ x 3⅞ inches (14 x 9.9 cm.)
Signed and dated at the left center: *J. Isabey./1831*

Exhibition: The Albertina, Vienna, 1927, no. 482.

Portrait of a Lady
Watercolor and gouache on ivory, 3 x 2³/₁₆ inches (7.6 x 6 cm.)
Signed at the lower left: *Isabey*

Provenance: Warneck Collection, Paris.

Gifts in memory of Robert and Nellie Bunzl by their children, 1981.28 and 1981.36.

The most important of all the French portrait miniaturists, Isabey studied first with Jean Girardet in Nancy. In 1785 he went to Paris, where he entered the studio of Jacques-Louis David, who had recently departed for Rome. At first he earned his living by painting buttons and decorative boxes, but when the Marquess of Sérens had him paint miniatures of the children of Count d'Artois for Marie Antoinette to give to her mother, his career was assured. The Queen provided the artist with an apartment in Versailles and the patronage of the court. When David returned from Rome, he accepted Isabey as a pupil without pay.

Isabey adapted to every political shift, becoming a member of the Convention during the Revolution, and then reaching full glory in the period of the Directory as a friend of Mme. de Staël and Mme. Récamier, as well as Marie Bonaparte. He produced countless portraits of Napoleon and his family, was appointed master of the entertainments at Mal-

maison, and organized the Emperor's coronation ceremony. In 1805 he was appointed Premier Peintre de la chambre de l'Imperature and in 1810 became drawing master for Napoleon's new wife Marie-Louise. He was in Vienna in 1812 to paint portraits of the Imperial Family and returned in 1814 to record the participants at the Congress of Vienna. At the beginning of the Restoration he went to London, but returned to France in 1820. He received honors from Louis XVIII, Charles X, and Louis Philippe. As a respected old master, he was given a pension by Napoleon III, and was made a commander of the Legion of Honor.

Isabey's portraits are distinguished by his keen observation and the delicacy of his touch. He received so many commissions that he switched from the traditional miniaturist material of ivory to vellum stretched on small metal plaques, which enabled him to work with greater speed.

The High Museum's portrait of a man is set before a sky, while the woman is on a plain grey background. In both instances, the finesse of his technique is evident in the delicacy of the skin and the brilliance of the eyes. There is a characteristic fuzziness, almost a pointillist effect, in the tiny areas of color that make up the composition.

Jean Urbain Guerin
Strasbourg, 1761-1836, Obernay

Portrait of an Unknown Man
Gouache and watercolor on vellum, 7⅛ x 5⁹/₁₆ inches (18.2 x 14.2 cm.)
Signed (?) in pencil on the verso: *J. Guerin fe.*

Gift in memory of Robert and Nellie Bunzl by their children, 1981.24.

Alexandre-Denis Abel de Pujol, *Head of a Bearded Man and Other Studies*

Provenance: Sale, Schidlof, Vienna, April 3, 1925, no. 31; Robert and Nellie Bunzl Collection, Vienna and Atlanta.

Exhibition: *Internationalen Miniaturenausstellung*, Albertina, Vienna, 1924, no. 427.

Guerin received his first artistic training from his father, Christophe Guerin. Then, in Paris, he was a pupil of Regnault, David, and the younger miniaturist master J.-B. Isabey. He was employed to paint miniature portraits of both Louis XVI and Marie Antoinette, whom he protected from a mob in the Tuileries in 1792. His association with the royal family led to his banishment following the Revolution, but he regained his status during the period of the Consulate. He made his Salon debut in 1798 with several miniatures, including his famous *Portrait of General Kléber*, which fascinated Napoleon and is now in the Louvre.[1] A similar romantic flair is evident in this portrait of a young man.

[1]See Leo Schidlof, *Die Bildnisminiatur in Frankreich*, Vienna, 1911, pl. XXXIV.

Alexandre-Denis Abel de Pujol
Valenciennes, 1785-1861, Paris

Head of a Bearded Man and Other Studies
Charcoal on paper, 23⅝ x 17¼ inches (60 x 43.9 cm.)
Stamped with the artist's name.

Gift of Yannick Bideau, 1984.2.

Provenance: Yannick Bideau, Paris.

Abel was the illegitimate son of Mortry de Pujol, the founder of the Ecole des Beaux-Arts at Valenciennes, where he studied before going to Paris. He was admitted free to David's studio after the master saw his painting *The Recognition of Philopoemen*. Abel worked in the neoclassical manner of David and Gros, painting religious and historical subjects. In 1806 he won a first class medal at the Academy, and in 1810 a second prize medal at the Salon. When he won the Prix de Rome in 1811 for his *Lycurgus Presenting the Heir to the Throne*, his father recognized him and he added the name of Pujol. Illness forced him to return from Italy after only about a year, but in 1814 he won gold medals from both Louis XVIII and Napoleon for his *Death of Britannicus* (now in Dijon). In the Salon of 1817, he exhibited a *Stoning of St. Stephen* painted for the Church of St. Etienne-du-Mont that won a medal and widespread acclaim. He continued to exhibit regularly at the Salon and received many official honors and public commissions—especially for murals, such as those in the Louvre and at St. Sulpice.

This drawing shows the artist's careful draughtsmanship in preparation for what must have been one of his biblical subjects. Some similar bearded and turbaned types appear in his painting *Jacob Confiding Benjamin to the Care of his Brothers*.[1]

[1]See the exhibition catalogue *Forgotten French Art*, Heim Gallery, London, 1978, no. 13.

Eugène Delacroix, *Study for Figures of the Salon du Roi*

Eugène Delacroix
Charenton-Saint Maurice, 1798-1863, Paris

Study for Figures of the Salon du Roi, ca. 1833
Pencil on paper, 7⅝ x 11¾ inches (19.4 x 29.9 cm.)

Gift of Dr. and Mrs. Michael Schlossberg, 1982.41.

Provenance: Sale, Hôtel Drouot, Paris, Nov. 6, 1979, no. 5; David Yates, New York; Dr. and Mrs. Michael Schlossberg, Atlanta.

In 1833, Delacroix received his first commission for a large-scale mural decoration, the Salon du Roi in the Palais Bourbon (now the Chamber of Deputies). Delacroix found the room inappropriate for paintings, since there were so many windows and doors. Nevertheless, he designed a scheme of four friezes for the narrow spaces between the arches and the ceiling cornice. These compositions symbolically represent various interests of the state: Justice, Agriculture, Industry, and War. The project was completed in 1838.

Delacroix set about his task in a traditional manner, first making a study for the overall scheme (now in the Louvre).[1] Next he did rough sketches for the arrangement on each wall (now in the Tate Gallery, London).[2] The artist then made many studies from the nude model to get the proper pose for each figure. Many of these were never used, but Lee Johnson (in a letter of September 26, 1983) has observed that the studies seen on this sheet have some features in common with a figure in the Justice painting and another in the Agriculture painting[3] and are also similar to a figure in the Tate Gallery's watercolor study for Industry.

[1] RF 23313, see Maurice Sérullaz, "Delacroix Drawings for the Salon du Roi," *Master Drawings*, I, 1963, no. 4, pl. 28a.
[2] See Maurice Sérullaz, *Memorial de l'exposition Eugène Delacroix*, Paris, 1963, nos. 266-268.
[3] Especially the female figure leaning on the arch to the right of the central pendentive of Agriculture. See Maurice Sérullaz, *Les Peintures Murales de Delacroix*, Paris, 1963, p. 327, fig. 15.

Jean-Baptiste Camille Corot, *Ravine in the Morvan, near Lormes* (color plate, page 91)

Jean-Baptiste Camille Corot
Paris, 1796-1875

Ravine in the Morvan, near Lormes, ca. 1840-45
Oil on canvas, 18 x 18¾ inches (45.7 x 47.7 cm.)
Signed at the lower left: *COROT*

Gift of the Forward Arts Foundation, 1972.39.

Provenance: Collection of the artist, Ville d'Avray; Corot sale, Paris, May 26, 1875, no. 107; Bardon Collection; Plantié Collection sale, Dec. 13, 1886; Sale, Christie's, Dec. 1, 1967, no. 48; E. V. Thaw & Co., New York.

Bibliography: Alfred Robaut, *L'oeuvre de Corot*, Paris, 1905, II, no. 427; "Art Across North America," *Apollo*, Oct. 1973, p. 313, fig. 7.

Following a general education, Corot became an apprentice cloth merchant, but was bored by this work. When he resolved to become a painter at age twenty-six, his well-to-do parents provided him with an allowance that enabled him to study with the landscape painter Jean-Victor Bertin, from whom he learned to create a classical landscape based on careful observation of nature.

Between 1825 and 1828 Corot was in Italy, painting small, bright, spontaneous canvases of the hills and villages near Rome. Corot exhibited some of these works at the Salon of 1827, and in 1833 won a medal. He returned to Italy in 1834 and 1843 and also journeyed to England, Holland, and Switzerland, producing many landscapes.

In the 1830s Corot began to incorporate biblical and classical subjects in large-scale landscapes. His themes included *Hagar in the Wilderness* (1835) and *Flight of the Holy Family* (1840). In 1843 a particularly severe Salon jury rejected his *Burning of Sodom*, but in 1845 two other works with classical subjects were accepted and Baudelaire in his reviews placed Corot at the head of the modern school of landscape painters.[1]

By 1850, when he exhibited *Morning, the Dance of the Nymphs*, Corot had evolved a more romantic type of landscape, presenting lyrical scenes of nymphs and shepherds in forest settings. He pursued this theme through the 1860s, veiling the woods and pastoral figures in a shimmering silvery haze. He also produced figural works in the late 1850s and 1860s—either single pensive women or monks.

Corot continued to paint outdoors at Sens until the year before his death. His unselfish devotion to his art, his humility, and his support of younger artists earned him the respect of many, most notably Pissarro.

Corot's ability to invest an ordinary forest glade with lively interest is evident in this work. It is one of a series of paintings produced at Morvan and the region of Lormes in the early 1840s.[2] We sense a world of activity in the changing patterns of light and shade, the strokes of color that indicate flowers, and the dappled texture of the bark.

[1]See *Art in Paris, 1845-1862*, trans. by Jonathan Mayne, Ithaca, 1965, p. 24.
[2]See Robaut, 1905, nos. 426-429.

Jean-Baptiste Camille Corot, *Farm Scene*

Jean-Baptiste Camille Corot
Paris, 1796-1875

Farm Scene, ca. 1865-68
Oil on canvas, 18½ x 15⅛ inches (47 x 38.5 cm.)
Signed at the lower right: *Corot*

Bequest of Albert Edward Thornton in memory of his mother, Mrs. Albert Edward Thornton, Sr., 1954.15.

Provenance: James Wilson Morrice, Montreal; Mr. and Mrs. R. B. Morrice, Montreal; Hirschl & Adler Galleries, New York, 1954.

Bibliography: *Masterpieces*, Atlanta, 1965, p. 32.

Although not positively identified, the location of this scene is probably the Ville-d'Avray near Versailles, where Corot's parents lived after 1817 and where he frequently returned to work in a bedroom-studio. The village, with its idyllic combination of interlocking tree-lined ponds and quaint farm houses, provided many picturesque compositions for the painter. The figures going about their daily occupations provide points of bright color and action within the otherwise calm, green setting.

Alexandre-Gabriel Decamps
Paris, 1803-1860, Fontainebleau

Farm Yard, 1849
Oil on canvas, 23½ x 16¼ inches (59.7 x 41.3 cm.)
Signed and dated at lower left: *Decamps 49*

Gift of Mrs. J. W. Simpson, 1942.22.

Provenance: Baron Corsivart, Paris; S. Goldschmidt, Paris; Sale, Galerie Georges Petit, Paris, May 17-19, 1888, no. 3; Mr. Blumenthal, Paris; John W. Simpson, New York, 1942; Mrs. J. W. Simpson, Craftsbury, Vermont.

Exhibitions: *Exposition Universelle*, Paris, 1855, no. 2870; *Exposition Centennale de l'art Français*, Paris, 1889; *French Salon Paintings from Southern Collections*, High Museum of Art, Atlanta, The Chrysler Museum, Norfolk, North Carolina Museum of Art, Raleigh, John and Mable Ringling Museum of Art, Sarasota, Jan. 21-Oct. 23, 1983, no. 22.

Bibliography: *Visites et Etudes de SAI le Prince Napoléon au Palais des Beaux-Arts ou Description Complète de cette exposition*, Paris, 1856, p. 123; Adolphe Moreau, *Decamps et son oeuvre*, Paris, 1869, p. 164; Dewey F. Mosby, *Alexandre-Gabriel Decamps, 1803-1860*, New York, 1977, I, p. 266; II, p. 528.

Decamps received his early artistic training in Paris, first with Philibert Bouchot and then with Abel de Pujol, whose studio he left in about 1820. In 1827 he made his Salon debut. Later that year he went on an extensive journey through Asia Minor and North Africa, and when he returned he began to specialize in small-scale genre and Oriental scenes. At the same time, Decamps developed his distinctive man-

Gabriel-Alexandre Decamps, *Farm Yard*

ner of rapidly applying thick paint. He never perfected an academic precision of design, and his freedom of handling and richness of color (along with his choice of subject) marked him as an early champion of Romanticism.

By 1839, when he was named a Chevalier of the Legion of Honor, Decamps was generally considered a master. Balzac, for example, had written: "Decamps possesses to the highest degree the art of interesting the eye, whether he represents a stone or a man . . . Decamps has in his brush what Paganini has in his bow, a magnetically communicative power."[1]

In 1845 Decamps showed a group of drawings illustrating the life of Samson, but his hopes of receiving official commissions were not fulfilled, and the following year the jury rejected all but his genre and Oriental subjects. The Revolution of 1848 brought him additional difficulties, since he had been patronized by the Orléans family. He did not reappear at the Salon until 1850-51, when he was appointed to the jury with *hors concours* status and exhibited ten paintings, gaining elevation to the rank of Officer of the Legion of Honor. He then received a commission from the State for a painting for the Musée de Luxembourg and produced two versions of *Job and His Friends*, a biblical scene set in a realistic courtyard. The work was never given to the State, and by 1853 Decamps had lost not only his desire to be a Bible painter but, for a time, to be a painter at all. He sold the effects of his Paris studio and moved to the region of Fontainebleau, which he had been frequenting since the 1840s. He resumed painting only sporadically, and died as a result of a hunting accident.

At the Exposition Universelle of 1855 there was a major retrospective of Decamps's works—fifty-nine examples—and he, Delacroix, and Ingres won medals of honor. Included in this exhibition was the *Cour de ferme* shown here. Decamps liked to rework his favorite motifs, such as the farm yard. He painted this work in 1849 but exhibited a different *Intérieur de cour* at the Salon of 1850—probably the painting now in the Louvre. Also in the Louvre is another painting entitled *La cour de ferme* which is dated 1850. The setting is the same as in the High Museum's painting, but the woman is shown raising the bucket from the well and instead of the turkeys there is a small dog.

The intimacy of the space in this painting reveals the artist's debt to the Dutch painters of the seventeenth century. Baudelaire recognized this when he wrote that "sometimes the splendour and triviality of Rembrandt were Decamps's keen preoccupation."[2]

[1]Honoré de Balzac, *Oeuvres complètes . . . L'Interdiction*, Paris, 1892, p. 249, trans. in Mosby, 1977, I, pp. 5-6.
[2]Baudelaire, "The Salon of 1846," trans. in *Art in Paris*, 1981, by Jonathan Mayne, p. 74.

Eugène Fromentin, *Arabs on the Way to the Pastures of the Tell* (color plate, page 91)

Eugène Fromentin
La Rochelle, 1820-1876

Arabs on the Way to the Pastures of the Tell, 1866
Oil on canvas, 25 x 41⅞ inches (63.5 x 106.4 cm.)
Signed and dated at the lower right: *Eug. Fromentin 1866*

Gift in memory of Frank D. Stout, 1976.66.

Provenance: The Prince Khalil-Bey, Paris: Sale, Hôtel Drouot, Paris, Jan. 16-18, 1868, no. 27; Henry Say, Paris; Sale, Galerie Georges Petit, Paris, Nov. 30, 1908, no. 9 (as *Le Passage du Gué*); Boussod et Valadon; Mr. and Mrs. Frank D. Stout, Chicago; Mrs. Floyd McRae, Atlanta.

Exhibitions: Salon, Paris, 1866, no. 759; Exposition Universelle, Paris, 1867, no. 282; *Exposition des cent chefs-d'oeuvre*, Paris; *French Salon Paintings from Southern Collections*, High Museum of Art, Atlanta, The Chrysler Museum, Norfolk, North Carolina Museum of Art, Raleigh, John and Mable Ringling Museum of Art, Sarasota, 1984, no. 31.

Bibliography: Charles Blanc, "Salon de 1866," *GBA*, 1866, p. 40; Théophile Gautier, *Salon 1866, Le Moniteur*

Universel, July 17, 1866, p. 1; Edmond About, *Salon de 1866*, Paris, 1867, pp. 37-38; *Paris Universal Exhibition, 1867, Complete Catalogue*, London, 1867, p. 11; *Exposition Universelle de 1867, Catalogue Général*, Paris, 1867, I, p. 24; Maxime du Camp, *Les Beaux-Arts à l'Exposition Universelle et aux Salons de 1863-67*, Paris, 1867, pp. 223-224; Olivier Merson, "M. Fromentin," in *L'Exposition Universelle de 1867, Illustrée*, ed. M. F. Ducuiny, Paris, 1867, 2, p. 54; Théophile Gautier, "Collection de S. Exc. Khalil-Bey," *Catalogue des Tableaux*, Hôtel Drouot, Paris, 1868, pp. 19-20; Louis Gonse, "Eugène Fromentin," *GBA*, 1879, p. 291; L. Gonse, *Eugène Fromentin, Peintre et Ecrivain*, Paris, 1881, pp. 29, 81; Bellier and Auvry, *Dictionnaire général des artistes de l'école française depuis l'origine des arts du dessin jusque à nos jours*, Paris, 1882-87, I, p. 594; Georges Beaume, *Fromentin*, New York, 1913, pp. 42-43; Prosper Dorbec, *Eugène Fromentin*, Paris, 1926, p. 72; Maxime Revon, ed., *Oeuvres Complètes de Eugène Fromentin: Un Eté dans le Sahara*, Paris, 1938, p. 318; A. Lagrange, *L'Art de Fromentin*, Paris, 1952, p. 147; A. Tabarant, *La vie artistique au temps de Baudelaire*, Mercure de France, 1963, p. 380; *Masterpieces*, Atlanta, 1965, p. 33; Foued Marcos, *Fromentin et l'Afrique*, thesis, University of Paris, 1954, published Montreal, 1973, p. 140; *Selected Works*, Atlanta, 1981, p. 17.

Fromentin was equally famous as a writer and as a painter, and his circle of acquaintances in Paris included such leading cultural figures as George Sand, Gustave Moreau, the Goncourts, Flaubert, and Sainte-Beuve. He received his first instruction from his father, a physician who was also an amateur painter. Sent to Paris in 1839 to study law, Fromentin did pursue a legal career for a while, but his unhappiness and his constant drawing and sketching finally convinced his father to allow him to study painting—first with the landscape painter Jean-Charles-Joseph Rémond and then with the more distinguished Nicolas-Louis Cabat.

After seeing the works of A.-G. Decamps and Prosper Marilhat, Fromentin developed an interest in the East. When the watercolor painter Emil-Charles Labbé invited him on a trip to Algeria in 1846, Fromentin readily accepted. Two days after he arrived in Blidah, Algeria, he wrote, "The more I study nature here the more convinced I am that, in spite of Marilhat and Decamps, the Orient is still waiting to be painted."[1] The first examples of Fromentin's Orientalist painting were exhibited at the Salon of 1847 and were well received. He returned to Algeria in 1848 and again in 1852 with his wife. Fromentin was particularly fascinated by the lives of the nomadic Arabs inhabiting the untamed region, and his impressions were published in two books, *A Summer in the Sahara* (1857) and *A Year in the Sahel* (1859), as well as in a series of major canvases.

The High Museum's painting was exhibited at the Salon of 1866 and again in a group of seven pictures shown by the artist at the Exposition Universelle of 1867, for which he was awarded another first class medal. Most writers, then and subsequently, have agreed with About that it is a *"chef-d'oeuvre."* Du Camp called it "a symphony," Gautier in his review in *Le Moniteur Universel* considered it Fromentin's most distinguished work and later described it as "a

true pearl," and George Sand wrote in a letter to the painter that it was "the discovery of the Salon and a fine diamond."[2] The subject—an Arab tribe or *smala* on the move towards the fertile fields of the Algerian Tell—was, according to Charles Blanc, a veritable illustration of a scene witnessed by Fromentin and described in his book *A Summer in the Sahara*. Maxime Revon has pointed to another account of a caravan in an entry (Saada, March 11, 1848) in Fromentin's diary:

> We broke camp (the sheik El-Arab had given the order in writing the previous evening). In half an hour the tents were taken down and rolled up and all the goods organized for the caravan—all done by the women. The horsemen in full costume, the guns at the ready, all their showy ammunition in their belts, mounted on their horses bedecked in long blankets of colored silk, they await their signal to depart. . . . The horsemen proceed and follow the procession slowly, for the immense caravan, divided into groups, is composed of seven hundred camels, of women on foot, of servants and children (a total of at least a thousand persons).
>
> It is about 9 o'clock, the sky and the plain are flooded with an incomparable light.
>
> We arrive at the edge of the river. Its steep banks are in the shade of tamarind trees. We establish ourselves on the far bank to assist the sheik in presiding over the crossing of the entire caravan. It is an indescribable procession, one contingent following another. Each new group is a painting.[3]

[1] Quoted in *Ingres & Delacroix through Degas & Puvis de Chavannes, The Figure in French Art, 1800-1870*, Shepherd Gallery, New York, May-June 1975, p. 219.
[2] Quoted in George Sand, *Correspondence*, letter of May 9, 1866, p. 199.
[3] Fromentin, quoted in *Un Eté dans le Sahara*, 1938, ed. by M. Revon, p. 318.

Henri-Joseph Harpignies, *The Joys of Painting*

Henri-Joseph Harpignies, *Landscape with Bridge*

Henri-Joseph Harpignies
Valenciennes, 1819-1916, Saint Privé

The Joys of Painting, 1869
Watercolor on paper, 6½ x 8¾ inches (16.5 x 22.2 cm.)
Signed at the lower left: *H. Harpignies*
Dated at the lower right: *1869*

Gift of Mrs. Henry D. Sharpe, Jr., in memory of her grandmother, Mrs. Isaac Seawell Boyd, 1955.7.

Provenance: Gift of the artist to Mary Wescott Owen in Paris, 1869; by descent to Mrs. Henry D. Sharpe, Jr., Atlanta.

Exhibition: *Drawings from Georgia Collections: 19th and 20th Centuries*, High Museum of Art, Atlanta, and Georgia Museum of Art, Athens, May 14-Aug. 23, 1981, no. 120.

At age nineteen, Henri-Joseph Harpignies toured France for a year before starting a seven-year career as a travelling salesman. In 1846 he enrolled in the atelier of the landscape painter Jean-Alexis Achard. He spent much of 1848 and 1849 travelling in Brussels, Holland, Germany, and Italy. One of his views of Capri was accepted for exhibition at the Salon of 1853, and later Salon juries generally favored the picturesque paintings he produced on his journeys to such regions as Marly, Marlotte, the Pyrenees, and the Forest of Fontainebleau.

In addition to painting oils, Harpignies became a master of watercolors, and the transparency of this medium allowed a brighter and freer style in his views of cloudy skies, forests, and Paris streets. His lively sense of observation is evident in a work such as this amusing study, in all probability a self-portrait of the city artist *en plein air*, surrounded by amazed country urchins. This theme recurs in other works by the artist, including an oil of 1897 (Brooks Museum of Art, Memphis).

Henri-Joseph Harpignies
Valenciennes, 1819-1916, Saint Privé

Landscape with Bridge, 1896
Oil on canvas, 16¾ x 11¼ inches (42.5 x 28.6 cm.)
Signed and dated at lower left: *H. Harpignies '96*
Inscribed at lower right: *Cannet* (?)

Gift of Judge and Mrs. E. Marvin Underwood, 1955.6.

Provenance: M. Knoedler & Co., Inc., New York, 1901; C. S. Smith sale, American Art Association, New York, April 24-25, 1919, no. 135; John Levy Galleries, New York, 1920; Judge and Mrs. E. Marvin Underwood, Atlanta.

Exhibition: *Dedication Exhibition*, The Mobile Art Gallery, Alabama, Oct. 1964.

In 1883, the year in which he was made a Chevalier in the Legion of Honor, Harpignies became associated with the art dealers Arnold and Tripp, who agreed to commission and sell his works. Living to be ninety-seven, Harpignies was a prolific painter of landscapes even after his eyesight began to fail. In

César de Cock, *Landscape with Two Women*

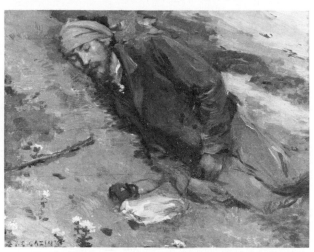

Jean Charles Cazin, *Study of Henri Duhem Reposing on the Dunes at Dannes-Camiers*

his later work he returned to broad masses and the silvery tonality of Corot. The inspiration of Corot is quite evident in this 1896 work, in which the simple elements of a stream, trees, and an old bridge are combined to form a splendidly harmonious composition, both crisp and evocative.

Cesar de Cock
Ghent, 1823-1904

Landscape with Two Women, 1872
Oil on canvas, 19 x 25⅝ inches (48.2 x 65.2 cm.)
Signed and dated at lower left: *Cesar De Cock 1872*

Bequest of Charles Loridans, 1956.112.

Of Flemish origin, de Cock worked primarily in France. He lived at Gasny and exhibited at the Paris Salons. He was a student of Daubigny and Français, but his work, mainly landscapes, was most strongly influenced by Corot.

Jean Charles Cazin
Samer, 1841-1901, Lavandou

Study of Henri Duhem Reposing on the Dunes at Dannes-Camiers
Oil on panel, 12⅝ x 15¾ inches (32.1 x 40 cm.)
Signed at the lower left: *J. C. CAZIN*

Purchase with funds from the Fay and Barrett Howell Fund, 1982.322.

Provenance: Henri Duhem; Nelly Duhem; Ernest Gaillard, 1962; Galerie Coligny, Paris.

Bibliography: Léonce Bénédite, *Jean-Charles Cazin*, Paris, 1901, p. 53.

The son of a doctor, Cazin was encouraged to practice art when he displayed an early talent for draw-

ing. He studied in Paris with Horace Lecoq de Boisboudran and became friends with a number of artists—including Bonvin, Ribot, Fantin-Latour, and Legros. His *Souvenir des dunes de Wissant* was exhibited at the 1863 Salon des Refusées, and in 1865 and 1866 his landscapes were accepted for the Salon. In 1868, through his teacher's influence, he was placed in charge of the Ecole de Dessin in Tours, where he became interested in the industrial arts. In London in 1871, he produced and decorated ceramics. Cazin then travelled to Italy and Holland but settled in France, first in Boulogne and later in Paris.

In the mid-1870s, Cazin began to paint biblical subjects and genre scenes with carefully delineated figures in contemporary dress set in landscapes reminiscent of Corot. Many of his landscape paintings show the area of northern France, especially Equihem, where he had a studio overlooking the dunes and the sea. The High Museum's painting shows the artist Henri Duhem, who once owned the work. According to Léonce Bénédite, this sketch is a study for a painting on the subject of the Good Samaritan. An oil study of the figure's head is in the Cincinnati Art Museum (1935.149)[1] and there was also a pencil sketch of the bandaged Duhem.[2]

[1]Exhibited in *Masters of the Barbizon School*, American Federation of Art, June 1950-Dec. 1951.
[2]See *Art et Décoration*, Dec. 1897, p. 174.

Nicolas-Louis Cabat, *Study of a Tree*

Nicolas-Louis Cabat
Paris, 1812-1893

Study of a Tree
Charcoal on paper, 9⅛ x 12½ inches (23.2 x 31.8 cm.)

Gift of Dr. David James, 1964.17.

At first employed as a painter of porcelain, Cabat entered the atelier of Flers, who sent him to Romainville and Montmartre to paint from nature. These suburbs of Paris provided the inspiration for the romantic landscapes which Cabat began to exhibit in the Salon in 1833. A trip to Italy introduced him to a more classical landcape manner. From 1879 to 1885 he was the director of the Academy of France in Rome.

This study reveals a highly competent draughtsman. Cabat sought a purposeful simplicity in his work. He wrote: "Art is not a study of actual reality; it is a search for the ideal."[1]

[1]See Philippe Comte, *Catalogue Raisonné des Peintures*, Musée des Beaux-Arts, *Ville de Pau*, 1978, n. p.

Eugène Boudin
Honfleur, 1824-1898, Deauville

Still Life with Lobster on a White Tablecloth, ca. 1853-56
Oil on canvas, 22½ x 32¼ inches (57.2 x 82 cm.)
Signed at the lower right: *E. BOUDIN*

Gift in memory of Lena B. Jacobs, 1970.31.

Provenance: Marande, Le Havre, purchased from Boudin in September, 1859; Sale, Hôtel Drouot, Paris, Oct. 25, 1957, no. 98; Alexandre Popoff, Paris, to 1963; Mme. Popoff, Paris, to 1970; Richard L. Feigen & Co., New York.

Exhibitions: *Cent Tableaux d'Eugène Boudin*, Galerie Charpentier, Paris, 1958, no. 61; *One Year of Acquisitions: December 1970-December 1971*, High Museum of Art, Atlanta, Feb.-May 1972; *Louis-Eugène Boudin: Precursor of Impressionism*, Santa Barbara Museum of Art, Art Museum of South Texas, Corpus Christi, Museum of Fine Arts, St. Petersburg, Columbus Gallery of Fine Arts, Ohio, Fine Arts Gallery of San Diego, Oct. 8, 1976-June 12, 1977, no. 1; *The Realist Tradition: French Drawing and Painting 1830-1900*, The Cleveland Museum of Art, The Brooklyn Museum, The St. Louis Art Museum, Glasgow Art Gallery and Museum, Kelvingrove, Nov. 12, 1980-Jan. 4, 1982, no. 114.

Bibliography: "La Chronique des Arts," *Supplément à la Gazette des Beaux Arts*, 1237, Feb. 1972, p. 106, no. 378; Robert Schmit, *Eugène Boudin*, Paris, 1973, I, p. 19, no. 57; Jean Selz, *E. Boudin*, New York, 1982, p. 11.

The son of a sailor, Eugène Boudin spent his youth at Honfleur on the Normandy coast and then in the port of Le Havre, where his family settled in 1835. In 1844 Boudin was part owner of a stationery and framing shop that displayed paintings by artists such as Constant Troyon and Jean-François Millet; their example and advice inspired him to begin painting. In 1846 he met Théodule Ribot, a specialist in genre painting who may have encouraged him to attempt still lifes. Later that year Boudin left Le Havre for Paris, where he remained for two years, spending long hours at the Louvre.

In 1851 the Le Havre Société des Amis des Arts awarded Boudin a three-year scholarship to study art in Paris. In addition to his copying, he painted still lifes. After the scholarship was cancelled, he returned to Normandy and concentrated on landscapes and seascapes. In 1857 he made his first trip to Brittany, which resulted in his first Salon entry. Boudin met Claude Monet at Le Havre in 1858 and

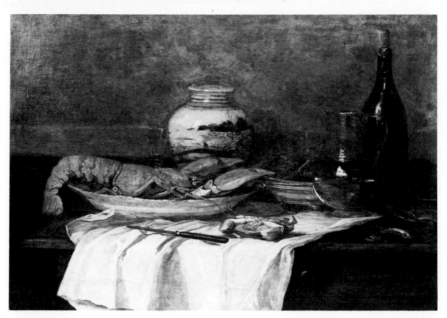

Eugène Boudin, *Still Life with Lobster on a White Tablecloth*
(color plate, page 92)

invited him to paint outdoors at Rouelles, an experience which influenced Monet's development as an Impressionist.

Through Monet, Boudin met Johan Barthold Jongkind in 1862, and the three painters worked together on the Normandy coast in 1864. Boudin was then creating the first of a series of views of fashionable ladies and gentlemen vacationing at the seaside resort of Trouville, which he frequented throughout the decade.

In the 1870s and 1880s, Boudin worked in Belgium, Paris, and Brittany, and continued to paint in his direct manner his favorite subjects: ships assembled in a bay, people strolling on a beach, and the activities of the marketplace. Although he contributed paintings to the first Impressionist exhibition in 1874, he was not formally aligned with the movement. Rather than adopting the Impressionist manner of rendering atmosphere and objects in flickering strokes, he remained devoted to the objective realism which had been his original style.

As early as his student period, Boudin was interested in the seventeenth century Flemish still-life painters whose works he copied in regional museums. In Paris he had the opportunity to study both the Dutch and Flemish old masters in the Louvre and also the still lifes of Chardin, which were then undergoing a revival of popularity. In 1849, he pursued this interest, traveling to Brussels and Antwerp. Throughout the 1850s Boudin painted and exhibited still lifes of fruit and game—in 1856 at Rouen, a still life *à la Chardin*, and in 1858 several still lifes at Le Havre. Boudin was undoubtedly influenced by the French still-life school, whose chief representative, Antoine Vollon, he particularly admired. In 1871 he was in Brussels to avoid the Franco-Prussian War; there he joined Vollon in painting fish

still lifes. In 1876 he was again in Belgium and Holland, and the still lifes of this period also show the influence of Courbet.

Boudin rarely dated his still lifes and, as Charles Cunningham has demonstrated, determining their chronology is difficult.[1] Boudin produced other still lifes with a lobster—one of ca. 1850 was at Durand-Ruel.[2] A more elaborate composition with oysters, vegetables, and a pot, which may have been exhibited at Le Havre in 1858 and later at Knoedler Gallery in New York, is similar to the High Museum's painting in details such as the knife on the tablecloth and the placement of the lobster on the dish.[3] Both works reflect the influence of Dutch painters, primarily de Heem. The combination of the Oriental ceramic jar, the glass objects, and the seafood makes this one of the most complex of the artist's tabletop still lifes.

Although Boudin thought of his still lifes simply as "dining room pictures," these works have an impressive, somber nobility. Historically, they are significant, since it was through Boudin's example that Monet painted still lifes in the 1850s, and the Impressionists were to continue the interest in this subject matter.

[1]Charles C. Cunningham, "Some Still-lifes by Eugène Boudin," *Studies in the History of Art Dedicated to William E. Suida on his Eightieth Birthday*, London, 1959, pp. 382-392.
[2]Schmit, no. 61; Cunningham, p. 390, fig. 8.
[3]Schmit, no. 135; Cunningham, p. 386, fig. 5.

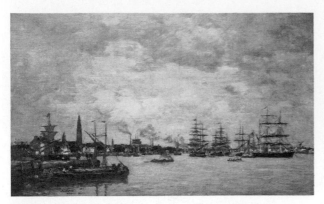

Eugène Boudin, *Antwerp, Boats on the Scheldt*

Eugène Boudin, *Landscape (Fervaques)*

Eugène Boudin
Honfleur, 1824-1898, Deauville

Antwerp, Boats on the Scheldt, 1871
Oil on canvas, 15⅞ x 25⅝ inches (40.8 x 65.2 cm.)
Signed, dated, and inscribed at the lower left: *Eugène Boudin/Anvers 71*

Gift of Dr. Nancy W. Walls, 1981.1.

Provenance: Georges Petit Gallery, Paris; Arthur Tooth and Sons, London; J.C.W.S. Erle-Drax, London, 1932; The Lefevre Gallery, London; H. J. Dunsmuir, Scotland, 1943; Sir Eric Millbourn; Dr. Nancy W. Walls, Atlanta.

Bibliography: Robert Schmit, *Eugène Boudin*, Paris, 1973, I, p. 246, no. 677.

This is one of a large number of works Boudin painted during his 1871 visit to Antwerp. Many of them feature the same view of the busy port with the Cathedral in the background.[1] The painter has captured the rapidly moving grey clouds which bring almost daily squalls to the city.

[1]See Schmit, 1973, nos. 649-663.

Eugène Boudin
Honfleur, 1824-1898, Deauville

Landscape (Fervaques), 1884
Oil on canvas, 21⅞ x 30⅜ inches (55.6 x 77.2 cm.)
Signed and dated at lower left: *E. Boudin 84*
Inscribed at lower right: *Fervaques*

Gift of the family of J. J. Haverty, 1949.20.

Provenance: Delmonico Collection, New York (?); Abbey Collection, Springfield, Massachusetts; George Ainslie, New York; Hobard Young Galleries, New York, 1924; J. J. Haverty, Atlanta.

Exhibitions: *Louis Eugène Boudin: Precursor of Impressionism*, Santa Barbara Museum of Art, Art Museum of South Texas, Corpus Christi, Museum of Fine Arts, St. Petersburg, Columbus Gallery of Fine Arts, Ohio, Fine Arts Gallery of San Diego, Oct. 8, 1976-June 12, 1977, no. 13.

Bibliography: Robert Schmit, *Eugène Boudin*, Paris, 1973, II, p. 226, no. 1890.

Fervaques is a small village in Normandy near Livarot. Boudin occasionally went there to visit his friends the Jaquette family, for whom he painted a number of works.[1] This is a rare example of his mastery of an impressionist landscape, rather than his usual marine subject.

[1]According to Robert Schmit, in a letter of September 9, 1970.

Frédéric Bazille
Montpellier, 1841-1870, Beaune-la-Rolande

Beach at Sainte-Adresse, 1865
Oil on canvas, 23 x 55⅛ inches (58.4 x 140 cm.)
Signed and dated at lower left: *F. Bazille 1865*

Gift of the Forward Arts Foundation in honor of Frances Floyd Cocke, 1980.62.

Provenance: Mr. Pomié-Layrargues, Montpellier; Mme. Brunel, Montpellier; Pierre Fabre, Saint-Comes; Wildenstein & Co., Inc., New York.

Exhibitions: *Bazille*, Wildenstein & Co., Inc., Paris, June-July 1950, no. 15; *Frédéric Bazille and Early Impressionism*, The Art Institute of Chicago, March 4-April 30, 1978, no. 17; *The Subjective Vision of French Impressionism*, The Tampa Museum, Florida, Sept. 27-Nov. 29, 1981, no. 1; *A Day in the Country, Impressionism and the French Landscape*, Los Angeles County Museum of Art, The Art Institute of Chicago, and Grand Palais, Paris, June 28, 1984-April 22, 1985, no. 4.

Bibliography: Gaston Poulain, *Bazille et ses amis*, Paris, 1932, pp. 52, 211, no. 3; Ernst Scheyer, "Jean-Frédéric Bazille—The Beginnings of Impressionism, 1862-1870," *The Art Quarterly*, 5, 1942, p. 119; François Daulte, *Fré-*

Frédéric Bazille, *Beach at Sainte-Adresse* (color plate, page 92)

déric Bazille et son temps, Geneva, 1952, p. 172, no. 15/1; John Rewald, *The History of Impressionism*, New York, 1961 (and 4th revised edition, New York, 1973), p. 110; J. Isaacson, *Monet: Le déjeuner sur l'herbe*, New York, 1972, pp. 22-25, 98-99; Kermit Swiler Champa, *Studies in Early Impressionism*, New Haven and London, 1973, p. 85, fig. 115; Daniel Wildenstein, *Claude Monet (1840-1881)*, Lausanne, I, 1974, p. 130; "La Chronique des Arts," *Supplément à la Gazette des Beaux Arts*, 1346, March 1981, p. 39, no. 216.

The son of a wealthy Languedoc family, Frédéric Bazille initially studied medicine in Montpellier. In 1862 he convinced his father to send him to Paris to study art, on condition that he also continue medical school there. Bazille enrolled in the studio of Charles Gleyre and became friends with Claude Monet, Auguste Renoir, and Alfred Sisley. Influenced by both Courbet and Manet, these young artists, led by Monet, began to conceive an approach to painting based on direct observation of nature.

In 1863 Monet persuaded Bazille to spend Easter with him painting outdoors in the Fontainebleau Forest. They worked together again at Honfleur in 1864 while Bazille awaited the results of his medical school examinations. He was not dismayed to learn that he had failed. His parents, at last accepting his desire to devote himself to painting, provided financial support. Their allowance spared Bazille the extreme financial hardships that often afflicted his contemporaries, and enabled him to lend them money or buy their paintings.

After leaving Gleyre's studio, the four young artists corresponded, travelled together, and shared studios. In 1865 Bazille and Monet shared a studio in Paris and frequented the Café Guerbois, a center for young writers and artists. During that year he posed for Monet's version of *Déjeuner sur l'herbe*. The following year, Bazille had his first work accepted at the Salon. In 1867 Bazille and Monet discussed organizing an exhibition of their fellow painters in op-position to the official Salon, but did not carry out the idea. Three years later, Bazille, who had volunteered for military service in the Franco-Prussian War, was killed in action at age twenty-nine. During his short career, the artist produced only about seventy-five paintings.

The High Museum's painting is the result of Bazille's 1864 visit to Monet's home at Honfleur near Le Havre. In a letter to his parents, Bazille described the appeal of the setting, "especially the sea, or rather the Seine broadening out, which gives a delightful horizon."[1] Monet had completed a similar view of the beach looking toward Le Havre, *The Coastline at Sainte-Adresse* (now in The Minneapolis Institute of Arts) in June 1864. After their return to Paris, where the artists were sharing a studio, Bazille received a commission from an uncle in Montpellier for a pair of overdoor paintings. The result was the painting in the High Museum and its pendant (now in a private collection, Japan), a view of cows in a field at Saint-Sauveur.

The overdoor commission imposed on Bazille's work a more horizontal format than that of Monet's painting, but they are very close in composition. Both works show the sailboat and men rowing a small boat, but Bazille adds the rustic figure walking along the shore. Monet used such a figure in an 1864 sketch, *La Pointe de la Hève* (Wildenstein, 40), and incorporated it in his Salon painting of the following year (Wildenstein, 52). As we know from his correspondence with Monet, Bazille labored over his pair of paintings for an unusually long time, from April to August of 1865. The result was a vigorous work in which the touch is sure and the effect convincing, and he emerges as a major figure in the vanguard of Impressionism.

[1]Quoted in Charles C. Cunningham, *Jongkind and the Pre-Impressionists: Painters of the Ecole Saint-Siméon*, Northampton, 1976, p. 19.

Paul Cézanne, Recto: *Various Studies including a Seated Nude, a Standing Woman, and an Embracing Couple*

Verso: *Studies of a Seated Woman and Men in Cocked Hats*

Paul Cézanne
Aix-en-Provence, 1839-1906

Various Studies including a Seated Nude, a Standing Woman, and an Embracing Couple (recto); *Studies of a Seated Woman and Men in Cocked Hats* (verso), ca. 1865

Pencil, pen and ink on paper, 4¹¹/₁₆ x 8⅝ inches (12 x 22 cm.)

Gift of Mrs. Charles B. Nunnally, 1965.8.

Provenance: Cézanne family, Paris; Huguette Berés, Paris; Mrs. Charles B. Nunnally, Atlanta.

Exhibition: *Drawings from Georgia Collections: 19th and 20th Centuries*, High Museum of Art, Atlanta, and the Georgia Museum of Art, Athens, May 14-Aug. 23, 1981, no. 20.

Bibliography: Theodore Reff, "Cézanne and Hercules," *The Art Bulletin*, XLVIII, 1966, pp. 39-40, fig. 6; Meyer Schapiro, "The Apples of Cézanne," *Art News Annual*, XXXIV, 1968, p. 53; Adrien Chappuis, *The Drawings of Paul Cézanne*, Greenwich, 1973, I, p. 64, no. 57, and p. 90, no. 189; II, figs. 57, 189.

Cézanne made his first visit to Paris in 1861. He had already begun sketching and his visits to the Louvre and the Salon inspired him in 1862 to dedicate his life to art. After failing the entrance examination for the Ecole des Beaux-Arts that year, he frequented the Académie Suisse, where he could draw from the model. There he met Pissarro, whom he later credited as his teacher.

Cézanne's early drawings reflect his struggle to learn by copying from the masters. A good deal of his own intractable character, however, is already in evidence. This double-sided page is from a notebook formerly in Cézanne's studio in Aix-en-Provence and subsequently dispersed. Cézanne's compulsive approach is evident in the way he draws new subjects over old ones. It is possible that he used the notebook first in one direction and then the other, but all the drawings seem to date from the early 1860s.

The two figures in cocked hats on the *verso* recall policemen who appear in other early drawings. The pen study of the seated woman resting her head on her hand is thought by Chappuis to be related to a painting and other drawings of a composition known as *The Conversation*,[1] but it is more likely that this melancholy figure was copied from some other work of art, possibly a print or a sculpture. Certainly this is the case with the pen study of the standing woman on the *recto*, which appears to be a Mary Magdalen. Similarly, the bold study of a seated man seen from the back does not seem like the "academic study" suggested by Chappuis, but rather a free copy after a sculpture such as Puget's *Hercule Gaulois*, which Cézanne used on a number of occasions. The man lying on his side, also sculptural, is repeated in a wash drawing by Cézanne.[2]

The embracing couple sketched more lightly at the lower left has been identified by Theodore Reff as the Paris and Venus in a preliminary study for Cézanne's 1860 painting *The Judgement of Paris*, where the young man's intimacy with the goddess is stressed.[3] Meyer Schapiro, however, has expressed doubts about this identification.[4] It may have been copied after another source, such as an Adam and Eve, or, since the man is bearded, possibly Lot and his daughters. Such scenes of sexual abandon were on Cézanne's mind during this period and culminated in the oil painting *The Orgy* (1864-68).[5]

[1]Chappuis, 1973, I, p. 64, no. 57, and p. 90, no. 189.
[2]Venturi, 1936, no. 812.
[3]Ibid., no. 16.
[4]Schapiro, 1968, p. 53.
[5]Venturi, no. 92.

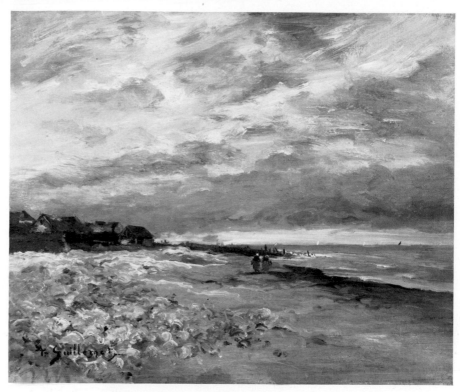

Jean-Baptiste-Antoine Guillemet, *Coastal Scene*

Jean-Baptiste-Antoine Guillemet
Chantilly, 1843-1918, Dordogne

Coastal Scene
Oil on canvas, 15⅛ x 18⁵/₁₆ inches (38.5 x 46.6 cm.)
Signed at lower left: *A Guillemet*

Bequest of Charles Loridans, 1956.114.

Guillemet was born to a family of ship owners at Rouen, and wanted to become a sailor. His parents urged him to study law, and he enrolled at La Pension Savary at Passy. In 1861, however, he was introduced to Camille Corot, who encouraged him to paint and helped him meet Honoré Daumier, Antoine Barye, Gustave Courbet, and Charles-François Daubigny. Guillemet often accompanied Daubigny and his son Karl on painting excursions on the Oise aboard their boat-studio.

From 1862 to 1864, he frequently attended the Académie Suisse, an open studio where artists could work from a model. There he came in contact with Emile Zola, Camille Pissarro, Claude Monet, and Paul Cézanne. He and Cézanne became friends in 1863, and they spent three months painting together in Aix-en-Provence in 1866. Later, as a Salon juror, Guillemet argued repeatedly, but in vain, for Cézanne's acceptance into the official exhibitions. Finally, Cézanne had his only Salon showing in 1882, when each juror had the option of selecting with no

discussion the work of one artist. Guillemet chose Cézanne, who was listed in the catalogue as his pupil. Despite the superficial impressionistic quality of many of his works, Guillemet was committed to the official hierarchy and did not participate in the independent exhibition of 1874.

Little of Guillemet's painting from the 1860s has survived, but his canvases of the following decades show an unending interest in coastal scenes, in which he depicts an expanse of sky with a low horizon over a stretch of water, edged by a quiet beach or waterfront village. Guillemet also painted views of Paris. His works, never revolutionary and always pleasant, were popular, and the artist exhibited annually at the Salon from 1869 until 1914. Two years after his death there was a retrospective selection of his work at the Salon.

The High Museum's painting, with its cottages by the ocean and peasant women, is similar in subject to several others by the artist set at the Bay of Morsalines, not far from Cherbourg on the Normandy coast.[1] The way that the oily brushstrokes enliven the surface and create the effect of sparkling light reflected on the water and sand is typical of Guillemet's work.

[1]See the examples illustrated in Peter Mitchell, *Jean-Baptiste Antoine Guillemet, 1841-1918*, London, 1981, pls. 15, 22.

147

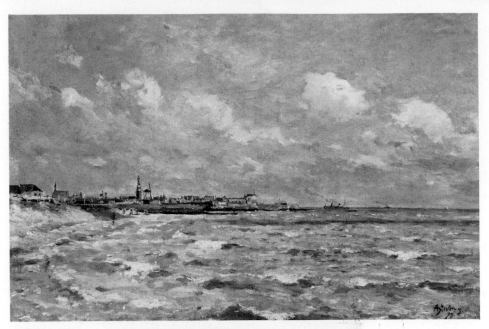

Alfred Stevens, *The Harbor at Ostend*

Alfred Stevens
Brussels, 1823-1906, Paris

The Harbor at Ostend, 1879
Oil on canvas, 17 x 25¹¹/₁₆ inches (43.2 x 65.3 cm.)
Signed and dated at lower right: *A Stevens/79*

Gift of Mr. and Mrs. Noel Wadsworth, 1981.114.

Provenance: Colnaghi and Co., London.

Stevens's father was an avid art collector and encouraged his sons Alfred and Joseph to be artists. Alfred studied first with a follower of David, François-Joseph Navez. He was taken to Paris in 1844 by a family friend, the painter Camille Roqueplan. He studied at the Ecole des Beaux-Arts and remained in Paris until his return to Brussels in 1849. Stevens made his debut at the Brussels Salon in 1851 and was back in Paris a year later. His early style was dark and romantic, influenced by Velázquez and Courbet, who painted a portrait of him. Through his brother, Joseph, who had become a successful painter of animals, he was also acquainted with Isabey, Couture, and Rousseau.

At the Paris Salon of 1853 Stevens showed three works; *Ash Wednesday Morning*, purchased by the State, won a third-class medal. The Exposition Universelle of 1855, where he won a second-class medal, brought Stevens wide attention. One painting, *They Call It Vagabondage*, became prominent when the Emperor objected to the practice it depicted—soldiers arresting an indigent family. Another painting, *Chez soi*, showed an elegant woman in an intimate boudoir setting. It was this type of subject matter—scenes of well-dressed or fashionable women—that made the artist's reputation. For such depictions of "*La Parisienne*" (as she was called), he often used his own luxurious home and studio as a setting.

Stevens developed an influential, wealthy clientele ranging from King Leopold of Belgium to the Vanderbilts of New York. Princess Mathilde lent him clothing to use in his compositions; Sarah Bernhardt studied painting in his popular atelier for women and was his subject on a number of occasions. Stephens frequented the boulevards and cafés, and was a friend of the Goncourts, Baudelaire, Manet, and Degas. In 1863 he was made a Chevalier of the Legion of Honor. At the Exposition Universelle of 1867 he triumphantly showed eighteen pictures, received a first-class medal, and was promoted to Officer of the Legion.

By the early 1880s Stevens, for reasons of health, began going to Normandy and other coastal areas of France, where he painted landscapes with figures and pure impressionistic marine subjects.[1] This view of Ostend clearly shows Stevens's debt to Boudin and Jongkind, although the highly keyed colors are in keeping with his own luxuriant style.

[1]See the exhibition catalogue *Alfred Stevens*, The University of Michigan Museum of Art, 1977, no. 44.

Camille Pissarro
St. Thomas, 1830-1903, Paris

Bouquet of Flowers, ca. 1873
Oil on canvas, 21⅝ x 18¼ inches (55 x 46.4 cm.)
Stamped at lower right with the artist's initials: *C.P.*

Gift of the Forward Arts Foundation in honor of its first president, Mrs. Robert W. Chambers, 1974.231.

Provenance: Lucien Pissarro, London; M. Knoedler & Co., Inc., New York; Edwin C. Vogel, New York; Acquavella Galleries, Inc., New York.

Exhibitions: *Centenaire de la naissance de l'artiste Pissarro*, Musée de l'Orangerie, Paris, Feb.-March 1930, no. 25; *Summer Loan Exhibition*, Metropolitan Museum of Art, New York, 1961, no. 72; *Pissarro*, Wildenstein & Co., Inc., New York, 1965, no. 18; *Summer Loan Exhibition*, Metropolitan Museum of Art, New York, 1968.

Bibliography: Charles Kunstler, *Camille Pissarro*, Paris, 1930, pl. 5; Ludovico Pissarro and Lionello Venturi, *Camille Pissarro, son art–son oeuvre*, Paris, 1939, I, no. 198; II, pl. 39; John Rewald, *Camille Pissarro*, New York, 1963, p. 91; *Arts Magazine*, March 1965, cover ill.

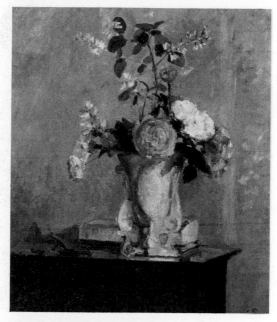

Camille Pissarro, *Bouquet of Flowers*
(color plate, page 93)

Camille Pissarro was born in the Danish West Indies, the son of a French-Portuguese merchant and a creole woman. At age twelve he was sent to a boarding school in Passy, where he took his first lessons in painting. Returning to St. Thomas in 1847, Pissarro worked as a clerk in his father's store and drew at the harbor whenever he found time. Five years later, forsaking his father's business, he sailed with a Danish painter, Fritz Melbye, to Caracas to paint. In 1855 his father agreed to send him back to Paris to study art, and he worked at both the Ecole des Beaux-Arts and the more informal Académie Suisse, where he met Monet.

Pissarro was particularly interested in the works of Courbet and Corot, whom he visited several times seeking advice. Corot allowed Pissarro to list him as his teacher in the catalogue of his first Salon exhibitions in 1864 and 1865. In 1863 he had participated in the Salon des Refusées with three paintings, and in the mid-1860s he lived with members of the nascent Impressionist movement at Pontoise and Louveciennes. In 1870, at the outbreak of the Franco-Prussian War, Pissarro and Monet met again in London, where they were received enthusiastically by Durand-Ruel, who exhibited their work in his London gallery and later in Paris.

When Pissarro returned to France after the war, he found that his studio had been ravaged by the Prussians and much of his work destroyed. In 1872 he settled at Pontoise, where he was soon joined by Cézanne, and the two artists worked frequently together. Pissarro introduced Cézanne to *plein-air* painting and an Impressionist manner (as he also did Gauguin). At the same time, he absorbed Cézanne's solid sense of composition. Abandoning the official Salon, he participated in the first independent showing of the Impressionists in 1874 and remained the most loyal member of the group, contributing to all the subsequent exhibitions.

In 1884 Pissarro came in contact with Seurat and Signac. He experimented with their divisionist techniques from about 1886 to 1890, but gradually abandoned them as too rigid. Returning to a freer brushstroke, he retained the fresh, pure color of the divisionists and devoted himself to new subjects. He also at last enjoyed a measure of financial success with a retrospective exhibition at Durand-Ruel in 1896.

Pissarro had settled at Eragny in 1884 but made many painting trips to other locations such as Le Havre, Dieppe, London, Rome, and Paris. Inspired by Monet's example, he painted views of city streets seen from an upper window at different times of day. He observed the colors and patterns of crowds moving on the boulevards below and translated the distant figures into thick dabs of paint.

Although Pissarro specialized in landscapes, he also painted genre scenes, portraits, and still lifes. John Rewald has written:

> On rainy days when they could not paint out of doors, Pissarro and his friends worked in their studios. . . . On these occasions Pissarro seems to have particularly favored flowers. . . . The artist's wife was extremely fond of them. In the early days of their life together she had even worked for a florist. Later she always grew masses of flowers in her garden; among them her greatest pride were pink peonies. No wonder then that she often gathered bouquets for the still lifes of her husband and that these, as in the case here, would feature peonies of various shades, but especially pink.[1]

An 1873 painting of a similar bouquet is in the Ashmolean Museum, Oxford.[2]

[1]Rewald, 1963, p. 91.
[2]See Raymond Cogniat, *Pissarro*, New York, 1975, p. 28.

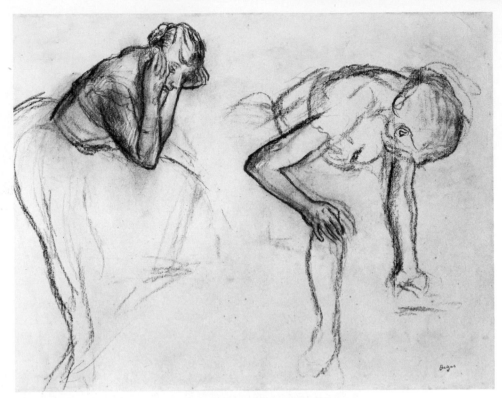

Edgar Degas, *Study of Two Dancers* (color plate, page 93)

Edgar Degas
Paris, 1834-1917

Study of Two Dancers, ca. 1884-85
Charcoal with highlights in white pastel on tinted paper,
18¼ x 24 inches (46.4 x 61 cm.)
Stamped in red at the lower right corner and on the *verso*
with the artist's estate stamps (Lugt 657 and 658): *degas*

Anonymous gift, 1979.4.

Provenance: Degas Atelier Sale, third sale, Georges Petit
Gallery, Paris, April 7-9, 1919, no. 233; Dr. Viau(?);
Adam-Dupré, Paris; Matthieson Gallery Ltd., London;
Lilienfeld Galleries, New York; Mrs. Ralph J. Hines,
New York; Mrs. Harry E. T. Thayer and Robert S. Pirie,
Cambridge, Massachusetts.

Exhibitions: M. Knoedler & Co., Inc., New York, March
1963; *Drawings from Georgia Collections: 19th and 20th
Centuries*, High Museum of Art, Atlanta, and Georgia
Museum of Art, Athens, May 14-Aug. 23, 1981, no. 16;
Degas: The Dancers, National Gallery of Art, Washing-
ton, D.C., Nov. 22, 1984-March 10, 1985.

Bibliography: Lillian Browse, *Degas Dancers*, New
York, ca. 1949, p. 375, no. 112a; "La Chronique des
Arts," *Supplément à la Gazette des Beaux Arts*, 1334,
March 1980, p. 42, no. 216; *Selected Works*, Atlanta,
1981, p. 44.

In his many studies of ballet dancers, Degas did not
seek to convey the glamour of dance, but rather to
reveal the hard work that went into creating this
illusion. He was particularly interested in depictions
of the dancers at rehearsals or off-stage, and sought
to catch their most telling poses and unstudied at-
titudes.

The two poses seen here—the brooding head on
hands and the adjustment of a slipper—were so
striking that Degas incorporated them into several
other works. The most finished treatment is the pas-
tel *The Dance Class*, where dancers in these poses
appear on a bench with another dancer who is pulling
up her tights.[1] The poses also figure in slightly dif-
ferent form in a drawing of *Three Seated Dancers*
and a pastel of *Dancers at Rest*.[2]

Degas has rendered the outlines with his boldest,
most powerful strokes, smudged the charcoal for
coloration in some areas, and then added the white
chalk for dramatic highlighting. He has achieved the
effect of intense life, capturing in the dancer at the
left a sense of exhaustion close to despair.

[1]See Paul Lemoisne, *Degas et son oeuvre*, Paris, 1947-48,
no. 1107.
[2]Ibid., nos. 530, 531.

150

Henri de Toulouse-Lautrec, Recto: *Two Huntsmen*

Verso: *Studies of Frogs*

Henri de Toulouse-Lautrec
Albi, 1864-1901, Malromé

Two Huntsmen (recto); *Studies of Frogs* (verso), 1879-1881
Pencil on paper, 5¼ x 8½ inches (13.4 x 21.6 cm.)

Gift of the friends of Mary Helen Poland in her memory, 1966.22.

Provenance: Hirschl & Adler Galleries, Inc., New York.

Exhibition: *Drawings for Collectors*, Main Street Galleries, Chicago, Nov. 1-26, 1966.

Bibliography: Maurice Joyant, *Henri de Toulouse-Lautrec*, Paris, 1926-27, II, p. 179; M. G. Dortu, *Toulouse-Lautrec et son oeuvre*, New York, 1971, IV, pp. 200-201, nos. 1203, 1204.

Toulouse-Lautrec began drawing as a child. His aristocratic parents encouraged his ability by sending him at age eight to the local art master Princeteau, whose lively system suited the boy. His first works were caricatures and drawings of horses and riders. In a letter of 1879 to his friend Devismes he wrote: "You may think my menu is a varied one, but not at all—it consists of horses and sailors. I have more success with the former."[1] His drawings reveal a desire to capture the features and movements in a direct original manner. Horse and rider, in this example and others of the period 1878-80,[2] are set down in a continuous rhythmic web of lines. The studies of frogs on the verso are typical of the humorous sketches of animals made by Lautrec during this period.

[1]Quoted in André Fermigier, *Toulouse-Lautrec*, New York, 1969.
[2]See Jacques Lassaigne, *Toulouse-Lautrec*, Paris, 1946, p. 37; and the exhibition catalogue *From the Age of David to the Age of Picasso*, Museum of Art, Rhode Island School of Design, Providence, 1984, p. 112, no. 50, as well as the many examples in Dortu, 1971, especially D1202, in which the frogs appear.

Adolphe-Joseph Monticelli, *Garden Fête*

Adolphe-Joseph Monticelli
Marseilles, 1824-1886

Garden Fête, ca. 1875
Oil on wood panel, 16¼ x 26¹/₁₆ inches (41.3 x 66.2 cm.)
Signed at the lower left: *Monticelli*

Gift of the family of J. J. Haverty, 1949.21.

Exhibitions: *J. J. Haverty: The Taste of a Southern Collector*, Asheville Art Museum, Louisiana Arts and Science Center, Baton Rouge, The Mint Museum of Art, Charlotte, Columbus Museum of Art, Georgia, Art and Culture Center of Hollywood, Florida, Sept. 1, 1981-June 25, 1982.

Bibliography: *Masterpieces*, Atlanta, 1965, p. 35.

Adolphe Monticelli passed most of his life in the region of Provence. He visited Paris for the first time in 1846 and attended the Ecole des Beaux-Arts for nearly two years as a pupil of Paul Delaroche. Until the mid-1850s much of his work consisted of commissions for formal portraits or religious themes. When he was in Paris again from 1855 to 1856, he worked with the landscape painter Narcisse Diaz de la Peña and adopted the bold colors of Delacroix. These influences led Monticelli to embrace more exotic themes, brighter colors, and a looser application of paint.

Monticelli's visits to Paris also exposed him to the "Rococo revival," and charming scenes of costumed ladies and gentlemen enjoying themselves in outdoor settings *à la Watteau* became one of his favorite subjects. In Paris again from 1863 until the end of the decade, he repeatedly explored variations of the *fête galante* theme.

The Prussian siege of Paris in 1870 forced Monticelli to return to Marseilles. His final sixteen years were his most productive. The vibrant colors and turbulent impasto of his late landscapes and portraits struck a responsive chord in the young Vincent van Gogh, who collected Monticelli's paintings and often expressed his indebtedness to the older artist's work.

Garden Fête is typical of Monticelli's work in the mid-to-late-1870s. The faceted patches of thick paint and shimmering overglazes create a brilliant surface which mirrors the coy playfulness of the figures, costumed as if for a fancy dress ball. A similar but larger composition is in the collection of the Cailleux Gallery in Paris.

Emile Bernard, *Inn Keeper at Verneuil*

Emile Bernard
Lille, 1868-1941, Paris

Innkeeper at Verneuil (recto), 1886
Not illustrated: *Landscape Study* (verso)
Pencil on paper, 8½ x 6½ inches (21.6 x 16.5 cm.)
Signed in ink on lower right edge: *Emile Bernard 1886*
Inscribed in pencil at upper right corner: *Verneuil le 9 avril 86 auberge*; and very faintly near lower right corner: *L'aubergiste*

Promised gift of Mrs. Robert R. Snodgrass, Atlanta.

Provenance: Paul Petrides, Paris.

Exhibition: *Drawings from Georgia Collections: 19th and 20th Centuries*, High Museum of Art, Atlanta, and Georgia Museum of Art, Athens, May 14-Aug. 23, 1981, no. 25.

The year 1886 was significant for the young Emile Bernard. He was dismissed from the studio of the academic painter Cormon for insubordination and set out on a walking trip through Normandy and Brittany. On his trek he met Gauguin at Pont-Aven.

Bernard's skill as a draughtsman, even at this early stage, is evident in the series of drawings he made at the Norman town of Verneuil. This drawing and another dated a day later showing a woman's head and a still life of a bottle are both inscribed

"auberge"—indicating they were studies of interesting individuals the artist observed in the local inn.[1] In this case the faint inscription informs us it is the innkeeper himself. Bernard also sketched a landscape at Verneuil on April 10.[2] The size of all three sheets is nearly identical, indicating that they probably come from the same sketch pad. Both this work and the landscape bear signatures which appear to have been added later by the artist.

[1]Altarriba collection, Paris; see the exhibition catalogue *Emile Bernard 1868-1941*, Palais des Beaux-Arts, Lille, April 12-June 12, 1967, no. 184.
[2]Ibid., no. 164.

Emile Bernard, *Breton Peasants Outside a Church*

Emile Bernard
Lille, 1868-1941, Paris

Breton Peasants Outside a Church, 1889
Watercolor and chalk on paper, 18⅝ x 24½ inches
(47.3 x 62.2 cm.)
Signed and dated at the lower right edge: *Emile Bernard 1889*

Promised gift of Mrs. Robert R. Snodgrass, Atlanta.

Provenance: Paul Petrides, Paris.

Exhibition: *Drawings from Georgia Collections: 19th and 20th Centuries*, High Museum of Art, Atlanta, and Georgia Museum of Art, Athens, May 14-Aug. 23, 1981, no. 26.

On his first meeting with Gauguin, Bernard had not been warmly received, but when they met again at Pont-Aven in the summer of 1888 they developed a close working relationship. It was apparently Bernard who introduced Gauguin to the tenets of the Cloisonnist movement, with its flat patterning, dark contour lines, ambiguous space, and vivid colors. Both artists were intrigued by the costumes and customs of the devout peasants of Brittany, especially the women's bonnets which, as Gauguin noted in a letter to van Gogh, were in the shape of a cross. In the late spring of 1889, several of their paintings of Breton subjects were exhibited in the show of Synthetist artists at the Café Volpini near the Arts Pavilion of the Paris World's Fair.

During the summer of 1889, Bernard worked at Saint-Briac and Pont-Aven, having been forbidden by his father to join Gauguin, who was at Le Pouldu, not far away. It was probably during this period that Bernard made this watercolor. As in several major paintings of the previous year, such as the *Pardon at Pont-Aven*,[1] individual heads rise up in the fore-ground of the composition. The crippled man making his way toward the church suggests that it may contain a relic reputed to have healing power. The medieval religious attitude evident in this drawing was shortly to lead Bernard to the purely biblical subjects of 1890-91 that van Gogh so deplored. Bernard returned to Breton subjects in the years 1892-93, and in at least one painting, *Breton Women at the Entrance of a Church* (1892),[2] the massing of the women and children outside the church door seems to have been adapted from this earlier watercolor.

[1]Private collection, Paris. See exhibition catalogue *Post-Impressionism*, National Gallery of Art, Washington, D.C., 1980, pl. 135.
[2]Hammer Galleries, New York, *Decades of Light*, Oct. 8-25, 1980.

Jacques-Fernand Humbert
Paris, 1842-1934

The Virgin and Child with St. John the Baptist, ca. 1874
Oil on canvas, 31¹⁵/₁₆ x 18¼ inches (81.2 x 46.4 cm.)

Purchase with funds from the Mrs. Floyd McRae Bequest, 1982.22.

Provenance: Paris Art Market; Shepherd Gallery Associates, Inc., New York.

Exhibitions: *Christian Imagery in French Nineteenth Century Art 1789-1906*, Shepherd Gallery, New York, Spring 1980, no. 152; *French Salon Paintings from Southern Collections*, High Museum of Art, Atlanta, Chrysler Museum, Norfolk, North Carolina Museum of Art, Raleigh, John and Mable Ringling Museum of Art, Sarasota, Jan. 21-Oct. 23, 1983, no. 44.

Humbert entered the Ecole des Beaux-Arts in 1861 and studied with Picot and Cabanel. In 1865 he exhibited his first Salon entry, *Flight of Nero*. In the next two years, his entries *Oedipus and Antigone* and *An Episode from the Saracen Invasion of Spain* won medals and were purchased by the State. From 1870, when he exhibited a *Sacred Heart* painted for the Church of Saint-Eustache, the artist concentrated on religious subjects.

Humbert entered the circle of artists around Eugène Fromentin and became one of the master's favorites. In 1872 he sought Fromentin's advice about a painting of Judith he was planning, and the older artist replied in a letter: "Try not to make of it a pastiche, but keep yourself at those heights of perception where all danger of modern interpretation disappears; ask yourself how an Italian of the best period would conceive this picture. . . ."[1]

Unfortunately, when Humbert exhibited his large finished version of *The Virgin and Child with St. John the Baptist*[2] at the Salon of 1874, the most frequent criticism of it was that it was a pastiche after a variety of Italian prototypes. Louis Janmot wrote:

> There is so much to know in painting by Humbert that one can only consider it seriously. But . . . as Ingres said apropros of an analogous work, "It is good to absorb the old masters, but it is not necessary to get indigestion." In spite of its able execution and strong unified color, and a general aspect that attracts our attention, we find in considering the work carefully that what comes from nature isn't seen enough, what comes from the old masters is seen too much, and what comes from M. Humbert isn't seen at all.[3]

The serious nature of *The Virgin and Child with St. John the Baptist* came as a surprise to the critics after the "indecent" *Dalila* which Humbert had shown the preceding year. Jules Claretie wrote:

> M. Humbert wanted to prove that after the ill-conceived *Dalila* which he showed last year, he was able to give to the Salon a more serious painting, with strong colors, and a composition not only chaste, but almost austere. . . . But didn't we know already the competency of M. Humbert's paintbrush? Who could reproach him, except for his penchant for *pastiche*? But what is this Madonna, other than a *pastiche* composed after the early Florentines and Venetians?[4]

Louis Gonse, however, approved,[5] and both Chesneau and Duvergier de Hauranne called it the outstanding religious work in the Salon.[6] Montrosier summed up the situation:

> *The Virgin* by Humbert is of another era. . . . All the great religious schools of Italian art are evoked by this canvas, which recalls as much the Primitives as Cima and Bellini. . . . Humbert's work is one of the most accomplished in the exhibition.[7]

The painting was purchased for the State and sent to the Musée de Luxembourg. It is now in the bishop's residence at Metz.

The High Museum's *modello* for the painting renders almost exactly the composition and color of the final work. Only a slight adjustment was made in the drapery folds around the Virgin's left arm. Even in this study, the imposing hieratic quality of the work is evident. The throne rising up against the dark landscape emphasizes this dramatically. Humbert's careful delineation of the inlaid marble of the throne and his treatment of the Virgin provided inspiration for Bouguereau's painting of the same subject, shown the following year.[8]

Jacques-Fernand Humbert, *The Virgin and Child with St. John the Baptist*

[1]Quoted in exhibition catalogue, *Christian Imagery in French Nineteenth Century Art 1789-1906*, 1980, p. 380.
[2]Paris Salon of 1874, no. 949. See *Le Musée de Luxembourg en 1874*, exhibition catalogue, Grand Palais, Paris, May 31-Nov. 18, 1974, p. 104, no. 126.
[3]Louis Janmot, *Salon de 1874*, Paris, 1874, p. 16.
[4]Claretie, *L'Art et Les Artistes Français Contemporains*, Paris, 1876, pp. 227-228.
[5]Louis Gonse, "Salon de 1874," *GBA*, June 1874, p. 514.
[6]Ernest Chesneau, "Le Salon Sentimental," *La Revue de France*, June 30, 1874, p. 755; and Ernest Duvergier de Hauranne, "Le Salon de 1874," *Revue des deux mondes*, June 1874, p. 659.
[7]E. Montrosier, "Le Salon de 1874," *Musée des Deux Mondes*, May 15, 1874, p. 19.
[8]Formerly in the Tanenbaum collection, Toronto; see *The Other Nineteenth Century*, exhibition catalogue, National Gallery of Canada, Ottawa, 1978, no. 12.

Hugues Merle, *Maternal Love*

Hugues Merle
Saint Martin, 1823-1881, Paris

Maternal Love, 1880
Oil on canvas, 45⅝ x 34⁷/₁₆ inches (115.3 x 87.5 cm.)
Signed and dated at lower left: *Hugues Merle. 1880.*

Gift of Mr. and Mrs. Crawford M. Sites in memory of Pauline McLendon Sites and Frank Boas Sites, 1975.1.

Provenance: Mr. and Mrs. Crawford M. Sites, Atlanta.

Exhibition: *French Salon Paintings from Southern Collections*, High Museum of Art, Atlanta, Chrysler Museum, Norfolk, North Carolina Museum of Art, Raleigh, John and Mable Ringling Museum of Art, Sarasota, Jan. 21-Oct. 23, 1983, no. 52.

Merle, a student of Léon Cogniet, began exhibiting at the Salon in 1847 but did not receive any awards until 1861 and 1863, when he won second class medals. In 1866 he was made a Chevalier in the Legion of Honor. Merle concentrated on allegories or humble scenes, usually of mothers and children. His paintings were often drawn from literary sources such as *The Scarlet Letter* (Walters Art Gallery), or had sentimental, moralizing subjects like *The Bible Lesson* (Wallace Collection, London).

Contemporaries noted the similarity of Merle's work to that of Bouguereau. Stranahan even wrote that the artist "became a considerable rival of Bouguereau in subject and treatment."[1] His paintings were popular in America. An earlier treatment of *Maternal Love* was in the Vanderbilt collection, and two of his mother-and-child paintings—one quite similar to the High Museum's painting—are in the Sterling and Francine Clark Art Institute.

In this *Maternal Love*, as in his other works on this theme, Merle evokes a spiritual bond between mother and child reminiscent of Raphael's various treatments of the Virgin and Child theme.

[1] C. H. Stranahan, *A History of French Painting*, New York, 1917, p. 398.

Luc-Olivier Merson
Paris, 1846-1920

"Je vous salue, Marie" ("Hail, Mary"), ca. 1885
Oil on canvas, 32 x 23½ inches (81.3 x 59.7 cm.)

Gift of the Piedmont Driving Club, 1940.9.

Provenance: Purchased by the Exposition Fund, Atlanta, 1895; Piedmont Driving Club, Atlanta.

Exhibitions: Cotton States and International Exposition, Atlanta, 1895, no. 432; *Reality, Fantasy and Flesh: Tradition in Nineteenth Century Art*, University of Kentucky Art Gallery, Lexington, Oct. 13-Nov. 18, 1973, no. 59; *French Salon Paintings from Southern Collections*, High Museum of Art, Atlanta, Chrysler Museum, Norfolk, North Carolina Museum of Art, Raleigh, John and Mable Ringling Museum of Art, Sarasota, Jan. 21-Oct. 23, 1983, no. 53.

Bibliography: W. A. Coffin, "Atlanta Exhibition," *Nation*, 61, Nov. 7, 1895, p. 325; *Harpers Weekly*, Dec. 14, 1895, rep. p. 1188; Gustave Larrounet, "Luc-Olivier Merson," *Revue de l'art ancien et moderne*, Dec. 1897, p. 443; Roger Pevre, *La Peinture Française*, Paris, n.d., p. 295; Raymond Bouyer, "Luc-Olivier Merson," *GBA*, July 1921, p. 41; *Luc-Olivier Merson, Exposition de l'oeuvre*, Ecole Nationale des Beaux-Arts, Paris, May 1921, p. 64, no. 522; Adolphe Giraldon, *Luc-Olivier Merson: Une noble vie d'artiste*, Paris, 1929, p. 19; "Art Across North America," *Apollo*, July 1983, p. 102, fig. 3.

Merson, whose father, an artist and critic from Nantes, had written that "religious painting constitutes the highest level of the ideal,"[1] became one of the few late nineteenth century painters who produced convincing religious pictures.

Merson received his training from Lecoq de Boisboudran and Chassevent at the Ecole des Arts Décoratifs and then from Isidore Pils at the Ecole des Beaux-Arts. Pils—himself a pupil of Picot, a winner of the Prix de Rome, and a graduate of the Ecole—passed on the accepted academic methods to Merson, who began exhibiting at the Salon in 1867. His first major subjects were drawn from classical mythology and history. In 1869 he won the Prix de Rome for *The Soldier of Marathon*, which enabled him to spend two years at the Villa Medici in Rome. In Italy Merson studied quattrocento masters such as Fra Angelico, whose refined style and spiritual qualities would be reflected in his own work. In 1872 he sent *St. Edmund, King of England, Martyr* (Musée de Troyes) to the Salon. This painting, which depicts the dead king supported by an angel, helped establish Merson as a painter of religious and medieval subject matter.

On his return to France, Merson exhibited *The Vision*, which won a first class medal in the 1873 Salon. His later honors included a gold medal at the Exposition Universelle of 1889, membership in the Institute in 1892, and a professorship at the Ecole des Beaux-Arts in 1894. Merson worked on large mural decorations for the Palais de Justice, the Opéra Comique, the Hôtel de Ville, and other buildings in Paris, and also designed stained glass windows, book illustrations, and even bank notes.

For his religious paintings, Merson chose humble subjects and imbued them with a delicate poetic character. Among his best known works were *The Wolf of Gubbio* (Salon of 1879, Musée de Lille), *St. Francis Preaching to the Fish* (Salon of 1881, Musée de Nantes), and *Rest on the Flight into Egypt* (Salon of 1879, Musée de Nice). This last, representing the Virgin and Child resting in the paws of the Sphinx under the star-filled desert sky, was an especially popular subject that Merson repeated several times.[2] Writing of Merson's 1885 Salon piece *Arrival at Bethlehem*, A. Michel noted the mystical and purposely archaic quality that characterized Merson's art.[3] Dated by Bouyer to the same year, *"Je vous salue, Marie"* has the appearance of an enlarged page from a medieval manuscript.

The painting has a curious ambiguity about it. The peasant with his child and dog, returning home after

Luc-Olivier Merson, *"Je vous salue, Marie"* ("Hail, Mary") (color plate, page 94)

his day in the fields, greets the Virgin and Christ Child. This is not a Virgin and Child of stone or wood, but rather the living presence of these holy personages, yet one is hard pressed to determine if this is a miraculous apparition or reality. Merson often represented the Virgin as an elongated, otherworldly figure. Shown here in profile, she has a remote presence and seems to gaze into the far distance. The sense of melancholy is enhanced by the use of traditional iconographic details: the ax in the left foreground recalls St. Joseph's profession, and the two wooden beams suggest the Cross. The peasant's words of greeting are those spoken by the Angel of the Annunciation to the Virgin Mary. The *Ave Maria* theme was one of Merson's favorites. A version of the *Annunciation* that he painted in 1908 shows the Virgin in a courtyard and the angel on the roof of a thatched cottage similar to those in the High Museum's painting.[4]

[1]Olivier Merson, *La Peinture en France, Exposition de 1861*, quoted in *Equivoques*, Musée des Arts Décoratifs, Paris, 1973, n.p.
[2]A version is in the Museum of Fine Arts, Boston, 18.652.
[3]A. Michel, "Le Salon de 1885," *GBA*, June 1885, p. 492.
[4]Illustrated in the sale catalogue *Rêves symbolistes*, Hôtel George V, Paris, June 25, 1975, p. 105.

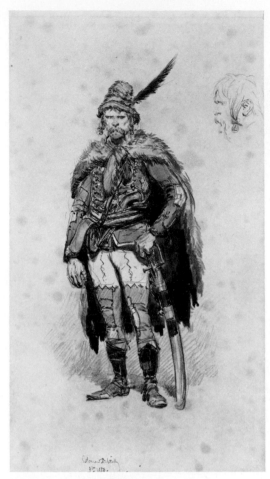

Edouard Detaille, *Serbian Soldier*

Edouard Detaille
Paris, 1848-1912

Serbian Soldier, 1886
Pencil, pen and ink, with watercolor, 8⅜ x 4⅝ inches
(21.3 x 11.7 cm.)
Signed and dated at lower center: *Edouard Detaille/ 9-1886*

Bequest of Charles Loridans, 1956.105.

Detaille was born in Paris and showed an early interest in both drawing and the military. At the age of seventeen he was introduced to J.-L. Ernest Meissonier, who took him on as a pupil. The older artist, with his strict methods and dedication to detail, gave Detaille a firm grounding in "proper artistic methods." The student long remembered Meissonier's "marvelous lessons," which always ended with the advice, "Follow my example; reality, always reality (*'la nature, toujours la nature'*)."[1] This influence was seen in Detaille's first Salon piece, *A Corner of Meissonier's Studio* of 1867. Detaille became one of the most famous artists of the Belle Epoque. His specialty, from the Salon of 1868 onward, was military subjects, either historic incidents or contemporary events.

Detaille was a prolific and proficient draughtsman, having learned to make studies while under fire in the Franco-Prussian War. He used his sketches to produce paintings and also for his illustrated books on the uniforms of the French army. Detaille also travelled to England, Russia, and other countries to make studies for a volume on the uniforms of their soldiers, such as the costumes of Cossacks.[2] This study is probably related to that project.

[1]Quoted in the exhibition catalogue, *War à la mode, Military Pictures . . . from the Forbes Magazine Collection*, New York, 1977, p. 13.
[2]See Jean Humbert, *Edouard Detaille*, Paris, 1979, pls. 53-54.

Antoine-Louis Barye
Paris, 1796-1875

Walking Lion
Bronze, 9 x 15½ x 4 inches (22.9 x 39.4 x 10.2 cm.)
Incised at lower left front, top of base: *BARYE*; at lower left back, top of base: *F. BARBEDIENNE, Fondeur*

Walking Tiger
Bronze, 8½ x 15⅛ x 3⅞ inches (21.6 x 38.4 x 9.8 cm.)
Incised at lower left front, top of base: *BARYE*; at lower right back edge, top of base: *F. BARBEDIENNE, Fondeur*

Gifts of the J. J. Haverty Family, 1949.42 and 1949.43.

Barye was the son of a goldsmith from Lyon. At the age of thirteen, he was apprenticed to the diemaker Fourier and learned the art of engraving. His apprenticeship was cut short in 1812 when he was drafted into Napoleon's army, to serve in a corps of engineers molding relief maps. He completed his military service in 1816 and entered the studio of the Italian academic sculptor Bosio. The following year, he began to study in the atelier of the painter Baron Gros.

In 1819 Barye submitted his first entry to the Salon, a relief medallion, *Milo of Crotona Devoured by a Lion*, in hopes of winning the Prix de Rome. Instead he won an honorable mention. He continued to compete each year with diminishing success until he was denied entry to the competition in 1824. He joined the workshop of the fashionable jeweler and goldsmith Fauconnier in 1823, and began to cast small ornamental animals.

Barye made frequent trips to the Jardin des Plantes to study animals and their anatomy. While sketching there, he was often joined by his friend, Eugène Delacroix. The sculptor carefully observed the animals, seeking to capture their ferocious energy.

His success was evident at the Salon of 1831 when he exhibited his bronze *Tiger Devouring a Gavial*. This led to several notable commissions from royal patrons and the government. The Duc d'Orléans, son of Louis-Philippe, became Barye's patron, and the

Antoine-Louis Barye, *Walking Lion*

Antoine-Louis Barye, *Walking Tiger*

Duchesse d'Orléans became his occasional pupil. Barye's commissions during the 1830s and 1840s included an enormous project for the Duc de Barry involving five hunting scenes and four scenes of animal combat.

In 1834 the Salon once again rejected his entry and by 1837 the sculptor's unconventional work was completely excluded from the competition. In defiance, he established his own studio in 1839, producing bronze editions from the dozens of models he had already accumulated, and for nine years he boycotted the Salon.

Barye was not much of a businessman, and in 1848 his financial backers sued him and seized his models (the only capital he owned). Fortunately for Barye, the Revolution of 1848 brought liberal reforms to the Academy, including the formation of a jury of artists to select Salon pieces, to which Barye himself was elected. He was named curator of plaster casts at the Louvre, and he greatly improved the casting system during his four years in the position. In 1850, he showed two works at the Salon, including the famous *Jaguar Devouring a Hare* which won the Grand Medal of Honor for Sculpture at the Exposition Universelle of 1855 in Paris. In 1854 he became Professor of Zoological Drawing at the Jardin des Plantes, and among his students was Auguste Rodin. Barye continued to receive important commissions during the 1860s and 1870s, such as colossal allegorical statues for the Louvre and monuments to Napoleon.

As with Delacroix, those prime romantic beasts—the lion and the tiger—figured prominently in Barye's work in both sculpture and watercolors. For a commemorative plaque on the column in the Place de la Bastille, Barye had depicted a striding lion in high relief; this probably led him in 1836 to the *Walking Lion* and its pendant *Walking Tiger*, which were cast in editions of varying size.

Antoine-Louis Barye, *Juno*

Antoine-Louis Barye
Paris, 1796-1875

Juno
Bronze, 10⅞ x 5¼ x 5¾ inches (27.7 x 13.4 x 14.7 cm.)
Incised at lower right: *BARYE*
Stamped on underside: *205*

Gift of Mrs. Isabelle Woolford Kennedy, 1972.32.

In 1840, Barye was commissioned by the Duc de Montpensier, brother of the Duc d'Orléans, to produce an enormous *dessus de cheminée* for his mantle. The result was *Roger et Angélique* surrounded by a great ornamental candelabra depicting Juno, Minerva, and the Three Graces. In Barye's treatment of the nude figures, one can clearly see the ancestor of Maillol's full-bodied women.

Auguste Rodin
Paris, 1840-1917, Meudon

Eternal Spring, 1884
Bronze, 26 x 28½ x 16 inches (66.1 x 72.4 x 40.6 cm.)
Incised at lower right side: *A. Rodin*; at lower right of base: © *by musée Rodin. 1963*.
Foundry mark on left front: *Georges Rudier. Fondeur. Paris.*; on right bottom of base: © *by musée Rodin. 1963*.

Gift of the B. G. Cantor Art Foundation, 1977.132.

Exhibitions: *Auguste Rodin*, Musée Nicolas Sursock, Beirut, April 13-June 15, 1964; *Auguste Rodin*, Finland: Helsinki, Turku, Tampere, Sept. 9-Dec. 4, 1965; U.S.S.R., 1966; *Rodin*, Tel Aviv Museum, Feb.-March 1967; *Mostra di Auguste Rodin*, Accademia di Francia Villa Medici, Rome, May 26-June 30, 1967; *Homage to Rodin*, Los Angeles County Museum of Art, The Museum of Fine Arts, Houston, Herron Museum of Art, Indianapolis, The Brooklyn Museum, Virginia Museum of Fine Arts, Richmond, California Palace of the Legion of Honor, San Francisco, Nov. 14, 1967-Jan. 19, 1969; "*Auguste Rodin*" *from the B. Gerald Cantor Collection and B. G. Cantor Art Foundation*, William Rockhill Nelson Gallery of Art, Kansas City, Missouri, Oct. 7-Nov. 14, 1971; Indianapolis Museum of Art, Dec. 1971-May 1976.

Bibliography: Eleanor H. Gustafson, "Museum Accessions," *Antiques*, April 1978, p. 786.

The *Gates of Hell* commission of 1880 unleashed a great flow of creativity from Rodin. He produced a series of marble portraits, such major masterpieces as the *Burghers of Calais* (1884), and monuments to Hugo and Balzac. Between 1884 and 1896, he produced a series of voluptuous nudes and erotic couples, including *The Eternal Idol* and *The Kiss*. One of the most exciting of these couples, *Eternal Spring*, may represent Rodin's gloss on Canova's famous *Cupid and Psyche Kissing*, for the male figure has remnants of wings. The embrace in Rodin's work is much more physical, however, which may reflect Rodin's own passionate involvement during this period with his young student Camille Claudel. The model for the female figure was a girl named Adèle, whose torso he sculpted in 1882 for the *Gates of Hell*; she was also used for his *Illusions Falling on the Earth*.

160

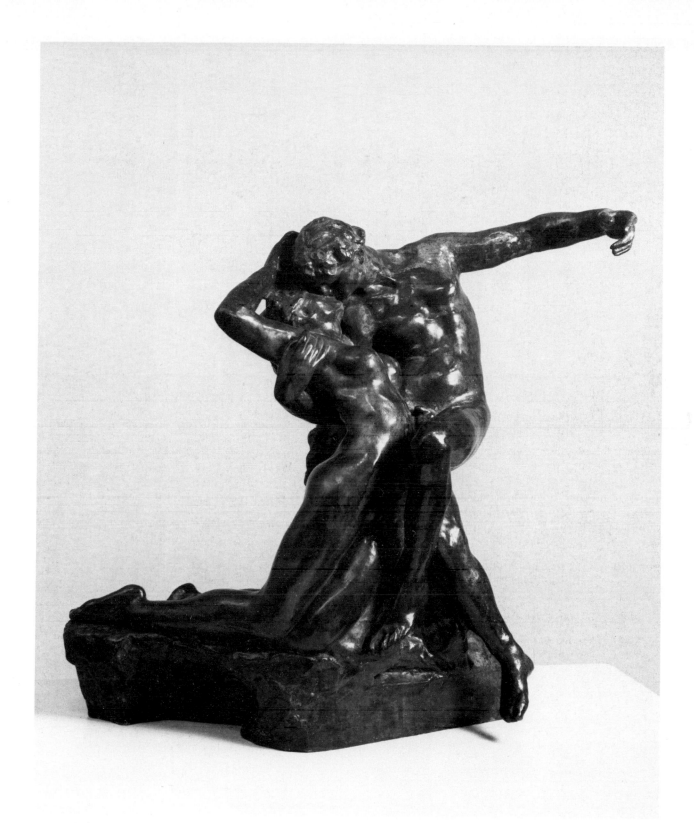

Auguste Rodin, *Eternal Spring*

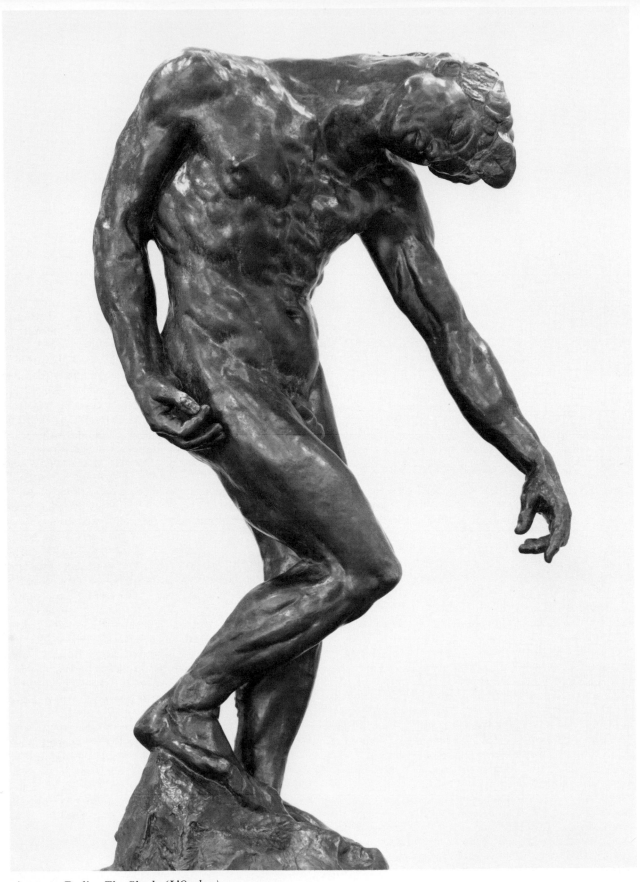

Auguste Rodin, *The Shade (L'Ombre)*

Auguste Rodin
Paris, 1840-1917, Meudon

The Shade (L'Ombre), 1968 cast
Bronze, 75¼ x 44⅛ x 19¾ inches (191.3 x 112.1 x 50.2 cm.)
Incised at lower right of base: *RODIN*
Incised at back of base: *COPYRIGHT BY MUSEE RODIN 1968*; at lower left of base: *SUSSE FONDEUR. PARIS*
Gift of the French Government to the Atlanta Arts Alliance, 1968, EL 78.1983.

Having shown an interest in drawing from an early age, Rodin was allowed by his father, a minor government official, to enter the Petite Ecole de Dessin in Paris at age fourteen. There he studied with Horace Lecoq de Boisboudran and found his true vocation as a sculptor. After three years, he applied to the Ecole des Beaux-Arts, but was denied admission. Throughout the 1860s, Rodin supported himself with a variety of jobs, assisting decorators and jewelers, and working for the sculptor Carrier-Belleuse at the Sèvres porcelain factory. In 1863 he received some instruction in animal anatomy from the painter and sculptor Antoine Louis Barye. That year he began work on his first major clay piece, *The Man with the Broken Nose*, which was rejected by the Salon jury of 1864 for its strong realism.

Rodin, however, persevered in his realistic studies of the human form. In 1875 he journeyed to Italy to study the works of Donatello and Michelangelo. The following year, working in Brussels, Rodin created his first full-scale figure, *The Age of Bronze*, which clearly shows the influence of Michelangelo. Shown at the Salon of 1877, it created a controversy, for the sculptor was unjustly accused of having cast the work from life. The controversy brought wide attention to Rodin and three years later a cast of the piece was purchased by the state and erected in the Jardin du Luxembourg.

In 1880 Rodin received a commission from the French government for reliefs for a set of monumental doors for a proposed new museum of decorative arts in Paris. This museum was not built, but Rodin continued work on his project. He originally planned to illustrate certain episodes from Dante's *Divine Comedy* in a segmented fashion, but the *Gates of Hell*, as the work was called, evolved into a seething, fluid arrangement of figures in violent action over the entire surface of the lintel and doors. Rodin conceived a ninety-foot high version of this work and made independent over-life-size enlargements of some of the figures such as *Adam*, *Eve*, *The Thinker*, and the *Shades*. The *Adam* and the *Shades* were clearly derived from the Adam of the Sistine ceiling. Like Michelangelo, Rodin kept the limbs close to the body, so that "you see none of those openings which, resulting from the freedom with which the arms and legs were placed, gave lightness to Greek sculpture."[1] It was indeed the opposite effect, the downward pull of the tomb, that Rodin wanted to evoke with the three identical figures of the *Shades* placed on the top of the gate. His composition probably alluded to the three large figures atop Ghiberti's first Baptistry doors, which Rodin would have seen in Florence in 1875. But the *Shades*, standing between earth and heaven, convey a sense of anguish and despair.

The *Gates of Hell* was only cast as a whole after the sculptor's death. The Musée Rodin, housed in the Hôtel Brion, has carried on the production of Rodin's sculpture in bronze. According to his will, such casts may be made in editions of twelve. *The Shade* was a gift of the French Government in memory of the 122 friends of the High Museum who perished in an air crash at Orly in 1962.

[1]A. Rodin, *On Art and Artists (L'Art)*, trans. A. Werner, New York, 1957, p. 208.

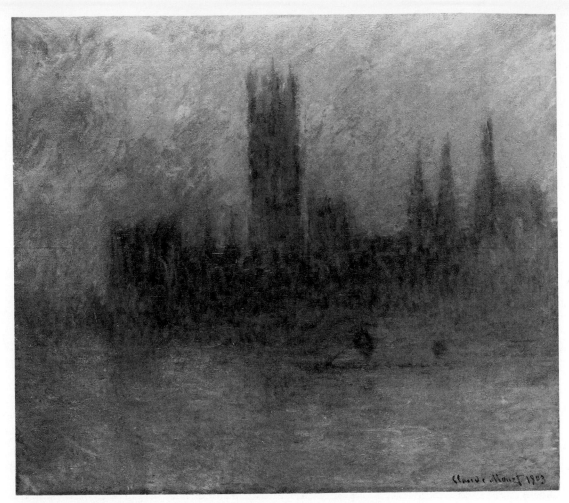

Claude Monet, *Houses of Parliament in the Fog* (color plate, page 95)

Claude Monet
Paris, 1840-1926, Giverny

Houses of Parliament in the Fog, 1903
Oil on canvas, 32 x 36⅜ inches (81.3 x 92.5 cm.)
Signed and dated at lower right: *Claude Monet 1903*

Great Painting Fund purchase in honor of Sarah Belle Broadnax Hansell, 1960.5.

Provenance: Bernheim-Jeune, Paris; Private collection, Paris; Wildenstein & Co., Inc., New York.

Exhibitions: *Vues de la Tamise à Londres*, Galerie Durand-Ruel, Paris, May 9-June 4, 1904, no. 31; *Claude Monet: Seasons and Moments*, The Museum of Modern Art, New York, March 7-May 15, 1960, no. 86; *Monet and the Giverny Group*, The Dayton Art Institute, Ohio, Charles and Emma Frye Art Museum, Seattle, Phoenix Art Museum, University of Nevada, Reno, Fine Arts Gallery of San Diego, Atlanta Art Association Galleries, Jan. 6, 1961-Jan. 28, 1962; *Landscape Into Art*, Atlanta Art Association Galleries, Feb. 6-25, 1962, no. 52; *Focus on Light*, New Jersey State Museum, Trenton, May 20-

Sept. 10, 1967, no. 62; *French Impressionists Influence American Artists*, The Lowe Art Gallery, Miami, March 19-April 25, 1971, no. 110; *Civilization Revisited*, Wichita Art Museum, Dec. 4, 1971-Jan. 30, 1972; *The Modern Image*, High Museum of Art, Atlanta, April 15-June 11, 1972; *The Impressionists in London*, Hayward Gallery, London, Jan. 3-March 11, 1973, no. 26; *Masterpieces East and West, from American Museum Collections*, Western Museum of Art, Tokyo, and the National Museum, Kyoto, Sept. 10-Dec. 5, 1976, no. 49; *Fifty Years of French Painting: The Emergence of Modern Art*, Birmingham Museum of Art, Alabama, Feb. 1-March 30, 1980, no. 17.

Bibliography: William Seitz, *Claude Monet: Seasons and Moments* (exhibition catalogue), The Museum of Modern Art, New York, 1960, p. 63, no. 86; "Monet and the Giverny Group," *The Dayton Art Institute Bulletin*, Dec., 1960, cover; *Masterpieces*, Atlanta, 1965, p. 37; Eloise Spaeth, *American Art Museum: An Introduction to Looking*, New York, 1975, p. 112; *Hommage à Claude Monet*, exhibition catalogue, Grand Palais, Paris, 1980, p. 315; *Selected Works*, Atlanta, 1981, p. 19.

As a young man in Le Havre, Monet gained a local reputation for his caricatures. Impressed by his drawing skill, Eugène Boudin in 1858 suggested that Monet paint landscapes and convinced him to work spontaneously, outdoors. The following year Monet attended the Académie Suisse in Paris, where he met Camille Pissarro and later Armand Guillaumin and Paul Cézanne. After two years of military service in Algeria, he returned to Le Havre in 1862 and painted with Boudin and Jongkind along the coast. That same year he returned to Paris and enrolled in classes at the studio of the Swiss painter Charles Gleyre. There Monet became acquainted with Renoir, Sisley, and Bazille. Rejecting Gleyre's academic formulas of an idealized nature, the four often travelled to the Forest of Fontainebleau to paint outdoors.

Two seascapes by Monet were accepted into the Salon of 1865 and obtained favorable reviews. In subsequent years, however, his work was not well received, and in 1869 he decided not to submit to the Salon again. During this period his financial situation was so bad he had to turn to Manet and Bazille for assistance.

With the outbreak of the Franco-Prussian War, Monet went to England, where he made an important contact with the French art dealer Durand-Ruel. He also admired the works of Turner. After a brief stay in Holland, he returned to France, settling at Argenteuil from 1872 to 1878, often painting on a boat studio on the Seine.

In 1874 Monet, Degas, Pissarro, and Renoir, among others, organized the first group exhibition of independent artists who were dubbed the Impressionists. The title derived from one of Monet's works, *Impression, Sunrise* (1872), which was his attempt to capture the vibrations of color and light of the sun rising through the fog over the Le Havre harbor. His fascination with light and atmospheric effects continued in the years (1878-1883) he spent at Vétheuil, and later at Giverny. From this time dates the first of his "series" paintings, the *Haystacks*: the same subject observed at different times of day and under different conditions of light. This process continued with the *Poplars* in 1890-91, *Rouen Cathedral* in 1892-94 and the *Water Lilies*, beginning in 1899 and culminating in the large curved panels installed in the Orangerie, Paris, in 1927.

During the 1880s and 1890s, Monet travelled widely, looking for subjects. He visited Etretat, the Côte d'Azur, Venice, Antibes, and London, where he returned each winter from 1899 to 1901. Perhaps inspired by the works of Turner, he was particularly drawn to the Thames and the Houses of Parliament. He made his studies from Saint Thomas's Hospital on the South Bank. More than ninety canvases (including twenty of the Houses of Parliament) were brought back to be finished at Giverny. In a letter of 1903 to Durand-Ruel, Monet wrote:

> Though I am not in London, my mind is there, I am working hard at my paintings which give me much trouble. . . . I cannot send you a single one of my London paintings because in the type of work I am doing, it is essential that I should have all of them under my eyes and to be quite frank, also because not one of them is completely finished. I work at all of them at the same time or at least at some of them, and am unable for the moment to say how many will be exhibited, as what I am doing here is most delicate. One day I am satisfied, the next day I find it all bad, still I hope that someday I will find some of them good. . . .[1]

Thirty-seven of the works were successfully exhibited at the Durand-Ruel Gallery in Paris in 1904, and Octave Mirbeau wrote in the preface of the exhibition catalogue that there was in these canvases but a single theme, "single and yet different: the Thames." He described the various views of the Houses of Parliament as "airy and light in one canvas, in another massive, further on scarcely outlined and harmoniously lost amid an evanescence of things whose existence we faintly discern."[2]

The High Museum's painting has been identified by Anthea Callen as number 31 in the 1904 exhibition: *Westminster, le Parlement, effet de brouillard*.[3] The artist carefully characterized the effects he had achieved in each painting: one particularly colorful version is entitled *Le Parlement, Effet du Soleil dans le Brouillard*.[4] In 1920 Monet commented, "Above all in London I love the fog. It is the fog that gives it its magnificent amplitude."[5] In this painting the buildings, reduced to silhouette, hover like an insubstantial vision in the vibrant colored atmosphere, uniting water and sky.

[1]Quoted in Lionello Venturi, *Les Archives de l'impressionnisme*, Paris, 1939, I, p. 388. Translated in the exhibition catalogue *Claude Monet at the time of Giverny*, Centre Culturel de Marais, Paris, 1983, p. 130.
[2]Translated in *Claude Monet*, Paris, 1983, pp. 130-31.
[3]In the exhibition catalogue *The Impressionists in London*, Hayward Gallery, London, 1973, pp. 47-48.
[4]In a private collection; see Robert Gordon and Andrew Forge, *Monet*, New York, 1984, p. 185.
[5]Quoted in William Seitz, *Claude Monet*, New York, 1960, p. 148.

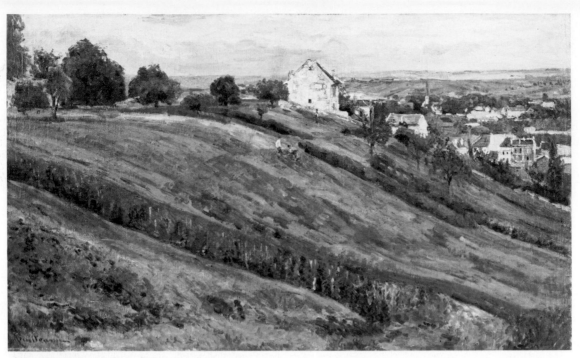

Jean-Baptiste Armand Guillaumin, *Landscape*

Jean-Baptiste Armand Guillaumin
Paris, 1841-1927

Landscape, ca. 1887
Oil on canvas, 24 x 39½ inches (61 x 100.1 cm.)
Signed at the lower left corner: *Guillaumin*

Gift of Mr. and Mrs. George Levin, 1981.53.

Guillaumin began to study art at Moulins, where his family had moved shortly after his birth. At sixteen he returned to Paris and worked as a clerk in the shop of his uncle. He also enrolled in a municipal art school and by 1859 had a work accepted for the Salon. In 1860 and 1861, he studied at the Académie Suisse, where he met Camille Pissarro and Paul Cézanne, who were to become his lifelong friends. They introduced him to Frédéric Bazille, Emile Zola, and Claude Monet.

Guillaumin's pastels and paintings of the 1860s depicted barges on the Seine and scenes around Paris, themes that he treated throughout his life. He painted with Cézanne and Pissarro at Pontoise (1872) and at the house of Dr. Gachet, a collector who had a printing studio in his home which he allowed the three artists to use. In 1874 Guillaumin participated with his friends in the independent exhibition that resulted in their designation as Impressionists. Guillaumin, like his fellows, was concerned with the depiction of light and the use of pure brilliant color applied in short, sketchy strokes to suggest form and depth. In 1875 he and Cézanne lived near each other on the quai d'Anjou and often painted together on the Seine.

Guillaumin participated in most of the Impressionist exhibitions through 1885, but he was the only member of the original Impressionists who chose to exhibit in 1884 with a younger group of artists, including Signac and Seurat. Although Guillaumin did not adopt their methods, he remained friendly with the pointillists and occasionally exhibited with them and their associates, Paul Gauguin and Odilon Redon.

After 1891, when he won two lotteries for a total of 100,000 francs, Guillaumin could devote himself to exploring and painting the environs of Paris and the quais of the Seine. During his last thirty-five years, he painted frequently at Crozat, Agay, and Saint-Palais-sur-Mer. His many views of the sea and rocky coastline or village streets and nearby valleys were generally thickly painted in vibrant colors. Guillaumin was honored the year before his death with a retrospective exhibition at the Salon d'Automne.

When acquired by the High Museum, this painting was identified as a view at Argenteuil, a suburb of Paris on the banks of the Seine where Renoir and Monet painted in 1873. There is, however, no evidence of Guillaumin's having been there. This scene, with its great diagonal sweep of open fields in the foreground, resembles Guillaumin's painting (ca. 1887) of the Vallée de Chevreuse.[1] In works such as this, the colors are applied to create a bright patchwork that envelops vegetation, tiny figures, distant houses, and a wide band of sky.

[1]See Christopher Gray, *Armand Guillaumin*, Chester, Conn., 1972, p. 109, fig. 104.

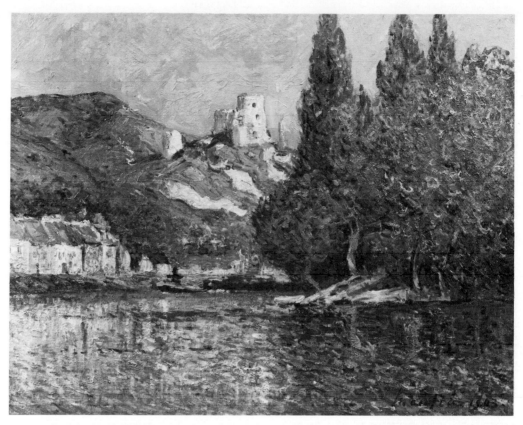

Maxime-Emile-Louis Maufra, *Le Château-Gaillard*

Maxime Emile Louis Maufra
Nantes, 1861-1918, Poncé

Le Château-Gaillard, 1903
Oil on canvas, 25¾ x 32 inches (65.4 x 81.3 cm.)
Signed at lower right corner: *Maufra 1903*

Gift of the Atlanta Junior League, 1938.1.

Provenance: Durand-Ruel, Inc., Paris, 1908; Mrs. H. L. Quick; Robert C. Vose Galleries, Boston.

Bibliography: Victor-Emile Michelet, *Maufra*, Paris, 1908, p. 77, rep. p. 2; Arsène Alexandre, *Maxime Maufra*, Paris, 1926, p. 204.

Maufra's interest in painting was stimulated by contact with two artists, the brothers Leduc. His father, however, who had a smelting business in Nantes, sent him to Liverpool as a commercial apprentice. When Maufra returned home, he took up painting for pleasure while supporting himself as a tradesman. He first exhibited at the Salon in 1886. Four years later, he abandoned his business career and travelled for the first time to Brittany, where he met Paul Gauguin and the circle of artists at Pont-Aven.

Most important for his own work, in Brittany he saw the ocean, which soon came to dominate his art. After leaving Brittany, Maufra established his atelier in Montmarte. He continued to revisit Normandy and Brittany, and went to Algeria in 1912-13.

Although Maufra professed to admire the work of Gauguin and Sérusier, his style is closer to that of Monet and the Impressionists. This painting was one of several views of the Château-Gaillard overlooking the Seine at Les Andelys, between Paris and Rouen, painted at various times of day in 1903. It shows his use of quick, impressionist brushstrokes to capture the transient quality of light as it diffuses through the scene.

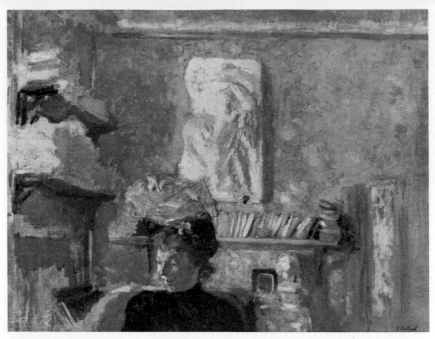

Edouard Vuillard, *Woman Before a Plaster Relief* (color plate, page 95)

Edouard Vuillard
Cuiseaux, 1868-1940, Paris

Woman Before a Plaster Relief, ca. 1900-1904
Oil on canvas, 21 x 27½ inches (53.3 x 69.9 cm.)
Signed at lower right: *E Vuillard*

Gift of the Forward Arts Foundation, 1970.33.

Provenance: Family of the artist; Sam Salz; Mr. and Mrs. Philip Weisberg, New York; E. V. Thaw, New York.

Exhibition: *French Masters of the 19th Century: Impressionism and Post-Impressionism*, Birmingham Museum of Art, Alabama, Feb. 10-26, 1973.

Bibliography: "La Chronique des Arts," *Supplément à la Gazette des Beaux Arts*, 1237, Feb. 1972, p. 117, no. 418.

As a young man Vuillard aspired to a military career, like his father, but meeting Ker-Xavier Roussel at the Lycée Condorcet in Paris in 1884 turned him instead toward art. He and Roussel took classes in painting in 1887 from Diogène Maillart, a respected official artist, and enrolled the following year in the Académie Julian. Vuillard, Roussel, and Maurice Denis, whom they had known at the Lycée Condorcet, began a lasting friendship with Pierre Bonnard. In late 1888 they came under the influence of Paul Sérusier, who introduced them to Gauguin-inspired ideas of representing nature with flat areas of concentrated pure color. They formed a group called the *Nabis*, after the Hebrew word for prophet. Vuillard's paintings from 1890 to 1892 show him working in the manner of the Nabis, without sharing the group's devotion to mystical or symbolic subjects. He preferred from the first to depict unposed moments of everyday life.

After 1893 Vuillard's palette became more somber, and until the end of the decade he exhibited intimate views of interiors painted principally in dark tones, broken by patches of brighter color. During this time, Vuillard was greatly influenced by his friend the poet Mallarmé, who believed language should "suggest" an object rather than "name" it. Similarly, Vuillard presented private scenes of contemporary life engulfed in shadow, with simplified details and blurred forms. Modest in size, and frequently painted on cardboard, these tightly organized compositions concentrate on creating an overall pattern.

Beginning in 1892 and for the rest of his life, Vuillard was commissioned to paint large-scale decorative works for private homes, the theatre, and public buildings. His friends the Natansons also encouraged his graphic works for the publication *La Revue Blanche*.

In 1900 Vuillard's social life and his style of painting changed. Although continuing to live with his mother, he began a long association with Madame Hessel, the wife of a director of the gallery Bernheim-Jeune. Her upper-middle-class world became the subject of his work, and he represented it on a grand scale with lighter, less-muted colors and more open compositions. After 1920, portraits of the notable people he met (largely through the Hessels) became one of his chief concerns.

One of Vuillard's favorite subjects was his own studio space, which he kept as part of the apart-

ments he shared with his mother on the rue Truffaut until 1904 and later on the rue de Calais. Thadée Natanson described the latter as "a jungle of pictures, household objects, half-finished oils, and other paraphernalia."[1] According to Antoine Salomon (in a letter of June 15, 1984) the setting of the High Museum's painting, which he dates to ca. 1900-1904, is a small room leading off the studio in the rue Truffaut apartment. This same room is visible in the background of another painting, *Woman in the Studio* (private collection),[2] but the distinctive plaster relief does not appear. Models in similar elaborate hats occur in several other paintings of this period, such as one in the Bührle collection (Zurich)[3] and another in the Dreitzer Collection (New York).[4] The High Museum's painting, with its rough but glimmering finish, displays the quality which Signac described in 1888, when he wrote that Vuillard's "finished pictures are like sketches."[5]

[1]Quoted in the exhibition catalogue *Edouard Vuillard 1868-1940*, Art Gallery of Ontario, 1971, p. 109.
[2]Reproduced in the exhibtion catalogue *Post-Impressionism*, National Gallery of Art, Washington, D.C., 1980, no. 151.
[3]See *Foundation Collection Emil G. Bührle*, Zurich, 1973, no. 106.
[4]See Stuart Preston, *Edouard Vuillard*, New York, 1974, p. 31, fig. 38.
[5]Quoted in the exhibition catalogue *Vuillard*, Ontario, 1971, p. 95.

Ker-Xavier Roussel
Lorry-les-Metz, 1867-1944, l'Etang-la-Ville

The Sleeping Diana, ca. 1924
Oil on canvas, 23¼ x 21⅝ inches (59.1 x 55 cm.)
Signed at the lower right: *K. X. Roussel*

Purchase in memory of Miss Ruth McMillan with funds from the 1960, 1961, and 1962 Flower Festivals of the Garden Club of Georgia, 1967.19.

Provenance: De Frenne Collection; Galerie René Drouet, Paris; Hirschl & Adler Galleries, Inc., New York.

Bibliography: *Selections from the Collection of Hirschl & Adler Galleries*, V, New York, 1963-64, no. 92.

Ker-Xavier Roussel first studied at the Lycée Condorcet, where he met Edouard Vuillard in 1884. The two young artists became friends, and in 1893 Roussel married Vuillard's sister. Roussel encouraged Vuillard to devote himself to painting, and in 1886 they began to study under Gérôme at the Ecole des Beaux-Arts. Two years later both artists entered the Académie Julian, where they were pupils of Bouguereau and Lefebvre. There they exchanged

Ker-Xavier Roussel, *The Sleeping Diana*

ideas with other young artists, including Maurice Denis, Paul Sérusier, Pierre Bonnard, and Felix Vallotton, and formed the Nabis group.

Roussel worked in the manner of the Nabis for a brief time and also painted still lifes and landscapes that reflect his interest in Cézanne, whom he visited at Aix-en-Provence with Denis in 1905. After 1900 his landscapes, although based on the environs of Paris, began to incorporate bathers and mythological figures such as fauns, nymphs, and goddesses. This pagan subject matter—which he continued to paint for the remainder of his career—was rendered in a light, bright impressionist manner that was suitable both for easel paintings and large scale decorative commissions.

Roussel prepared many preliminary studies of his compositions. This painting, for example, is related to a much larger decorative panel (1924-25, destroyed in 1944), which hung over the mantlepiece in the Château des Clayes.[1] In the large panel, the figure of Diana and the dead game at the right are more clearly defined than in the High Museum's painting; in the foreground is the figure of a faun sleeping with his head on his hand. In the Museum's painting and another version,[2] Diana is watched over by a classically-draped nymph. A preliminary drawing for the figure of Diana also is known.[3]

[1]See the reproduction in Romain Coolus, "Le Château des Clayes," *La Renaissance*, July 1930, p. 185.
[2]Reproduced in Lucie Cousturier, *K. X. Roussel*, Paris, 1921, op. p. 20.
[3]Ibid., op. p. 3.

Paul Signac, *Boats at Bourg St. Andéol*

Paul Signac
Paris, 1863-1935

Boats at Bourg St. Andéol, 1926
Watercolor, 10½ x 20⅝ inches (26.7 x 42.2 cm.)
Signed, dated and inscribed in pencil at lower right: *Paul Signac/ Bourg St. Andéol-Juillet 1926*

Purchase, 1968.6.

Following his encounter with Seurat in 1884, Signac assumed an important role in the divisionist school of Neo-Impressionist painting. After about 1892 his style became broader, his paintings more decorative and—influenced by Matisse, whom he entertained at his home in Saint-Tropez in 1904—more richly colored. If the paintings from the latter part of his career seem less original and more contrived, the opposite is true of his watercolors. On the advice of Pissarro, Signac first experimented with the medium in 1896 as a means of making quick color sketches, but gradually it became one of his chief modes of expression. Signac's love of sea travel took him to Italy, Holland, England, and Constantinople, and he used watercolor to record the vistas of these port cities. In the 1920s, he painted over two hundred watercolors devoted to the ports and harbors of France.

Bourg St. Andéol is a locale he visited on various occasions and recorded in many watercolors.[1] This 1926 work has both a lively viewpoint and a sense of excitement in the execution. To achieve the sparkling spontaneity of such works, Signac seems to have followed the procedure he attributed to Jongkind in his 1927 book on the Dutch artist. He noted the importance of the white, empty spaces, writing that "these luminous areas intensify each tint and allow them to harmonize with their neighbors."

[1] An early work of 1910 is included in the exhibition catalogue *Watercolors by Paul Signac*, Los Angeles County Museum, 1954, no. 3. Another from 1924 was in the exhibition *La Création de l'oeuvre chez Paul Signac*, Malborough Gallery, London, 1958, no. 182; another from 1928 was shown in *Paul Signac 1863-1935, Retrospective Exhibition*, Marlborough Gallery, London, 1954, no. 42.

Max Ernst, *Tree of Life (L'Arbre de Vie)* (color plate, page 96)

Max Ernst
Brühl, 1891-1976, Paris

Tree of Life (L'Arbre de Vie), 1928
Oil on canvas, 114½ x 82¾ inches (290.9 x 210.2 cm.)
Signed and dated at the lower right: *Max Ernst 28*

Purchase with funds given by Alfred Austell Thornton in memory of Leila Austell Thornton and Albert Edward Thornton, Sr-Sarah Miller Venable and William Hoyt Venable, 1983.92.

Provenance: Comte Etienne de Beaumont, Paris; Sale, Sotheby's, London, Dec. 10, 1969, no. 84; Billy Rose Foundation, New York; Joseph Slifka, New York; Sale, Sotheby's, New York, Nov. 3, 1981, no. 259; Marie-Antoinette Panchaud, Switzerland; Blum Helman Gallery, New York.

Bibliography: Werner Spies, Sigrid and Günter Metken, *Max Ernst Werke, 1925-29*, Cologne, 1976, p. 214, no. 1206.

Max Ernst
Tree of Life (L'Arbre de Vie), 1928

Werner Haftmann has called Max Ernst "the first truly Surrealist painter,"[1] and indeed Ernst was one of the most original artists of the twentieth century. With Johannes Baargeld and Jean Arp, he founded the Cologne Dada group in 1919. André Breton invited Ernst to exhibit his work in Paris in 1921, and was impressed by the collages that Ernst sent:

> Surrealism was already in full force . . . the external object had broken with its customary surroundings, its component parts were somehow emancipated from the object in such a way as to set up entirely new relationships with other elements, escaping from the principle of reality while still drawing upon the real plane.[2]

Following his move to Paris in 1922 Ernst continued his bizarre collages and photomontages. He developed the improvisatory processes of "frottage" (rubbing paper on various textures and then incorporating the patterns into finished works) and "grattage" (scraping the surface of a painted canvas to "uncover" hidden imagery). Dream-inspired themes, sometimes after the example of de Chirico but more often original poetic subjects with powerful mythological, exotic, and primitive concerns, dominated Ernst's work—paintings, prints, and sculpture—for the rest of his life.

Ernst characterized his life and work of the year 1928 as follows:

> *Entrance of the flowers*: Aux rendez-vous des amis . . . C'était la belle saison . . . *It is the time of serpents, earthworms, feather flowers, shell flowers, bird flowers, animal flowers, tube flowers. It is the time when the forest takes wing and flowers struggle under water . . . It is the time of the circumflex medusa.*[3]

The High Museum's large painting of that year seems to sum up most of the artist's concerns. Dominating the work is the large head of a bird on the body of a serpent, motifs which (according to Schneede) represented for Ernst pleasure and horror.[4] From childhood Ernst was obsessed by birds and fascinated by their emblematic and symbolic power. Beginning in 1925 he produced a series of paintings using bird imagery. Some of these had an ominous quality, reflected in his poetic memoir of 1936: "In a country the color of '*a pigeon's breast*' I hailed the flight of *100,000 doves*. I saw them invade the black *forests* of desire and endless *walls and seas*." But then, as he described, "In 1930 . . . I was visited nearly every day by the *Bird Superior*, named *Loplop*, an extraordinary phantom of model fidelity who attached himself to my person."[5] It is the protective and inspirational bird alter ego, Loplop, who is prefigured in the bird head seen here.

Ernst's painting is imbued with the mysteries and power of plant life. The "Tree of Life" itself is apparently represented by the great root-like form—Ernst's "forest taking wing"—which seems to be generated from the aqueous world inhabited by crabs and the *circumflex medusa*, a type of jellyfish. The same crab stencil was used in another painting, *Le Crabe*, dated 1926 by Spies.[6] The jellyfish, like so many of Ernst's images, seems to be derived from his frottages, specifically, two of 1925 in which he used the pattern of a metal drain.[7] He had in his earlier work already used mechanical disc-shaped pieces, but the design of this drain furnished the source both for the sun disk that soon began to appear in many works[8] and the "sea flowers" or medusas which can be seen in several other paintings of this period.[9]

The unusually large size of this painting may be the result of a specific commission from its first owner, Comte Etienne de Beaumont (1883-1956), who was a stage and costume designer and organizer of *fêtes*. In 1924 he sponsored with Massine a short-lived ballet company, *Les Soirées de Paris*, to compete with Diaghilev's *Ballets russes*. Among the artists and musicians with whom de Beaumont worked were Picasso, Cocteau, Braque, Satie, Milhaud, and Tzara.[10]

[1]Werner Haftmann, *Painting in the Twentieth Century*, New York, 1966, I, p. 268.
[2]André Breton, "Surrealism and Painting," 1927, translated in *Surrealism*, ed. by Patrick Waldberg, New York, 1965, p. 83.
[3]"An Informal Life of ME as told by himself," in the exhibition catalogue *Max Ernst*, The Museum of Modern Art, New York, 1961, p. 15.
[4]M. Schneede, *Max Ernst*, New York, 1972, p. 107.
[5]Max Ernst, "Beyond Painting," 1936-37, quoted and translated in Waldberg, *Surrealism*, 1965, pp. 98-99.
[6]Spies and Metken, 1976, no. 1034.
[7]These works, *Tremblement de terre* and *Quand la lumière fait la roue*, are reproduced in Spies and Metken, 1976, nos. 836, 837.
[8]For example in *Le Soleil couchant*, ibid., no. 975.
[9]One untitled and two others, *Les Amanites* and *Muschelblumen*, ibid., nos. 1284, 1310, 1311.
[10]For a full account of Comte de Beaumont, see Francis Steegmuller, *Cocteau, A Biography*, Boston, 1970, pp. 139-43, 326-30.

172

Bibliographical Abbreviations

Fredericksen and Zeri, 1972
Burton B. Fredericksen and Federico Zeri, *Census of Pre-Nineteenth Century Italian Paintings in North American Collections*, Cambridge, Mass., 1972.

GBA
Gazette des Beaux-Arts, Paris.

Kress Collection, Atlanta, 1958
William Suida and Reginald Poland, *Italian Paintings & Northern Sculpture from the Samuel H. Kress Collection*, Atlanta Art Association Galleries, Atlanta, 1958.

Lugt
Frits Lugt, *Les Marques de collections . . .*, Amsterdam, 1921; *Supplément*, The Hague, 1956.

Masterpieces, Atlanta, 1965
Masterpieces in the High Museum of Art: A Group of Works of Art from the Museum's Collection, Atlanta, 1965.

Middeldorf, 1976
Ulrich A. Middeldorf, *Sculptures from the Samuel H. Kress Collection: European Schools XIV-XIX Century*, London, 1976.

Pigler, 1956
A. Pigler, *Barockthemen*, 2 vols., Budapest, 1956.

Selected Works, Atlanta, 1981
Selected Works in the High Museum of Art: Sixty-one Outstanding Objects from the Permanent Collection, Atlanta, 1981.

Shapley
Fern Rusk Shapley, *Paintings from the Samuel H. Kress Collection: Italian Schools*, London, I, 1966; II, 1968; III, 1973.

Photograph Credits

Gary Bogue, Atlanta, pages 84 (top), 86, 87 (bottom), 92 (top), 95 (top)

Brenwasser, page 151 (top)

Bullaty-Lomeo, pages 48, 62

Courtesy Christie's, New York, pages 19, 70

Jerome Drown, Atlanta, pages 25-31, 33-36, 38 (right), 39, 41-44, 49, 50, 52-55, 57, 58, 63, 65, 69 (right), 76, 77, 98-105, 107-112, 113 (left), 114 (right), 115, 116, 118-125, 127, 129, 135, 137, 138, 140 (left), 141 (left), 142-144, 146-150, 152-158, 161, 164, 167-170

Michael McKelvey, Atlanta, pages 9-24, 28, 32, 38 (left), 40, 46, 47, 51, 56, 60, 66, 68, 69 (left), 71-75, 78, 81-83, 84 (bottom), 85, 87 (top), 88-91, 92 (bottom), 93, 94, 95 (bottom), 96, 97, 106, 113 (right), 114 (left), 117, 126, 128, 130-134, 136, 140 (right), 141 (right), 145, 159, 160, 162, 166, 171

Mary Carolyn Pindar, Atlanta, page 151 (bottom)

Index of Artists